Ribbon of Darkness

Ribbon of Darkness

Inferencing from the Shadowy Arts and Sciences

Barbara Maria Stafford

The University of Chicago Press

Chicago and London

The University of Chicago Press, Chicago 60637
The University of Chicago Press, Ltd., London
© 2019 by The University of Chicago
Published 2019
Printed in the United States of America

28 27 26 25 24 23 22 21 20 19 1 2 3 4 5

ISBN-13: 978-0-226-63048-9 (cloth)
ISBN-13: 978-0-226-63051-9 (paper)
ISBN-13: 978-0-226-63065-6 (e-book)
DOI: https://doi.org/10.7208/chicago/9780226630656.001.0001

Library of Congress Cataloging-in-Publication Data

Names: Stafford, Barbara Maria, 1941– author.
Title: Ribbon of darkness : inferencing from the shadowy arts and sciences /
 Barbara Maria Stafford.
Description: Chicago : The University of Chicago Press, 2019. | Includes
 bibliographical references and index.
Identifiers: LCCN 2018052440 | ISBN 9780226630489 (cloth : alk. paper) |
 ISBN 9780226630519 (pbk. : alk. paper) | ISBN 9780226630656 (e-book)
Subjects: LCSH: Art—Aesthetics. | Sublime, The, in art. | Art and science. |
 Art and technology.
Classification: LCC N66 .S73 2019 | DDC 700.1/05—dc23
LC record available at https://lccn.loc.gov/2018052440

♾ This paper meets the requirements of ANSI/NISO Z39.48-1992
(Permanence of Paper).

Contents

Preface

The Bottom of the Garden

> When I was young, a man told me that your work shouldn't be so
> idiosyncratic and personal that people can't find an entrance for
> themselves into it, and it can't be so general that they can't see what
> you have at stake in it. You want to feel that people have something
> profound at stake in your work, and at the same time you want to
> be able to fill your life with it.
> —KIKI SMITH[1]

When I was nine, my nomadic parents moved to an isolated villa in the forested outskirts of Vienna. To enter the long, narrow garden that rolled down the back, one exited the gloomy nineteenth-century kitchen with its cavernous stone walls and gray vatlike sinks, no doubt hewn from the calcareous Northern Alpine Range. From a shallow natural shelf—really a ridge studded with towering firs—two somewhat broader tiers sloped down a steep hillside ending in a ruined wooden gate opening onto a small secluded street. Memories of two visceral experiences will remain with me forever: one, lying, unseen, in the dusky shadow of fretted needles and entangled limbs rising high above me and the secret garden.

Then descending from the high, shaded shelf toward the sunlit

badminton court in the center of the property, the intent explorer encountered raw, rugged terrain. The weedy, overhung path plunged into a deep green place invisible from the prying windows of the house. In this umbraged wilderness of mossy stones, unkempt grasses, somber ferns, and densely massed leaves surging from the woodland thicket, I became Rima, Queen of the Jungle. Such a transformation required altered dress. I tore pine branches, pulled fronds, and gathered brush, intertwisting stalks, twigs, stems to construct what—a dress? a mantle? Cloaked from neck to foot, I played. In certain canopied spots, which even noonshine could not penetrate, the verdure was so thick that cavelike hollows opened amid the dying foliage. In those occulted spaces I often hid. Late in the day, and stripped of my sylvan attire, I optimistically dragged what remained of the shrubbery back up the hill to soak in the kitchen's laundry tubs for the next stealthy escape.

I think I became an art historian because, as far as I knew, no other field allowed one to stand unnoticed in a dark room with the audience's eyes trained, not on the podium, but on a beam full of luminous images. Kiki Smith's wonderful account (in the epigraph above) captures two intersecting creative realms: one enabling the artist (or any creative individual) to have her own, deeply personal experience, and at the same time another, enabling viewers to see that experience. A distinguished architectural historian once said something like that to my younger self—that is, the part about my work being idiosyncratic. Although the prospect of continuing to produce eccentric research, of existence as an outlier, initially took me aback, he was right. His remark let me see what I've unconventionally been about, just as Kiki Smith reminded me that (as an author) one must show what's at stake.

In addition to the many thoughtful artists, past and present, about whom I've written over the years, poet-songwriter Gordon Lightfoot, I realize in retrospect, has been an unlikely muse—infusing my books and this collection of essays with a strain of darkness. For many years, I taught an undergraduate course called *Strange Shadows: Four Painters (David, Goya, Manet, Gauguin) in Search of the Invisible.* In some essential way, my persistent topics wrestle with the strangeness of shadow, the mysterious varieties of shade, the opacity of surface, the blur of perception. Indeed, "a ribbon of darkness" flows through my work. It ripples through the hermetic line and color theories of *Symbol and Myth,* the dim caves and bottomless caverns of *Voyage into Substance,* the obscure fleshly interior of *Body Criticism,* the ghostly sorcery of *Artful Science,* the radiant screen illusions (meant to be seen in the dark) of

Devices of Wonder, the sophistic images of *Good Looking*, and Plato's eclipse-of-the-moon comparisons in *Visual Analogy*. In line with our obfuscating times—rank with increasingly covert targeting and tailoring of media—the widespread extinguishing of voluntary attention, examined in *Echo Objects*, turned into a multiauthor manifesto in *A Field Guide to a New Meta-Field*. The latter, intermedial project aimed to rouse imagists across the liberal arts to engage (as well as critique) findings coming from the emerging neurosciences on everything from emotion to consciousness, deliberation to imagination, memory to mirroring. These case studies concretely demonstrated the meaningful insights and depth of analysis that could be achieved—both in complex historical scholarship and evolving contemporary art practice—from such a double-focus, one shedding light on long-shrouded questions.

The following essays all postdate the financial crash of 2008. Coincidentally, I had just taken (perhaps unwisely given the economic realities) early retirement from the University of Chicago. It was then that I turned nomad and also essayist, having formerly believed myself to be primarily a book writer. I wrote in response to requests from journal and book editors, curators, and reviewers that, happily, seemed to materialize out of nowhere. I intuitively accepted, not all invitations, but those that prompted what you will read here. I say "intuitively" because only after I gathered and reworked the disparate essays—written for special issues of diverse publications (from *Art Jewelry Forum* to *Common Knowledge*, *Colour* to the *Oxford Art Journal*), for exhibition catalogs like LACMA's *Seeing the Light* and MASS MoCA's *Explode the Day*, for edited volumes from Routledge (*Perception and Agency in Shared Spaces of Contemporary Art*; *Contemporary Visual Culture and the Sublime*) and from Springer (*Ineffability: An Exercise in Comparative Philosophy of Religion*), and more—did I recognize that they corresponded to themes that have preoccupied me all my life.

No essay repeats another and yet, to me, they miraculously dovetail. Each, operating in a new arena, furthers the relational task begun in *Echo Objects* and the *Field Guide*: weaving together the cognitive work performed by the visual arts with the findings of the biological and neurosciences—always with an eye to mutual benefit. I view them as exercises in what John McPhee terms "creative non-fiction."[2] That is, I don't make things up, but I do care about the style. I selected my three overarching rubrics (Inscrutability, Ineffability, Intuitability) for formal as well as indicative reasons, to reveal both the particular character of the essays and the overall pattern connecting them—

while limiting myself, idiosyncratically, to the rich connotations of the alphabetic "I"s. Chief among them, and initiating the book's subtitle, is Inferencing—the ways in which the arts and sciences imaginatively infer meaning from the veiled behavior of matter: our future unreality.

Introduction

On Being Struck

Hitting the Eye/Arousing the Mind

> The consciousness darts back and forth in time like a weaver
> and can occupy, when busy with its mysterious self-formings
> and self-gatherings, a very large specious present. . . . It is odd
> that falling in love, though frequently mentioned in literature,
> is rarely adequately described.
> —IRIS MURDOCH, *The Black Prince*[1]

In 1981, when I joined the Department of Art History at the University of Chicago, I taught in the College Core. I was assigned the iconic 101, the "Learning to Look" course originated by the legendary and too-early-dead Joshua Taylor ("Sir Joshua" to his devoted followers). There were many professorial debates about its content, certainly. But one could teach pretty much what one wanted, I was told, as long as the subject matter dealt with visual art in a school founded and grounded in books. This was not easy. My undergraduates were very smart, very canny, and very opinionated. They *knew* what was intellectually important. Even before today's iPhone mania, they were loath to look up from their texts and observe their surroundings, let alone engage seriously with "lesser" media.

In desperation, I invented a game in lieu of the customary midterm exam. This proposed innovation was greeted with high enthu-

siasm and general hilarity until the students realized just how hard a task it was. The assignment consisted of sallying forth in midquarter—no protests about the dismal weather availed—to experience the miracle of "being struck." Ideally, and in all ways preferably, the jolting object, startling item, or intrusive phenomenon was to be brought back to class—shown, recounted, with circumstances graphically remembered—to be considered by a skeptical audience. Only after undergoing the trial of a private epiphany and enduring the subsequent dramatic display did each person analyze and write up his or her experience. These instructions seemed clarity itself. Nevertheless, a subverting tactic immediately surfaced. What if the student could not bring this "thing" back to class? What if it were ephemeral, not stationary, too big or too small, intangible? What if it were not a solid object but speckled veils of atmospheric color? To counter such wily, if astute, objections, I told the students to do what artists had done since the beginning of time: make copies.

Despite the litany of "what ifs," the focus remained squarely on planes of perception. No, they were not to go out and choose the first thing they bumped into. The goal was precisely to linger in this attentive state, not to get it quickly over and done with, thereby circumventing what appeared to them to be an irritatingly eccentric assignment. I painted optimistic pictures of how what they found might be the most astonishing event that had ever happened to them. To prepare for the impending ordeal, we performed Surrealist exercises to invite chance, we studied Jungian dream myths, we admired Joseph Cornell's allusively boxed *objets trouvés*. For the platonically as well as the sensuously minded, I invoked Iris Murdoch's witty description of an encounter with that capriciously obscure and playful god: the inscrutable Eros. Although the students' initiation was more prosaic, resistance proved similarly futile. Despite wails about the artificially limited time frame, during the prescribed week they were patiently to remain open, receptive, to await the mysterious happening. Should they become lucky, they too might be smitten by the demonic, by the full sensory force of tangible reality.

Although much guile was expended on the students' part and much cunning and energy on mine, over the years I believe this experiment in consciousness-transmutation ultimately (that is, more or less) succeeded. The "test" was to have them persuade an intelligent if dubious public—myself and their peers—that, indeed, for a moment, their internal and external worlds had coalesced into a meaningful, substantial thing. That some concretizable emotion, experience, or action had magically surfaced from the subterra-

nean river of consciousness to swim compactly above the incessant inner and outer noise. I continue to imagine this materialized knowing as a sort of perceptual/cognitive gem. In this divine-seeming crystallization, I proposed—when something ineffable unaccountably appears to you—could be located the compressive densities of visual art.

Some of my graduate student assistants—awash in the *différence* of French theory, paralyzed by the mournful lamentations on modernity by the Frankfurt School, and submerged under the disciplinary shipwrecks produced by deconstruction—were themselves struggling with how to get their perceptions of art together with agency. So the pedagogical tactic of "being struck" entered my seminars in the form of the sensorium-regaining field trip. This notion of enjoyable lessons from objects also tallied with my research for *Artful Science*—a study of visual education from the Renaissance to the Enlightenment, based on understanding abstract ideas by starting from ordinary material objects, artful devices, and image games.

The field trip as a process for teaching ideas through found or encountered objects challenged the equivalency assumption: the assumption that a uniform, self-preserving ideological method is relevant to all cultural products, especially images. Face to face, objects started to feel animated, as if talking back to the viewer with opinions of their own. These intellectual excursions also proved the intuition that we don't tend to look hard at what we don't greatly value. So it obliged us to formulate and test complementary mixed methods determined by the (to us) strange things we were looking at, rather than by the imposition of prior controlling beliefs. We searched for alternative interpretive frames, other developmental genealogies—adequate to the multiple sources and local variables we were confronting on the spot. Last but not least, the field trip encouraged a lifetime of intensive natural observation. Over time, I believe it built a receptive and empathetic mental architecture, a less ruthless way of projecting our psychology onto the natural or artificial environment.

To encourage this ingenuity-shaped scholarship, I frequently taught seminars off site in the University of Illinois at Chicago's Virtual Reality Cave and in the University of Chicago Center for Imaging Sciences—long before it was chic to put the museum visitor's head into a CT or fMRI scanner. We interviewed the lead partner of one of Chicago's major law firms to understand what "visual evidence" meant to lawyers and how the legal understanding of the term might be inflected by the humanities. When graduate students and

postdocs from the sciences began to take my seminars, we in turn frequented their biology, chemistry, and physics labs to learn about new visualizing technologies, new methods, new devices. On these expeditions we witnessed fantastic phenomena, to us previously unimaginable, and were continually shocked into an awareness of alternative modes of seeing and thinking. Although not Flaubert's *éducation sentimentale*, it definitely was an *éducation sensible*.

Thanks to a now, alas, defunct program of the Pew Charitable Trusts encouraging medical students to take courses in the humanities, it was not unusual for future physicians to take my "Art and Medicine" seminar. The artists and art historians, in turn, gained entry to their apparatus-filled hospitals, visiting wards, observing grand rounds. There, we were unforgettably exposed to their daily medical as well as moral decision-making. This ethical dimension to learning was strengthened when, thanks to its welcoming director, Dr. Mark Siegler, I became a member of the MacLean Center for Clinical Medical Ethics. It continues today with my participation in the Neuroethics Seminar and the Center for Mind, Brain, and Culture at Emory University.

At the same time, there was not a thought-provoking exhibition at the Art Institute of Chicago, the Museum of Contemporary Art, the Field Museum (with its early twentieth-century walnut-cased natural history dioramas, as well as a superb specialized library), or the Museum of Science and Industry (with its then new and innovative installation on the human brain) that we did not explore. We spoke to curators and museum directors; we worked on exhibitions. We regularly went to gallery openings at the Renaissance Society and did studio visits all over town. I taught seminars on image-rich encyclopedias and encyclopedism, illustrated travel accounts, and cabinets of wonder in the amazingly wide and deep collections of the Newberry Library; and on anatomical atlases, pictorialization in early modern science, and the artist's share in the making of the modern sciences (dermatology, geology, and mineralogy) in the terrific rare book room of the University of Chicago's Regenstein Library—then directed by the generous-to-a-fault Robert Rosenthal.

When the University of Chicago's Computational Neuroscience Workshop got up and running, I was the only member of the Humanities Division who attended. (I still remember the first day I was able to formulate a cogent question.) At those difficult, mind-blowing lectures, I took copious notes to be slaved over later and then "translated" back in my seminar into recognizable art historical concerns. From these demanding adventures, I aimed to

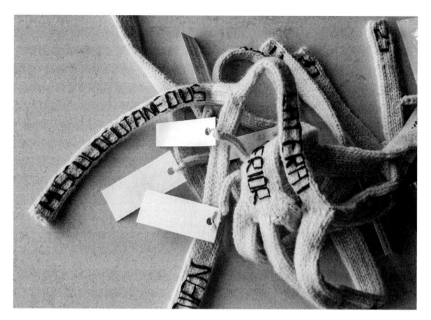

Figure O.1 Daniel Jue Lam, *Learning the Nerves of the Brachial Plexus by Knitting.*
Photograph: Jean Lachat. Courtesy of the University of Chicago/Lachat and Lam, a 2018
graduate of the University of Chicago Pritzker School of Medicine. www.masculiknity.com.

craft a neuroaesthetic approach. It would be brandless, disciplinarily unlocatable, leading not just to theoretical but to applied collaborations between the historical and new media research of visual humanists and intersecting projects emanating from the evolving brain sciences.

In books such as *Visual Analogy: Consciousness as the Art of Connecting* (1999), *Echo Objects: The Cognitive Work of Images* (2007), and *A Field Guide to a New Meta-Field: Bridging the Humanities-Neurosciences Divide* (2011), I predicted the resurgence of an artful experimental science. Take, for example, the interactive human eye, with its six working extraocular muscles. Or consider the nerves of the brachial plexus. Recently, both of these body parts, as well as other organs and functions, have been reified in yarn. Medical student Daniel Lam and a growing cohort of fellow students, tasked with learning the body, turned to knitting as a tangible aid to memory. But the wonderful results transcend the initial humble aim. They are, in fact, engaged in knitting a practical poetics of the body.[2]

Similarly, on the arts side, we find a new pragmatics—welding together the efforts of artist, architect, scientist, technologist, and designer-engineer.

Think of the huge geometries of Thomas Heatherwick, the virtual analglyphic shadow pictures of Tim Otto Roth, and the sculpted urban optical illusions of Anish Kapoor.

The applied side of this brave new technology world was driven home to me when I served as the Georgia Institute of Technology's Distinguished University Visiting Professor from 2010 to 2013. This was followed by a year as Distinguished Critic in the College of Architecture and, I am pleased to say, continues informally.

During those intellectually intense and physically strenuous years, I organized two cross-institutional exhibitions ("Art/Science Salons," as I provocatively termed them). The first addressed perception ("I See, I See: Considering Attention"), the second "Neuro-Humanities Entanglements." These were accompanied, in 2011, by an exciting panel of scholars pondering the future of education in the face of novel technological developments and, in 2012, by a three-day, multidisciplinary symposium on the impact of the brain sciences across wide areas of research. These installations and collaborations were accomplished by legwork, not, in the important formative stages, by email— a vital point. The practical as well as theoretical activity of binding fields and projects from initially alien universes needed to be done in person—given that my mandate was to try and tie together Georgia Tech's eight schools of engineering, computational sciences, and cognitive sciences with the Ivan Allen College of Liberal Arts in sustainable ways.

In seeking to enlist people who, at best, had merely heard of one another, the strategy was to visit the scientists and engineers during their office hours— when they had to be polite and could not escape me. I also requested money from the College of Liberal Arts dean, Jacqueline Royster, to host planning lunches to which I also invited faculty from Emory and SCAD Atlanta. (No one, even on staggering grants, I discovered, could resist a free lunch.) Those who attended were enthusiastic and highly vocal, and after meetings, I would return to my office to write up and circulate optimistic summaries of what we had accomplished. Admittedly, in the beginning, I painted a more coherent vision of our joint project than existed in fact. Later, it seemed miraculous to all of us that what had at first appeared to be a disjointed group of art historians, architects, designers, engineers, and scientists had managed, at the end of consecutive spring terms, to mount two multidisciplinary exhibitions with related public events. In the process, I know some of us came to see our singular future in all its radiant splendor and dark ambiguity in ineluctable ways.

In retrospect, I find that all of my projects (mounting exhibitions, orga-

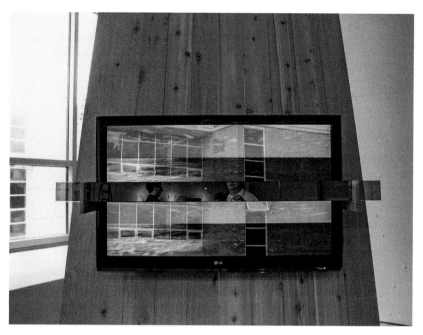

Figure O.2 Frederick Pearsall and Matthew Swarts, *Incline*, 2012. 55-inch color LCD/HD video monitor mounted on a black steel support; plane of wooden planks set at a 70° angle between the monitor and support, supporting a horizontal plane of reflective glass, cantilevered in front of the video screen, with a single Kinect sensor behind the glass; computer with Microsoft SDK software coded to control the video inputs/outputs. Installation at "Neuro-Humanities Entanglements" conference, Georgia Institute of Technology. *Incline* reveals the complexities of any mirroring process: encouraging seeing from the front, the back, and transversely through the piece, thus bringing multiple viewers, their viewpoints, and contexts simultaneously to the frontal plane—which itself presents an entirely different view. Courtesy of the artists.

nizing conferences, teaching, and writing books) are somatosensory as well as intellectual field trips, arduous and joyful expeditions into unusual, unfamiliar domains. "No theory without practice" had been the guiding motto of my seminars. So I guess, as Conrad's narrator remarks when viewing the Gulf of Siam in *The Secret Sharer*, the field trip was a "breathless pause at the threshold of a long passage [as] we seemed to be measuring our fitness for a long and arduous enterprise."[3] When I now go out alone, in my mind and heart I always carry a group of eager, inquisitive, and intensely conversing students along.

This collection of recent essays is no exception. Only the subjects, the shifting art/science relations, and the resulting urgencies have changed. Con-

sider them as exercises in noticing the confounding: those dark patterns and dim susceptibilities lurking at the intersection of art, science, and technology. Occupying different intellectual and emotional registers, these essays also vary in form, in their expansiveness or distillation; longer thought pieces are interspersed with epigrammatic interludes. The reader will find forays into the allure and perils of the new digital technologies that capture our attention and hold us captive, amplified by meditations on what I identify as contemporary ineffabilities: the fact, for example, that ordinary, intelligent people cannot find words for what is being created in myriad hybrid settings, from avant-garde science and BioArt laboratories to futuristic surgical transformations and genetic mutations. I also tackle our networked sociocultural inscrutables—the machinic-driven opacities and ambiguities we have created but can no longer penetrate or understand. Not surprisingly, artificial intelligence—from machinic Deep Learning to artificial emotional intelligence—looms large in these discussions, since thinking isn't what we used to think it is, nor, apparently, what we now glimpse it as.[4]

Some essays are downright practical. I suggest a way—for now and in the uncertain future—to save the intactness of the incomparable Warburg Library from obliteration by the dispersal of its books. I argue that drowning this hybrid collection in the vast holdings of the University of London Library would be tantamount to destroying a "house museum" similar to that of Sir John Soane. I mean by this comparison that the organizational system devised by the famous student of iconography, Aby Warburg, resembles the idiosyncratic system of viewing multicultural artifacts invented by the polymath British architect for his museum. Both intimately and indelibly confront the visitor with the pragmatic workings of a brilliant mind.

I also look, in epitome, at large, facts-of-life things you could look at for a long time, that possess a dimension of inwardness. Thus you will find personal essays on the chromatics of erotics; on my mentally impaired mother's still-astonishing awareness of jewels during her final years and, more generally, on the "jewelry of ideas";[5] on the psychosomatic experience of "belowness" in natural and, increasingly, artificial undergrounds. Then there are essays that mirror abiding passions: on the strangeness of shadows and the persistence of screens, on the crystalline as simultaneously mineral and model of self-generating thought, on the question of whether the Sublime still exists.

But above all, the phantom thread that runs through the whole enterprise is, as ever, the attention-training virtues—though battered—and the existential expertise historically provided by the visual arts. In short, I defend

their demonstrable, varied, and enduring performance of cognitive work. I see them not just as palpable expressions of imaginative vision but, more importantly, as lighting up the dangers of imbalance between imagination and reality—the gulf between the life we are creating and the one we live.

This collection, then, continues to offer an alternative lineage of aesthetic thought as practical, material, interactive, not disinterested as urged by Kant. Focusing on this performative trajectory shows how the discovery and making of formal patterns creates both a practical and a conceptual relationship between the arts and sciences. It would seem my early book *Symbol and Myth* (a study of eighteenth- and nineteenth-century embodied line and color theory) has become increasingly relevant. It outlined a historical model for art/science interaction based on pattern, the recognition of skeletal forms underlying all material objects—thus tying together the perceiving and interpreting human being with a foundational biology, a responsive nervous system, and the changing environment. Ultimately, even our most abstruse concepts are rooted in physiological response making for a profound interrelation between the arts and sciences.

So I continue to be struck by novel modes of apprehension. Consider the challenge laid down by the "Meta-Morph" panels, exhibitions, and performances at the 2018 Trondheim Biennale for Art and Technology. I welcome its summons to confront the key question of where, exactly, our innovative nature has taken us, first by accident and, now, by design. Of the myriad thought-provoking installations none impressed me more than Louis-Philippe Demers and Bill Vorn's prophetic *Inferno*—a sublimely surreal robotic project based on Dante's grim description of the nine circles of Hell.[6] Assailing the sensorium with live performance and raw techno-wear/ware, it paradoxically demonstrates the continued fascination for crafted materials. I also am fascinated by furtive or flaunted computer-designed fashions, combinatorial haptics from mosaic to collage, disorienting media-saturated interiors, hypnotic gems, and the Ovidean metamorphoses of stones.

I continue to be drawn to poetic and unflinching artists like Louise Bourgeois, who in her last projects combines drawing, painting, printmaking, watercolor, gouache, and writing—in collaboration with printers and publishers—to produce large, gut-wrenching panels. *The Red Sky*—the title of both a recent exhibition and a major work—achieves a nameless mode for seizing the unnamable.[7] On a recent field trip to Los Angeles, I stood undone before this metamorphosis of vulnerability into tumultuous object. The words "Red Sky," emblazoned at the top of the sheet, etched and re-etched

Figure 0.3 Louis-Philippe Demers and Bill Vorn, *Inferno*, 2015–2016. Participatory art performance, with 25 wearable robotic structures. Photograph from performance at the Prix Ars Electronica 2016. Concept, robots, light, and sound: Vorn, Demers. Electronics: Martin Peach. Studio assistants: Beatriz Herrera, Morgan Rauscher, Csenge Kolozsvari. Support: Canada Arts Council, MOE Tier 1 Nanyang Technological University. Coproduction: Acreq-Elektra, Maison des Arts de Créteil, ARCADI, Stéréolux, Conseil des Arts et des Lettres du Québec. Photograph © Magalie Fonteneau. Courtesy of Louis-Philippe Demers, Bill Vorn, and Magalie Fonteneau.

until they stand out in raw relief, are answered from below not by scrawled words (although these occur in other panels) but by bloody monochromatic washes ranging from membrane thick to capillary translucent. This heraldic escutcheon from Bourgeois's courageous last days incarnates inarticulate fear in blots, vanishing protection in streaks, loneliness in bubbles, pain in smudges, memory loss in dendritic wisps. She obliges us, induces us to experience in the bone an entire voiceless metabolism battling with trauma, terror, valor: all made present through raw materials.

These essays call for a new pragmatics for our proclaimed Age of Entanglement. If Bourgeois's coalescent final rites give the lie to the assertion that all is now "amalgam" or cobbled collections of "heterogenous components, a material-informatic entity whose boundaries undergo continuous construction and reconstruction,"[8] they also state a truth. It's undeniable that our global, internet-connected environments are being exponentially filled with elusive digital entities, secretive code, and entertaining special effects.

Add to this, on the positive side, an explosion of engineered pictures, audio-visual sculpture, projected-upon surfaces, immersive monitors, touchable ambients. We need to look to a different art/science combinatoric for guidance. Many examples of this come from the past.

Consider, for example, Simone Forti's series of seven "integral holograms" from 1975–1978, exhibited in 2018 for the first time since their original showing.[9] These space/time emanations are simultaneously rigorous manifestations of movement studies—a dancer jumping, walking, crouching, crawling—and distinct sculptural presences of the artist in action. Forti's holograms are so cognitively gripping—unlike the hyperrealism of VR prefab environments—because they consciously oblige the viewer to approach and retreat, to move sideways and up and down as the hovering image—luminously projected onto a scratched and yellowed convex acrylic surface—"smears" into an abstract rainbow spectrum or consolidates into a three-dimensional cinematographic body.

If it's accurate to say that a new area of research has been created by virtual embodiment, holography—unlike virtual reality or "experience on demand" systems—opens a chink between our inner and outer worlds. Its three-dimensional "out-thereness" or "hanging in space" projection provides a cognitive as well as a spatial break between our proximate self-models and immersive VR illusions. The latter are created not by a panoramic but by a conjunctive technology, yet "no one understands what . . . [it] is and how it can be used."[10] As Forti shows, holograms make transparent both our bodily experience of perceiving (especially the strong link between the visual and the sensorimotor systems) and the existence of a reality cast outside of the viewer, one that requires experiential and mental reconstruction.

Forti's process art performs the body as judicious assemblage—a deliberated organization "supplemented" by the associative cortex of the moving viewer who enhances the works' spatial gaps and temporal ellipses with her own performance and powers of inferencing. This conscious self-patterning, as we knowingly echo the patterns of intelligent objects, is vital as we increasingly grope sideways through unprecedented obfuscation. To repurpose W. B. Yeats: Are we heading toward a redemptive, Edenic Bethlehem as we slouch through the ethically shady jungle of genetic editing, amorphous biological "stuff," transhuman technologies, expertise-challenging algorithms, skill-narrowing humanoid robotics, AI, AL, brain-enhancing drugs or prosthetics, and other baffling indefinables—or toward what?

So, yes. Hybrid topics and compounded social and cultural issues—

resulting from the cascade of nonstop technological conjunctures—occupy center stage. I aim to be enlightening. But, in the end, this is also a study of shadows—the "ribbon of darkness" of the book's title. After more than a half century of declared art/science collaborations, where do we stand? I mean, where have we really gotten from the standpoint of application, of shaping one another's assumptions and projects, both intellectually and practically and in a sustained way? Not far enough, I think. Consider the rampant second-order romanticism touting an impulsive creativity unbound, the clandestine targeting of the public appetite for new experiences, the specter of neuroeconomics, the partitioning of the commercialized brain. Undeniably, these are some of the runic symbols that make up the texture of contemporary existence. But this melancholic as well as fantastical sequence also presents a tremendous view to the arts. This is what strikes me now.

Inscrutability

1

"Black and Glittering"

The Inscrutable Sublime

[Catherine:] "It's when everything goes black and glittering. . . . It's not like when you're down in the dumps, which is brown. . . . It's like that car," she said, nodding at a black Daimler that had stopped across the road to let out a distinguished-looking old man. The yellow of the early street lights was reflected in its roof, and as it pulled away reflections streamed and glittered in its dark curved sides and windows.

[Nick:] "It sounds almost beautiful." . . .

[Catherine:] "Well, it's poisonous, you see. It's glittering but it's deadly at the same time. It doesn't want you to survive it. . . . It's the whole world just as it is," she said, stretching out to frame it or hold it off: "everything exactly the same. And it's totally negative. You can't survive in it. It's like being on Mars or something."

—ALAN HOLLINGHURST, *The Line of Beauty*[1]

After Dark: Nocturne for Romanticism

I hear nothing but echo, echo of my own speech—am I then alone?
—*The Nightwatches of Bonaventura*[2]

Despite the bright market rhetoric of transparency, today's "global network civilization" is smudged with fake traffic and tarnished by computer-generated scams.[3] Pictures are composites, colors are doctored, online images are aggressively altered or manipulated. The spread of undocumentable Instagrams and other shape-shifting platforms have blurred the line between advertising, art, and photojournalism. Like the opaque Cloud on which the ethereal Web depends, large digital sectors are not only impenetrable but mute when it comes to revealing what is actually being sacrificed for "deeper" data, for more commodities designed to target individual consumers inhabiting increasingly leaky social media. No hyperlinked supply chains joining invisible users with innumerable glossy products or deceptive personal "stuff" can make up for the loss of credible connections in our supposedly leveling, yet unfathomable, Age of Connectivity.[4]

Today, two oppositional spatial concepts—premised on the thrill of surprise and the perverse protraction of terror—are a distantly familiar legacy from the Romantic longitudinal Sublime. Less familiar, yet undergirding the entire concept, is the horizontal notion of glassy inscrutability.[5] If sublimity's indeterminate dimensionality, its bold soaring into nebulous heights or plummeting into murky depths, has leveled in the twenty-first century into amorphous uncertainty, not so its unaccountable incomprehensibility and impenetrability that continue to make us feel out of our depth. Consider information technology's panoramic dazzle, the superficial sparkle of augmenting special effects, and the resulting engulfing ambiguity in which decipherable meaning drowns or is masked.

While the late eighteenth-century Sublime showed that shadows are fundamental to revealing the limits of human understanding, our contemporary epistemological darkness is fashionably lustrous, smoothed into inscrutable shine. The inflationary Internet of Things offers an aggressive mimicry of the world, all right, but as hypnotic product—coated with the duplicitous gloss of advertising. The global marketing industry's shift to smudging the line between ads and media (e.g., through branded content embedded in reality shows, online films, video games) ensures that we are seeing equivocally, receiving what its algorithms want us to see: directed content mirroring media companies' point of view and reflecting the general look and feel of their media properties.[6]

Belgian artist Joseph Nechvatal's 2014 series of palimpsestic paintings and animations, *1% Owns 50% of the World*, explores the ruthless compression

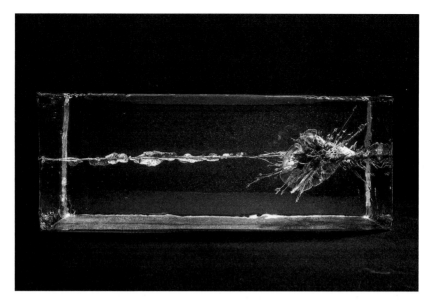

Figure 1.1 The Propeller Group, *AK-47 vs. M16*, 2015. Fragments of AK-47 and M16 bullets, ballistics gel, custom vitrine, digital video. 7.2 × 16.9 × 7.3 in. Courtesy of the artists and James Cohan, New York.

Figure 1.2 Still from music video for Bonzai, "I Did," 2016. Director: Tom Bunker. Art direction: Pete Sharp. 2-D animation: Issac Holland, Blanca Martinez, Sean Weston, Joe Sparkes, James Hatley, Tom Bunker, Alex Smith.

driving this surreal takeover. In the animated version, dissonance and glare accompany the swift erasure of a quick succession of teeming aerial maps. As the tempo speeds up, the gray-scale encoded terrain eerily dwindles beneath the repetitive obliterating stamp of a single percentage point. This startlingly small number also functions associationally, recalling a bargain label or cut-rate price tag—contemporary icons of devaluation that define a dire situation while concealing it. As a flickering figure, it is ominously suggestive of financial volatility, corporate shrinking, store markdowns, and slumping sales.

It seems that vaporous darkness has undergone extreme volatilitization. No longer fumy or miasmatic, the old misty Sublime has sublimed into a new slippery reality—at once brilliant and sinister, paradoxically violently hyper-sharp yet lacking clarity.

The opening epigraph to this essay captures the psychological breakdown such a transformation induces. Although arising from the economic, social, drug, and sexual upheavals of the 1980s, this sleek, acidic vision remains relevant to the obsidian opacities, the lack of firm structural supports, characterizing our current century. In Alan Hollinghurst's Hogarthian novel, the young, wealthy, and self-mutilating Catherine struggles to explain to Nick, a gay friend, her unaccountable condition of making nothing of what is seen, of not seeing for looking, of being unable to get through or behind or under or above things. All is insubstantial veneer, slick polish eternally returning the viewer to the image of herself. Similarly, the solipsistic field of view established by Argentinian artist Sebastian Diaz Morales in his short film *The Lost Object* (2017) does not end in a single thing (in this case, the radiant projection screen) but embraces the inky expanse of the environment. Here, too, the world is concealed behind its refulgent presentation. His glinting cube acts like an oracular mirror—scintillant and flaring, but icily empty.

In Catherine's near-pathological state of incomprehension, robust substance turns menacingly decorative or is inexplicably transformed into illegible ornament. This hard, cold, glamorous blackness surfacing in Margaret Thatcher's unraveling England is unlike Burke's fusive Sublime inhabiting a melodramatic surge of matter. Instead of rushing dizzyingly downward into the abyss or rising infinitely upward into the heavens, it disembodiedly skids over familiar objects and reflexively slips across things. Without any blunting atmosphere or three-dimensionality to lend perspective, this merciless metallic glare gallops horizontally, robbing identity of its hidden reality and flattening everything in its wake into vacancy or mirage.

Hollinghurst's evocation of what might be termed modern mechano-

cognitive phantasmagoria resembles the air of secrecy, presence of illusion, and Gnostic motifs born out of a negative or "Tantric" romanticism, that is, out of an abject or inverted sublimity so extreme as to be inscrutable. I am reminded, in particular, of the escalating anguish pervading the strange confessions of the pseudonymous author Bonaventura. His brooding, fragmentary *Nightwatches*, published in 1804—coincidentally the year of Kant's death—register the post-Kantian break with bright Enlightenment optimism by evoking a baffling subjectivism and restless irrationality. Ironically, in the midst of his disillusioned vigils, the narrator of this compulsive wandering yearns for what he has annihilated: the clear and lucid light of day.

> "What is the sun?" Thus the author, or "Cloaked Stranger," asks his mother one day as she is describing the sunrise from a mountain. "Poor boy, you will never understand, you were born blind!" . . . But the willful seeker's fantasy continued to belabor the question: my longing mind strove violently to break through the body and look into the light.[7]

All in vain since his obsession remains in thrall to the continuous nightmare. The reader careens through Piranesian twisted streets, lurching along with the crazed voyeur—the puppeteer–poet–night watchman Kreuzgang—as he moves through sixteen stormy episodes.

Confined to this small-town Babel of corruption, he stops to peer through a dirty window or a cracked door. Such clandestine vagrancy reveals secretly irradiant scenes, framed as if projected on a soiled magic lantern screen—macabre murders, frenzied madness, grotesque Blue Beard- or Don Juan-sex, each vision leading to violence and suffering. This mysterious miniature world anticipates Lothar Osterburg's dusky photogravures of "imagined realities"—tenebrous images made by embedding the camera inside a dreamlike model or staged setting, much as Bonaventura inserts his roving eye inside the sinister ambient. All the while, between the author's chaotic lines, the ghosts of Burke and Kant surreptitiously peep out, the former affronted by Bonaventura's egotistical glorification of the murky unconscious, the latter by his violent disdain for moral imperatives.

The two epochs evoked by Bonaventura and Hollinghurst share fundamental negative attributes—the loneliness of narcissism, the erosion of insanity, the disgust at ostentation and wealth, the rage at fraud constantly concealed. Yet for the Romantics, this Manichean foray into the absurd was still a sublime invention of a tormenting devil or of a distant god who inexplicably

Figure 1.3 Lothar Osterburg, *Downtown Transfer (State 2)*, 2010. Photogravure.
Courtesy of the artist and Lesley Heller Gallery.

allows the vileness of life. Contemporary pretense and deceptive appearances, by contrast (Hollinghurst, after all, is writing in the twenty-first century), are seen as self-generating, automated, coolly heartless, fashionably Goth. Think of the vampiric aura of the Daimler. Note how its light-reflecting skin is simultaneously alluring and repellent, an addictive, if devastating, symbol of soulless brand awareness. In her bleak reverie, Catherine's limbic brain, like ours, is being grooved by subliminal advertising awakening unconscious desires bathed in a retail twilight.

A Surface Sublimity?

I need the world to have a surface, the same surface everyone sees.
I don't like feeling like I'm always about to fall through to something else.
—WILLIAM GIBSON, *Zero History*[8]

What a concept: Sublimity. Especially in an age like ours—secular, disenchanted, anxiety-ridden, nomadic—simultaneously chilled or overheated, dehumanized or massively infrastructured. What, then, might serve as an antidote to this twisted Romantic legacy of the singular self, the branded genius who, inspired, creates inscrutably, esoterically for the few in the know? How to signal unequivocally, openly, why and how things get made? Could the knowing demystification of arcane processes, the putting aside of private "signature" styles, the rejection of blinding selfie-solipsism sensitize us to work made visible again?

Trevor Paglen's bravura photographs—part of a 2016 exhibition, *The Octopus*, at London's Photographers' Gallery—document the extent and ubiquity of government intelligence and military surveillance. These voguish abstractions, with their wayward Hogarthian lines, lead the eye on a grim chase. Thin streams of lucent color streak across a glittering black sky, with the paradoxical result that clandestine activity is flaunted in a blaze of spectacle. Paglen's work makes us understand just how thoroughly the new world we inhabit is enmeshed in intrigue and deception: "the allegorical octopus consuming the world."[9] Ironically, such flamboyant images—both gorgeous and deadly—are the lucid indicators of stealth. (Similarly, James Bridle outlines the shadows cast by camouflaged drones in use by the British Army; see fig. 3.3.) In the process of making global spying explicit, Paglen discloses the twenty-first century's chic armamentarium of concealment: the silvery network of fiber-optic lines converging beneath sprawling landscapes, shiny bits of electronic information coursing between continents through undersea cables, motion-dazzle drones fetchingly cloaked in metallic sheen.

In William Gibson's prescient *Zero History*, the author breaks ranks with science fiction to write about a contemporary material alchemy, hidden from common view, whose ethical rigors demand a renewal of craft discipline. The novel's characters tend to be featureless, paper dolls so deliberately flat as to be almost bodiless. Descriptive richness, by contrast, is lavished on their minutely analyzed clothes. Or, more accurately, on dismissing trending fashions to track down gnomic ideograms stitched or woven into garments for

which there seems to be no vocabulary. The central theme, it emerges, is following the evasive route taken by a few sphinxlike samples cocooned within unadvertised simple, but superb, apparel lines specializing in what is "almost impossible to find." As someone admittedly good at "figuring out what the *real* products are," Meredith—one of the book's discerning protagonists—opts out of the fashion empire's "industrialization of novelty" to both make and search out a "deeper code":

> [At first] I just wanted to explore processes, learn, be left alone. . . . Weird inversions of customary logic. That Japanese idea of secret brands. . . . [In the end] I'd have a brand, I decided, but it would be a secret. The branding would *be* that it was a secret. No advertising. None. No press. No shows.[10]

This noble secrecy obliges dedicated seekers after coveted—even archetypal—garments to be vigilantly perspicuous in an inattentive world whose distracted inhabitants cannot tell the difference, for example, between imitative "distressing" and genuine "patination."[11] Such almost morally inspired counter-revolutionaries claim not to be enslaved by the dictates of fashion but to be keenly aware of how the kind and quality of fiber, the yarn, the construction or weave, affect values—all values.[12]

Gibson's unflattering take on the dysfunctional aspects of this huge, label-driven, theme-park industry is contrasted with an elite realm of hieratic creators engaged in reinventing exclusivity. To my mind, this esoteric plain-style cultural phenomenon, which worships reticent antisystem design—authentic plushness, not poshness—epitomizes what might be called the Surface Sublime. It is after the soul of clothes. Not only are these sought-after arcane design studios, located at the far edge of normal commerce, hard to find. They require Grail-like treks across continents from aspiring buyers paradoxically in search of what cannot be described. This rare experience resembles that of the initiate in a quasi-mythical cult. Pure, austere, Parsifal-clients are under the spell of legendary patterns, primordial organics that miraculously absorb glare, fabled smoky colors, and richly textured synthetics that sink into muted substance. These occult qualities arise from marvelous and unobtrusive tailoring. Like watching flitting shadows, discovering secret nonlabeled "labels" is both subtle and noticeable—but only to discerning cognoscenti.

My guess is that unlike sensational, meretricious clothing (firestormed with sequins or studded with sharp hardware) that flashes its brands but is dead, as if painted on, the seduction of nonreflective pieces lies in their in-

scrutability, their need to be ferreted out, their resistance to being completely probed. Their overwhelming desirability is at least partly due to the fact that they thrive without the brandished advertising that makes everyone else desperately want them.

Perhaps this is what Dutch avant-garde designer Iris van Herpen means when she speaks of fashion's most recent marvels, radical artificial/natural hybrids or intermedial experimental constructions comprising a fantasy landscape of technical fabrics. This seductive, retail-defying, futuristic outback is stocked with indescribable wearables fabricated of digital wiring, laser-cut mesh, invisible thread, holographic moire, metamorphic Mylar, springy tulle, shimmering gauze, halos of lace, and something resembling bubbling "quantum foam." She entices the avant-garde couturista with wavy smoke-and-cloud skirts, quivering mermaid or jellyfish pants, personalized materials made from the wearer's body scans that ripple, coast, and glide over the skin.

Her translucent "Water-Splash" dress—frozen spray contrived from sheet plastic—abstractly crystallizes both the look and the feeling of becoming wet, of rigid substance undergoing a sea change. In a utopian vein, Herpen questions whether we will "keep on wearing fabrics in the future, or if dressing will become something non-material, something that is visible, not tangible or touchable?"[13] On the issue of whether haptic textiles will have an afterlife, I believe Australian artist, Sally Smart, would answer a resounding "yes." Witness her visionary use of felted cloth and appliqued embroideries. She moves freely between, and among, bespoke insider fashion design, "torn and cut" silhouetted room-size wall installations and imaginative 3-D models inspired by maritime history (marauding pirates, deathly shipwrecks, abandoned passengers). The sheer versatility of her practice is seen—in addition to summoning up this rapacious derring-do—in the fabrication of enchanting hand-dressed, cord-manipulated puppets that transform shirts, pants, jackets into extended performance pieces

Gibson could only glimpse this exciting explosion of volatile, unpredictable—sometimes beautifully monstrous—unfashion wear. Nor is it possible to foresee all the future applications of this emerging ambient-wear—ranging from environmental sensing to body armor to digital camouflage. But what's already out there—flamboyantly or barely hinted at—are the intriguing dynamics between conspicuously structured outfits and a choreography of concealed devices.

Malleable silicone, glinting chain mail, machine-generated plastic pleats, and dyes responsive to light or heat embedded in textiles and leathers have

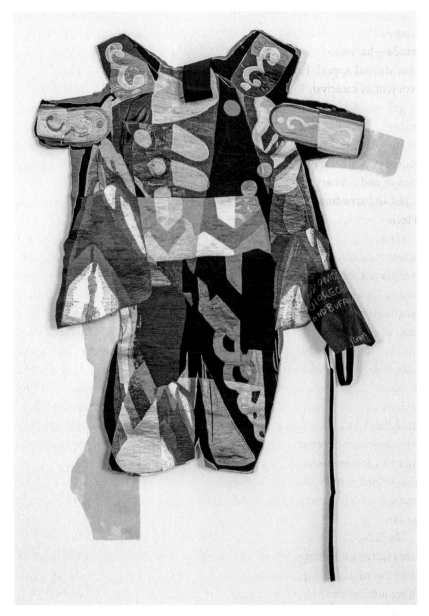

Figure 1.4 Sally Smart, *Assemblage Embroidery #6 (Buffoon)*, 2015–2016. Synthetic thread and collage elements. 60 × 30.5 inches. Courtesy of the artist and Postmasters Gallery, New York. Photograph: Tamas Banovich.

important precursors in the assemblages of contemporary sculptors. Sarah Krepp's transfigured ensembles, for one, composed of slashed, abraded tire treads—harvested from a crash-littered DMV graveyard in Chicago—have a raw, visceral appeal. Her explosive reliefs evoke a violent J. G. Ballard galaxy redolent of cataclysmic car collisions, shapes plowed together, saberlike jets of gas, smeared and obliterated color. The visual impact of destruction and resurrection, of tattered and tangled materials, is so powerful that she makes us see familiar flora and fauna in a new and forbidding light. Consider her mortuary feathers, Baudelairean flayed flowers of evil, abstract shooting-star sprays, and rubbery quilled shrouds cascading into space. Provocatively textured and arrestingly pitch-black, these slivered high-relief draperies forecast a techno-craft fashion that is literally cutting-edge.[14]

Herpen and Smart demonstrate that design wizardry constitutes an innovative art form, unconcerned with conventional dresses. Similarly, Gibson's story is not just about commercial espionage and the garment-establishment cabala. To my mind, his description of the almost spiritual pursuit of textile singularities resembles the obsessive early-modern chase after unique animal, plant, and mineral curiosities. In the seventeenth and eighteenth centuries, *Wunderkammer* collections of bizarrely carved narwhal tusks, exotic animal and plant specimens, anthropomorphic shells, talismanic sigils, and gem amulets embodied a searching sensibility, a cryptic performance art. Like today's "somatechnics"—folded, pleated, reactive apparel amalgamated from fiberglass, precious metals, and robotics—the objects in these "cabinets of wonder" were experiments in understanding a universe bursting with biomorphic mutations, zoomorphic transformations, and lithic metamorphoses. The visionary hunt after authentic oddities testifies to the spell cast by absolute originals in a world rife with copies, duplicates, and reproductions—then and now.[15]

In Gibson's tale, touch or "hand"—as a variable two-way pressure or constant tactile interchange between sensation and the raw data of perception—seems as much his topic as is visualization. He's after that inscrutable something lurking elusively in the weave, hovering mysteriously in the threads of a dead-stock swatch or a shrinking roll of fabric. It's significant, then, that perhaps the core discovery of the past decade's research into the cognitive phenomenon of touch is "that being skin-smart is as smart as any other kind of smart."[16] Fabrics from fluttering to sleek externalize what neuroscientists are calling "labeled lines"—startlingly specific neural touch systems. It's the "skin" of clothing, the body's auratic envelope, not bare nakedness, that seems

Figure 1.5 Sarah Krepp, *Blow-Out: Fly (713)*. Tire, paint, mixed media. Approx. 60 × 60 inches. Courtesy of the artist.

to possess an inner life, automatically and unconsciously copying our familiar poses, gestures, and actions. Thus the haptic intelligence of dexterous designers, old and new—working with opulent fabrics or engineered polymaterials that reciprocate the handling of them—has palpably infused the sublime lineage of manual and technical expertise.

Artful Engineering: Toward a Brandless Art

The Freiburg political scientist Wilhelm Hennis once ascribed to [Max] Weber's work the central idea of "training the power of judgment" . . . for a focus on the power of judgment springs from an understanding of science . . . namely philosophy as *practical* science.
—HANNAH BETHKE, "Evidence of the Power of Judgment"[17]

We are losing a vital cognitive asset, namely, the power of deliberation. In the rush to get information at hyperbolic speed, we have already lost *visible* judiciousness, that core Kantian relational process involving the exhibition of scrutable judgment in human thought and interaction as well as in a piece of work. Although he doesn't say it, Gibson's aversion to the global panopticon of branding, I think, stems from his realization that clever marketers use it to stage-manage our decisions without our realizing it. One of the negative legacies of a misunderstood Romantic Sublime to the twenty-first century is uncontrollable, impulsive action taken without self-awareness by the user. Yet what else is consciousness exteriorized but the mindful demonstration of attentive *practice* embodied in a just, that is, a *judicious* image? With growing assaults on deliberative selective attention by such rampant cultural realities as invasive manipulation and pervasive surveillance, we continue to drown in free-floating ambiguities and chronic sensations of groundlessness.

This brings me to a contemporary art form that defies the glassy cacophony of a repetitive hall of mirrors (Hollinghurst) as well as the Delphic riddle of sectarian marketing (Gibson). Neither "posthistorical" nor "new media," the room-size *Aura Calculata* is an imposing eighteen-glass-pipe water organ constructed by the German artist-engineer Tim Otto Roth. A video documentary provides an impressive introduction to the features of this monumental audiovisual instrument with its self-organizing colors and tones. Historians of science will also find it redolent of Baroque polymathy—evoking

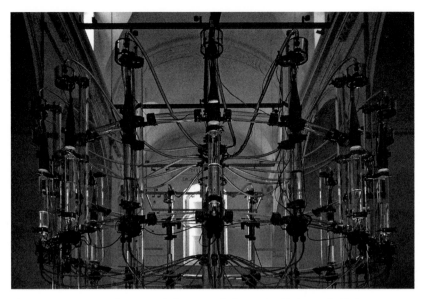

Figure 1.6 Tim Otto Roth, *Aura Calculata*, Kunsthalle Jesuitenkirche, Aschaffenberg (Germany), 2016. Approx. 300 × 200 × 200 cm. Courtesy Tim Otto Roth, Imachination Projects.

those two magi of early modern technology, Ramon Llull and Athanasius Kircher, and their complex combinatorial machines.

Roth's intermedial art-engineering experiment attaches invisible physical forces to specific mechanical and digital processes producing shifting multisensory effects, and thus renders them audible, visible, scrutable. There are two versions of *Aura Calculata*. In both, the "sound pixels" start off playing the same tone. The pitches then change over time in accordance with "the Pixelsex principle." In the speaker version

> all the active sound pixels play a tone at the standard pitch A4 at 440 Hz and light up green. Step by step the pitches drift up and down, weaving a sound carpet of beats changing its character depending on the listener's position. The color spectrum of the light is connected to the played pitch. When tending to higher tones the sound pixel changes its color towards blue. When tending to deeper tones, the color of the loudspeaker changes to yellow and red. If a sound pixel reaches a pitch threshold the whole system is reset.

In the organ version, the water level and, consequently, the starting frequency of the pipes is determined by timed intervals that open the inflow valves,

"so the water levels of the pipes are in balance with the central reservoir column. During its operation (of the organ) water flows in and out in accordance with the local activity of the sound pixels. Changing the water level not only changes the pitch of the sound, but also its timbre." Depending on how the sounds recompose in space, beats are created that, as in the speaker version, "weav[e] a sound carpet"—an oscillating, audible and visible *relational* microtonal texture.[18]

Aura Calculata thus defies a hermetic Romanticism as well as a dusky Sublime by re-engineering the system of the Western tone scale before our eyes and ears. Pitches are changed by varying the wavelength of the generated sine tones not logarithmically, but metrically, in millimeter steps. The audible differences are thus perceptibly smaller when playing deep tones and significantly larger at higher pitches. Again the pitch differences depend on the timed opening of the inflow and outflow valves as well the changing pressure, visible in the height of the water columns in the individual pipes and the water reservoir.

In a recent conversation with Peter Weibel, director of the ZKM in Karlsruhe, Roth dismisses the persistence in the art world of both the ironic modernist tradition and an imitative "signature" Romanticism—the original's authority having long been completed and closed. The current "ruinous system"—ruled by the art market, the gallery system, and ego-branded or theatrical gestures that count more than conceptually inflected artful materials—was, he says, introduced by Duchamp in the twentieth century.[19] He could have added, as we've seen, that its link to mystification extends back to the late eighteenth- and early nineteenth-century Sublime and its obsession with instant shock, inscrutability, and literal and metaphorical obscurity.

Weibel argues that—as has been true episodically throughout the history of art—Roth's real point is that innovative artists are now taking new audiences beyond those limiting perspectives by once again becoming serious scientists. Just recall the cross-field parity formerly achieved by Leonardo, Vermeer, Stubbs, Seurat, the Russian Constructivists, György Kepes, and the Art and Mathematics Group, to name just a few. What he and like-minded intermedial artists are urging is an intensive continuous engagement with the technical know-how needed to perform difficult experimental work, whether in synthetic biology, cognitive and neuroscience, theoretical physics, or network theory—or, in Roth's case, the advanced physics of light and sound, "to make from all this images, objects, sound installations."

Roth is not unique. Ágnes Mócsy, a theoretical physicist on the faculty in

Pratt Institute's Math and Science Program, uses film, art, design, and, yes, fashion to take her audience back to the earliest moments of our universe in "little bangs." What, she asks, can pulverizing gold nuclei teach us about the birth of our universe through strong nuclear interactions? At the Relativistic Heavy Ion Collider at Brookhaven National Laboratory, in New York, and the Large Hadron Collider at CERN, near Geneva, heavy atomic nuclei, like gold, can be smashed together with such violence that they melt into a glittering cosmic soup that has not existed since the universe was a microsecond old. These shiny specks are the hottest things ever made by humans, the most perfect liquids known in nature, and when they cool they create the heaviest antimatter nuclei ever observed. How, Mócsy asks in her documentary film *Smashing Matters*, might epic scientific endeavors like these provide her students, her collaborators, and her colleagues in the fine arts, film, design, and fashion fields with "a muse for their creations," and vice versa?[20]

In the face of ongoing digitalization, cleverly orchestrated platforms, and digital ecosystems, "the product changes into a process, something that can easily be observed in case of the most important software offers in the world, which are increasingly marketed as subscription-based services."[21] In light of marketing's—including art marketing's—desire to treat all processes (not just objects) as salable product, what's important from my perspective is that both Roth and Mócsy, in their ambitious, deeply informed, and wide-ranging work (from acoustics to astrophysics to cosmology), belong to a growing, as yet *brandless*, class of artists/designers/engineers engaged in shaping brandless genres. That is, the works are allowed to solidify into new authority without being obliterated or deadened by labels.

For many artists invoking the label "new media" is an exercise in vacuity. A host of polymathic makers, proficient in the latest scientific and technological developments, are formulating a contemporary aesthetics that is neither "postmodern" nor "retro." Profoundly performative and participatory in aim, this still-emergent aesthetics also calls for the creation of proactive audiences. So what sort of work might Roth and Weibel have in mind when summoning artists to escape an inauthentic "Romanticism"? Perhaps the kind produced by the Icelandic artist Ragnar Kjartansson in his video installation *World Light*, which treats Romanticism as if it were a downloadable brand. This weirdly self-reflexive piece is based on the strange four-volume novel of the same name by Halldór Laxness, Iceland's only Nobel laureate. "It's a book about a poet—not a great poet, but a poor person who longs to be an

artist, longs for beauty. The book is so hilarious, and so sad, and so beautiful. My father cannot quote from it without crying." While Kjartansson claims to mock the "romantic spirit" (undefined), he offers what amounts to caricatural retakes, bowdlerized reiterations of the gravely somber landscape paintings of Caspar David Friedrich. In the version of *World Light* mounted in Paris in 2016 at the Palais de Tokyo, a twenty-four-hour montage of all the collected footage was projected on four large screens in an empty room. Cushions were strewn over the floor so, as Kjartansson proposed, viewers could lie down and "let it wash over you."[22]

In fact, the art and science of projection has a long and distinguished history in the enactment of dimensional translation. It's much more than a tidal wave of entertainment rolling over a passive audience.[23] Projection is the archetypal—the primordial—medium meant to be seen in the dark. From shadow-casting on cavern walls, to grisaille video screens, to hovering holography, projection is one of the central activities in moving image practices. At the same time a precise geometrical operation and the haunted and haunting underpinning of ghostly artifice, it also leads a highly ambiguous existence.[24] Siegfried Zielinski dubs projection "a media strategy located between proof of truth and illusioning." Sean Cubitt, meanwhile, underscores how it produces a mobile condition of simultaneous "vanishing and becoming." Essentially active, not passive, it articulates the movement from dim space to bright surface and vice versa, thus bringing forth the performativity of media.[25]

Coda: Black Hole at High Noon

In the 1960s, astrophysicist John Wheeler coined the term "black hole" to describe a gravitationally collapsed star that is so dense, light would be unable to escape.
—TERENCE DICKINSON, *Hubble's Universe*[26]

In the Waters, life was a thin, primitive, fragile sheet. . . . Photosynthetic organisms crowded to the top, striving for light, while their buried peers split the weaker sulfide bonds to survive. . . . [Then, during the Cambrian explosion] the denizens of the seas grew to an inch, then a foot, then a meter, in the form of terrifying fishes that established suzerainties in the depths.
—C. E. MORGAN, *The Sport of Kings*[27]

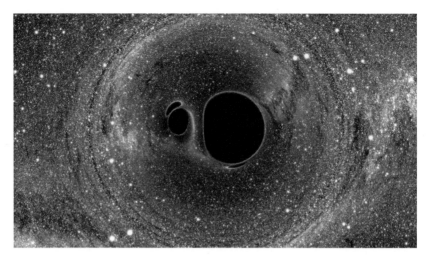

Figure 1.7 Still from a simulation of two merging black holes. Simulating eXtreme Spacetimes Project.

Is there, then, something in between the universe seen as dankly Burkean—surely a distant allusion to the universal Flood recounted in countless origin myths, as well as to the abyss of Hell whose shadowy monsters still lurk in our collective memory—and the absolute black of outer space? This pristine monochrome, or hole punched in the upper air, rises mysteriously, stretching steeply to infinity above the domesticated sun-shot band of blue.

The Void, however, is not nothingness since it contains our twenty-first-century fields (Faraday and Maxwell's electromagnetic fields, inherited from the nineteenth century, as well as featureless space-filling mists like the Higgs field).[28] Since these spontaneous emanations have a floating life of their own, they are more awe-inspiring than even Kant's vision of vast interstellar regions: the Sublime night sky tapestried with glimmering stars.[29] This disorienting omnipresent black, staining the vacuum of space, is the inscrutable antithesis not only of thick blurry atmosphere and scattered particulate sunlight, but of the glassy computer-generated world: thin, abstract, everywhere branded, both slickly polished and jarringly interrupted by the monitor's ubiquitous blue glow.

In the beginning, when the strong sun gilded the deep waters and flickered on the primordial ocean's waves, thickness began to thin. It's been a long road from brightness to brilliance. Astrobiological research is finding that, in addition to seeping groundwater and shattered frost, an eruptive cryovolcanism shaped the fissured, slimy, muddy, biomolecular-teeming surfaces

of our galaxy. Recall the recent discovery of a vast sea beneath Enceladus' icy shell. Add to this the dulled traces, detected by NASA's Cassini spacecraft, of plumed geysers and their remains—"tiger stripes" slotting the southern pole of Saturn's enigmatic moon. This ancient foamy, boggy, mossy, sinkhole-pitted matter is dissolving, disappearing, flowing into an augmentable virtual reality hovering within the engineered artifact or flush with the incandescent screen. The dark energy of cyberspace has released reams of venting private information—rage, voyeurism, self-advertising, surveillance, dissipation, and retail lust—into our world.[30] If galactic black holes are created when massive "dark stars" explode and collapse producing firestorms of X-ray emissions, then their metaphorical equivalent is the telltale ejection of terrifying material from the burning core of an indiscriminate internet. We live in an eerie reality whose engine is the online environment where secrecy and code have taken on their own forms of danger, power, and beauty.

Lying Side by Side

Fitting Color to Eros

> I think it was the smallness of these figures that carried them so
> penetratingly into my mind. . . . They were in their smallness like
> secret thoughts of mine projected into dimension and permanence,
> and they returned to me as a response that carried strangely
> into lower parts of my body. . . . We had come from lovemaking,
> and were to return to it, and the museum, visited between the
> evaporation and the recondensation of desire, was like a bridge
> whose either end is dissolved in mist—its suspension miraculous,
> its purpose remembered only by the murmuring stream running
> in the invisible ravine below. . . . My woman, fully searched, and
> my museum, fully possessed . . .
> —JOHN UPDIKE, "Museums and Women"[1]

Can the embrace of color continue to arouse joy or awaken sensu-
ality in today's anxious, brutally competitive, gender-confused high-
tech era? When every carnal desire is immediately satisfiable, does
pent-up passion (or prolonged expectancy) even exist? If so, can it
be conveyed? Despite what I consider generally passionless times,
the precision, intensity, and violence of color does shape-shift our
known world, radically defamiliarizing it.

Condensed or tightly inlaid patterns—from artisanal mosaics to

abstract emblems to puzzling Rorschach blots, Twitter snatches to pointilliste memes "with their hummingbird metabolisms"—keep you from "being precious about things."[2] Think of modern art's fascination with lowly pavements and the inexhaustible varieties of varicolored tessellation, from Jasper Johns' crazy-work flagstone paths to David Hockney's poolside terrazzo parquet to Yto Barrada's Moorish sidewalks—tiles lyrically checkered with stacked goldfish bowls.

But preciousness and perfectionism are not just the enemies of concise comedy, wit, and laughter. They undercut creativity itself. Reading about the positive implications of the new tiny electronic genres for "nano-clowning"—a sort of disposable ideation—made me reflect on the relation between eros and color as quintessentially short forms. Like John Updike's "dainty white dream," the statuette of an eighteenth-century sleeping nude, tinted smallness "intensifie[s] sensual content."[3] Not just aesthetic but philosophical and epistemological implications follow from conceiving thinking and feeling as a sort of bantering with prismatic bits.

What the eighteenth-century British Empiricists (Locke, Berkeley, Hume) termed "perceptual acquaintance" usefully captures the problem of what it means to acquaint oneself with a sensation or an experience for the first time. First knowledge is a rare thing since memory is necessary to all experience. Each bit of knowledge, like every single sensation, increasingly resides within the context of all the rest of our perceptions. The ancient—and still enduringly modern—inlay format,[4] I believe, addresses the fact that every human subject, because of our hardwired neural machinery, lays down individual connections between divided bits.

Crafting this coexistence of ideas, however, originates in personal history, the way in which an abstract system of stand-alone components gets inwardly oriented to ourselves. Hélène Cixous, writing on passion in *Coming to Writing*, remarks that breaking down walls does not necessarily lead to oneness.[5] Mosaicist-painters and other makers of tesselated compositions (from intarsia to collage and montage to tapestry to comic books' "packaged" panel structure[6]) recognize the aptness of this observation since they create composite formats as well as composite selves. By repositioning the anomalous elements of experience laterally, we see the stranger even in those we love. And more importantly, we see *how* we came to such a judgment, since splintered works make visible the order and intensity by which sensations come to us and are woven together.

To be sure, much expressive spatter and even agonized application of

Figure 2.1 Yto Barrada, *Aquariums for Sale on a Rainy Day, Tangier 2001* (for *Parkett*, no. 91), 2012. Chromogenic color prints. Each 20 × 20 cm. Committee on Prints and Illustrated Books Fund, Museum of Modern Art, New York. Digital Image © The Museum of Modern Art, licensed by SCALA/Art Resource, NY. © Yto Barrada. Courtesy of Pace Gallery; Sfeir-Semler Gallery, Hamburg, Beirut; Galerie Polaris, Paris.

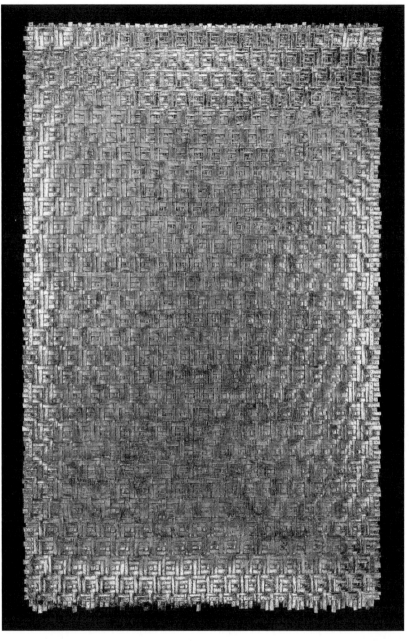

Figure 2.2 Olga de Amaral, *Memento azulado*, 2016. Linen, gesso, acrylic, gold leaf. 200 × 125 cm. Ref. OA1546. © Olga de Amaral. Photograph © Diego Amaral. Courtesy of the artist.

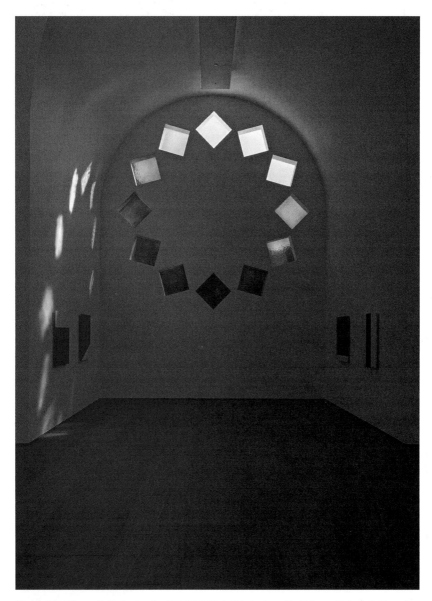

Figure 2.3 Ellsworth Kelly, *Austin*, 1986/2015. Artist-designed building with installation of colored glass windows, marble panels, and redwood totem. 60 × 73 × 26.3 feet. Blanton Museum of Art, University of Texas at Austin. Gift of the artist, with funding by Jeanne and Michael Klein, Judy and Charles Tate, the Scurlock Foundation, Suzanne Deal Booth and David G. Booth, the Longhorn Network, and other donors. © Ellsworth Kelly Foundation.

paint is evident in the history of art. Consider Titian's pastose *Scourging of Christ*, El Greco's tormented *View of Toledo*, Kokoschka's swirling Salzburg landscapes, or Francis Bacon's bloody and tortured bedroom triptychs. But in such work one also discovers the beauty and energy of raw color: bursts of unfettered, unfamiliar pointilliste pigment—acting as free agents and capable of reanimating an entire composition. Color encased within mosaic tesserae resembles a self-contained twitter (not unlike Updike's echolocating "bats that moved on the walls like intelligent black gloves"[7]) or the emphatic patch in a quilt. This essay, then, explores a self-assembling, pavement-like combinatoric that corresponds to our accumulating, frequently adjusting feelings.[8]

Consider how Ellsworth Kelly's precisionist spotlights become incorporated into a larger chromatic composition. Like jolting sense impressions or the "hits" of love, the inlaid pattern emerges out of repetition and as if by chance. Compression and saturation make each energized jot intensely alive in a particular moment. Essentially kinesthetic, the vibrant hue is caught on the fly by the moving viewer. The unexpected delivery of a dollop of pure color thus resembles the fierce riffs of love. Both are condensed performances inside a greater performance prone to responding to nonverbal cues.

The impact on the beholder is not entirely dependent on physical scale. Monochromatic works—big or small—have the capacity to condense the quintessence of a sprawling field into a froth of flower or air into a cloud. Cy Twombly's monumental seascape series *A Gathering of Time* (2003), on view at the Art Institute of Chicago, includes two vast canvases of the Caribbean Ocean off the banks of St. Barthélemy. These shimmering sheets of turquoise have their pellucid volume of water only slightly troubled by opaque patches—indicating great depth, with lighter, almost transparent, passages, for the nacreous shallows. The delicate pink and white jellies occasionally bobbing on the surface—adorned with thin streamer-membranes floating free—scarcely ruffle the impression of the sea's "green sameness." Although written decades before Twombly's produced these barely nicked swaths of a single color, the keen observations of John Updike seem apt:

> But the marks on the sea move . . . and the water near me is tinted with the white of the sand underneath, so that its clear deep-throated green is made delicate, acidulous, artificial. And I seem to see, now and then, running vertically with no regard for perspective, veins of a metallic color, filaments of silver or gold—it is impossible to be certain which—waver elusively, but

valuably, at an indeterminate distance below the skin of the massive, flat, monotonous volume.[9]

Twombly's corresponding winter-white panels—capturing the Gulf of Gaeta, on the Tyrrhenian Sea in Italy—display nothing of the Caribbean's buoyancy or tissue-paper lightness. Their chilly world is somber, heavy, mottled, freighted with the sea's decaying organisms: trailing brown algae and clogging kelp. Where the gem-colored summer panels—scintillating like a breeze-responsive sail—demonstrate freedom of motion, the muffled winter surf loses its deeps and becomes an impenetrable wall. In each case, visual illusion is at work. On the one hand, we become disoriented and "swim" dizzily in the sea's ethereal sameness, while on the other, we get cognitively trapped within its occluded, anti-perspectival surface.

The tendency of monochromatic color—writ small or large—to release packets of retinal and emotional energy was apparent as well in Christo and Jean-Claude's *Gates* (2007): seven thousand tropical orange nylon panels, suspended from steel frames, festooning a snowy Central Park in Manhattan. Waving in the frosty air or backlit by the rising or setting sun, these saffron curtains served as a gilded scrim for the bare or blackened skeletal trees. A documentary chronicling the evolution of this artificial garden island shows pedestrians' and bicyclists' with eyes perilously riveted by the unpredictable overhead swing of coppery "portals."[10] Each spicy billow stimulated a flutter of the heart, arousing anticipation in the stroller or rider of the next visible beat. In serene moments, there was virtually no activity. Inevitably, these lulls were followed by high winds that lifted the convulsed fabric into fiery shapes. As Darwin recognized, emotional expressivity is hardly limited to human beings.[11] Even the ordinary world of sheer scarves or falling drapery is animated, suffused by affecting patterns.

But what of the lateral erotics of compressive color? Its self-contained pleated form—or juxtapositive structure—*bonds* and magically resolves otherwise divided components into a temporary unity. Like the alternating arrangement of red and black pencils in an elegant box, the qualitative feelings aroused (the shiny surface inviting us to pick up and roll one between our fingers, to feel the smoothness of the wood, the slimness of its perfect roundness) are not separate from the recognition of their side-by-side organization. Simply put, this sensuous array of pencils let us see how more psychologically complex experiences are contained in their shape, in their direct physical *per-*

Figure 2.4 Perfetto pencils. Design by Louise Fili.

formance of color variance + layered organization. An invitation to responsive gesture, they exhibit how we can touch the world and it touches us back.

But let us return to Cy Twombly and to a more sultry integration of perception, thought, and feeling into a single sensory-motor concept.[12] I want to consider another large-scale series, this one echoing the lavish six-panel format typical in Japanese folding screens of the Edo period. His sumptuous and worldly *Peony Blossom Paintings* (2007) are immersive horizontal works. (Three of the six were exhibited at the Art Institute of Chicago.) Rather than exploring the relation between the painter's inner consciousness and a misty oceanic vista (as we saw earlier), they configure the implacability of bodily awareness: the arousal, climax, and ebbing flicker of passion. These inter-art panels are inspired by a taut and suggestive haiku, composed by Takari Kikaku, summoning up an erotic interlude in the life of the famous fourteenth-century samurai Masashike Kusonoki. Grown weary of endless combat and violence, the warrior turns away from battle to give himself up to pleasure. The lust of war and the ferocity of sex are conflated. It's not accidental that Twombly only lightly rubbed out the word *amour*, leaving the pentimento still legible though replaced with the poet's *armour*:

> Ah, the peonies
> for which

Kusonoki
Took off his armour.

The chromatic shifts distinguishing the three exhibited canvases trace a wrenching trajectory, with one dominant color tinting the roseate petals scattered over each picture plane. In the first, a lush, melting mint green supports five nectar-dripping peonies, their huge, creamy blossoms separated by Twombly's scrawl of snatches of the verse commemorating the sensuous undoing of the formidable hero:

> the white peony / at the moon one evening / crumbled and fell
> the peony falls / spilling out / yesterday's rain
> from the heart of the / peony a drunken / bee
> the peony quivers / quivers

The budlike freshness and lyrical novelty of early love is overridden in the second panel by a ripe crimson voluptuousness. Velvety blood-red peonies—evocative of unfolding and distending labia,—erupt from a glistening golden ground.

In the third panel, the heavy ruby flowers have withered into tarnished amethyst. The five fertile blossoms of the first panel have multiplied or fragmented into eight, wearily and repetitively speckling the surface like spilled wine. The browned hue signals deadening, the stagnation of exciting first en-

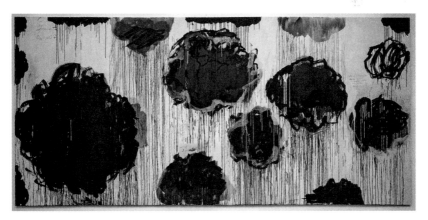

Figure 2.5 Cy Twombly, *Untitled*, 2007. Acrylic, wax crayon, lead pencil on wooden panel. 252 × 552 cm. © Cy Twombly Foundation. Courtesy of Gagosian Gallery.

counter and exuberant high-noon fulfillment followed by an inexorable slide
into loss. By dint of prolonged looking, the viewer become the repercussive
medium for the psychomachia taking place within Kusonoki. We are syn-
aesthetically confronted with the increase and decrease in chromatic strength
of his emotional realities—from jubilantly wet to forlornly dessicated.

Long before manufacturers of personalized products began dropping
tinctures of pheromones into their seductive compounds,[13] painters as well
as poets realized they not only boosted sex appeal but were intimately tied
to color as an erotic attractant. The ancient Egyptians knew the power of
fragrance. Stepping, after five thousand years, into a New Kingdom temple
housing small jars of amber perfume, the visitor cannot help but notice that
they still emit a scent. Clive James's poem captures this dual sensory potency
embodied in a legendary flower:

> The wild White Nun, rarest and loveliest
> Of all her kind, takes form in the green shade
> Deep in the forest, Streams of filtered light
> Are tapped, distilled, and lavishly expressed
> As petals. Her sweet hunger is displayed
> By the labellum, set for bees in flight
> To land on. In her well, the viscin gleams:
> Mesmeric nectar, sticky stuff of dreams.
> This orchid's sexual commerce is confined
> To flowers of her own class, and nothing less.
> And yet for humans she sends so sublime
> A sensual signal that it melts the mind.[14]

Like Twombly's splendid *Peony* series, James's rapturous lyric to an intoxi-
cating, darkness-defying bloom exhibits that conceptual knowledge is em-
bodied, that is, mapped within our sensory-motor system. The sensory-motor
system, then, provides structure to conceptual content as well as character-
izing semantic content in terms of our bodily behavior in the world (look-
ing, seeking, longing, kissing, tasting). This hypothesis defies the claims of
early cognitivism that concepts are disembodied abstract symbolic represen-
tations. Recent research, in fact, reveals that when we imagine seeing some-
thing, some of the same parts of the brain are activated as when we actually
see; and when we imagine moving something, some of the same parts of the
brain are activated as when we actually move.

Viewers of art and readers of poetry thus reenact affect and gesture or the "colors" of the emotions:

> Transported to the world, her wiles inspire
> The same frustration in rich connoisseurs
> Who pay the price for nourishing the stem
> To keep the bloom fresh, as if their desire
> To live forever lived again through hers:
> But in a day she fades, though every fold
> Be duplicated in fine shades of gold.

It is instructive to consider such form/color/emotion-encapsulating images (demonstrating imagining and doing as relying on the same neural substrate) in light of current reassessments of Kant's ascription of feelings to reason. This is the startling argument that supposedly cold, disinterested reason, in fact, has obscure interests, tendencies, even needs.[15] In his *Anthropologie in pragmatischer Hinsicht*, Kant associates feelings with "sensibility." He means by this that to sense is to feel, to be stimulated, to alter our perceptions—not entirely a positive propensity because to be thus affected is also a fleeting and contingent state fraught with ambiguity. Nonetheless, for Kant, these rational "wanderings" in the realm of the suprasensual are not merely Rousseauian drifting reveries but serve as a compass to steer behavior and action in the world. Nor are they Burke's dangerous Sublime—that vast and boundless torrent of emotion unleashed before the great, the uncommon, and the stupendous—rare sights by which we are "forced into compliance."[16]

What's notable is how a disciplined or embodied reason imparts *shape* and even a *typology* to the softness of soft emotions. Intarsia formats (both artistic and poetic) staunch the bleeding of colors and channel concepts into zones. Even our most intense physical and psychological experiences can be *framed* and *contained* for viewing. The aesthetic mechanism of "fixing" thus becomes all-important, enabling us to endure the pangs that accompany the comings and goings of arousal. On one hand, Burke is pertinent here since he speaks of the "awefulness" of the sudden and *single* strikes in the striking of a great clock or of a "single stroke on a drum"—the aural equivalent of the bulk of any large object seen as one entire piece. On the other hand, such unitary irrational experiences not only overwhelm; their excesses cannot be adequately contained by any aesthetic experience.

Monochromatic micro-or macro-mosaics, by contrast, intersect the rule-

driven, or governing, structures of art with the particular short-lived bursts of feeling discharged in life. Imagine them as grafting, or setting side by side, bits of intense pleasure and pain. Consider this passage from a short story about the reperformance of Christ's crucifixion in a New Mexican *morada* during Passion week. The suffering of the whipped wooden man on the crucifix is as garish under the buzzing fluorescent bulbs as the hero's is about to be personal and cruel:

> There is violence in the very carving: chisel marks gouge belly and thigh, leave fingers and toes stumpy. The contours of the face are rough, ribs sharp, the body emaciated. Someone's real hair hangs limply from the statue's head. The artist did not stop at the five wounds, but inflicted his brush generously on the thin body. And there are the nails. Three. One in each hand, one skewering the long, pale feet. Amadeo feels his own palms throb and ache.[17]

Just as Amadeo begins to sense what these torments will physically and morally do to him at the instant when his daughter's hand traces a trickle of blood down the bound wooden feet of the statue, inlaying genres are fundamentally *ethical*. As embodied simulation, they trap our intuitive receptivity, pause our quick responsiveness to seductive stimulation, and hold these disquieting impulses for principled consideration.

Stepping even farther back into the eighteenth century, Bishop Berkeley's *Essay toward a New Theory of Vision* belongs, as has recently been claimed, within a larger system foregrounding an embedded God. What interests me about Berkeley's prismatic theory of vision wherein "knowledge comes from presence," is that an *embedded* intimacy obtains not just between man and God but between chunks of perceived existence and the neural apparatus of the perceiver.[18] Moreover, in line with Gerald Edelman's hypothesis concerning the "remembered present," no perception is new but must already have something "old" or remembered about it.

Like Olafur Eliasson's installation *Take Your Time* (2009)—inspired by seventeenth-century Jesuit multiplying mirrors, crystal cabinets, and kaleidoscopic optical instruments—Berkeley's prismatic universe fits together a phantasmagoric inner reality from glittering facets of tinted glass. Eliasson's pieced-together antiquarian realm—reminiscent of magic lanterns, *Wunderkammer*, and cabinets of curiosities—is still apt in our age of dark nostalgia and taxidermic bricolage.[19] The *Multiple Grotto*—a spherical walk-in snow-

Figure 2.6 Olafur Eliasson and Little Sun, *Little Sun Light Swarm*, 2017. 33 lamps designed for Tivoli Gardens, Copenhagen. Photograph: Tivoli/Mathias Fjeldborg. © 2017 Olafur Eliasson and Little Sun.

flake whose internal shadowy projecting angles are ornamented with geometric feldspar lenses—offers evidence of Eliasson's deep spelunking not only into the history of the vitreous but into ancestral empiricism as well. In his ongoing *Little Sun* project, the artist stitches alternative realities together, just as the revisionist Neoplatonist Berkeley imagines ideas to be auratic, radiantly transforming nodes of interchange. At once plastic and temporary, that is, dependent upon one's point of view, such optical sorcery ties together vision and action in a gestural system of mutual exchange.

According to Berkeley, vision requires the substantialization of touch. To understand what we see involves the tactility that comes with moving in space. He thus finds vision to be kaleidoscopic, as it were, before its time, a sort of abstract slide show dancing before our eyes. For Berkeley, unless vision is conjoined with the hand, we cannot measure, control, or evaluate the life-world—observed from the limited localized vantage of a particular subject. As myriad, early-modern illusion-generating optical devices revealed—that is, devices dispensing with grasping the image—even when the mechanism behind the deception is unveiled, the viewer cannot escape his intrinsic hardwiring. Vision without touch is a two-dimensional flatland, a chaos of intangible forms and broken colors. Only when their patchiness or

gappiness is made manifest naturally, through contact, or artificially, through paint-gesture, do we get a momentary insight into the neural operating system standing behind it all.

For the immaterialist Berkeley, the ultimate guarantor for the continuity of the universe—even when we do not attend to it or feel it—is God. Today neuroscientists are like cryptographers trying to crack the code used by the nervous system to represent the external world. As V. S. Ramachandran puts it: how does the message from the eyeball on the retina go through the optic nerve to the two major visual centers of the brain—the old, evolutionarily ancient pathway (including the superior colliculus) and the new pathway heading to the visual cortex in the back of the brain?[20] Pathological disjunctions between locating objects spatially in the visual field (old pathway) and consciously recognizing objects (new pathway) help account for our being unaware or aware that we are seeing things.

Eliasson revisits these metaphysical and epistemological conundrums concerning apparent solidity—dating back to the seventeenth and eighteenth centuries—when he invokes Berkeley's rebus world. An endless succession of projected phantoms and distorting puzzle-piece imagery disrupts a well-ordered story line or any "normal" sequence of events. Unfurled by anamorphic cylinders and refracting prisms, these piercing packets of light-shot chromatic data desubstantialize matter and destabilize perception. The Icelandic artist's accordion-pleated stainless-steel *One-Way Tunnel*, coated with color-reflecting faceted acrylic mirrors, poses once more the venerable problem of objective knowledge and the truth of empirical observation. This early-modern worldview atomizes the illusion of space and time as a continuum, precipitating them into concrete patches or momentous instants.[21]

Eliasson's installation is reminiscent of Berkeley's prismatic optics in the sense that it is primarily about spatiotemporal conditions and constraints, or the singular adventures of units of light and color, and less about the coalescent ensemble. When the visitor enters his intarsia tunnel, she is bathed in a divided rainbow. But, on turning around at its exit and looking back toward the entrance, what originally appeared as a celebration of Newton's spectral optics is transformed into the blackest mine shaft because of kinetic occlusion. From this new vantage point, the rearranged combinatoric of facets interrupts the variable wavelengths of the sun's incoming rays, obscuring them. What a second before had been a vividly broken surface is now optically sheared away by a second, repetitively aligning surface that passes in front and blots the first from view.[22] Simlarly, life requires us constantly to rethink those parts of

experience that were not seen a moment before or whose prior meanings no longer seem to obtain. I propose that it is specifically the emotional quotient of perception that brings this potent realization to the fore. We exclaim *aha!* when we are forcefully put in contact with a traumatic packet of new data that punches a hole in the assumed perpetuation of existence as we know it, thus raising the local sensation to global awareness.

Like exceptional love, discrete color-saturated formats demonstrate that intrusive events are anomalous, breaking the daily repetitive grind by rupturing our expectation of what comes next. By seizing the viewer's sensory and emotional apparatus—through the interplay of shaped monochromatic colors that stand out against the blurry backdrop of mundane life and its dulling habits—gapped mosaics materialize opportunities for configuration to heave into view.

3

The Ultimate Conjuncture

What Shadows the Brain-Mind Merger?

> There is a winding path leading through a jungle of science and
> philosophy, from the initial bland assumption that we people are
> physical objects, obeying the laws of physics, to an understanding
> of our conscious minds.
>
> —DANIEL DENNETT[1]

The Inscrutable Combinatoric

> The girl knew that the world through which she moved was
> composed of structural fictions—ideograms of a kind— . . . for
> where she saw light, color, texture, solid shapes, where indeed
> she felt the physicality of solid shapes, and experienced herself
> as one, there existed nothing but a cascade of ever-shifting and-
> changing atoms and molecules, substanceless as hieroglyphics
> on a computer screen, in some mysterious way linked to the
> rhythms of the human brain.
>
> —JOYCE CAROL OATES, "Shot"[2]

Joyce Carol Oates deftly captures the mystery of a material biochemi-
cal brain being at the same time a nervy, enigmatic, associating

"mind" responsible for our emotional and aesthetic experiences. Brain activation, with its tempestuous electric jolts and evanescent flashes, underlies artistic assemblages—those incessantly worked-upon existential fragments mirroring the unstable nature of memory and grounded, not in causality, "but [in] contingency and *conjuncture*."[3] Originally, this physical as well mental activity of binding was rooted, not in symbolic or linguistic representational systems. as it now unstoppably is, but improvisationally in tactile manipulation.[4] Doing was a precondition of being: repetitive or shifting, but always rhythmic, patterned, responsive or resistant to a torrent of change.

The literally creative body—desiring, imagining, doing—thus looms as the driving force in our cognitive development. Not surprisingly, the human brain's performance tends to be situated by evolutionary biologists, anthropologists, and philosophers of embodiment in lived experience, interlocked with, or distributed into, a wider natural world.[5] This displacement of focus from inner mental theater to outer environment owes something to Daniel Dennett. His many books intercept the abiding lure of dualism by reminding us that cracks in the illusory magic of consciousness appear so rarely (for example, in brain injury) that the submerged processing machinery remains largely invisible.[6]

Doing-as-knowing, then, becomes one way of escaping the impasse of reaching out to touch a world that is phantasmal—"*except your hand does not go through it*."[7] This lack of graspable solidity prompts me to ask what is, and increasingly will be, our algorithmic future—radically diminishing the correspondence between communicative body-action and an involved working mind? That is, what happens to the brain-mind during enforced leisure, when its enclosing body does little that is physically and cognitively effortful? Like Oates's cryptic mist, will we become mentally substanceless, never achieving solid understanding through fluent practice or formal discipline, while our digital tools continue to get "smarter"?

In an age dominated by an institutionalized, largely unquestioned computationalism, it's urgent for all of us. but especially, I believe, for artists, to reclaim the importance of doing to thinking. We need tangible alternatives to inaction, views from the other side, perspectives beyond that touting a labor-free utopia of relentless automation—especially given the predictable consequences of a passive I—"freed" from the self's struggles and external demands. Add to the specter of growing will-lessness the rise of cognitive and manual disengagement, the perpetual sense of deflection as reality drains away in nonstop online experience.

Ironically, all this behavioral relinquishing comes at the moment when the materialist worldview prevails and the neurosciences continue to demonstrate that we consist of an uncanny material synthesis of nonlinear dynamics, a behind-the-scenes autopoietic biology that, oddly, leaves us feeling not whole but vacant or useless. If scientists and engineers have gained a deep understanding of the autonomous performance of sensorimotor loops and interconnected networks, have ordinary people lost a useful belief in the why and, especially, the how of person-structuring work; willed, not covertly targeted, attention; imaginative, non-automated combinatorics? What are the sociocultural consequences of unreflective wanting without needing?

It seems an appropriate question to ask when large sections of the United States are drowning in opioids. In the past, I often hiked in the coal-chasmed mountains and ridged hollows around Berkeley County, West Virginia. In that wild and wonderful state, abounding in idyllic, Edenic-named spots — Canaan Valley, Black Water Falls, Dolly Sods Wilderness — the current despair and blurry apathy seems not only incongruous but inconceivable.[8] Is this seductive drug addiction in dead-end Appalachian and Midwestern small towns — resulting from boredom, the feeling of impotence coming from lost purpose and simply not doing anything meaningful — a preview of our work-free future? As industrial automation lowers wages, it also provokes a decline in dextrous artisan-makers and in discerning, judgment-requiring production. Does this diffusion of artificial inertia presage a failure-cascade? Will more of us be driven to self-medicate as Big Pharma, AI developers, and change-managing roboticists pursue a course of blotting out the manual in a programmable world. No wonder people around the world feel satisfying workaday experience is becoming a relic, obliterated by the relentless encroachment of machines and technologies.[9] Is it inevitable that the functional rituals and labor-intensive activities that saved us in the past, that imparted dignity, will vanish? Some artists are countering enforced stasis — the growing imposition of mental and motor fixity — with feats of resilience.

Eduardo Kac is known for putting the scientific palpably in relation with the artistic, thus avoiding the danger of sterility when both investigations go off, uninflected, on their own. Since the 1980s, Kac has been theorizing and producing art and poetry that challenge the limits of gravity (his *Space Poetry* manifesto was published in 2007). In a recent project, the intermedia artist links the experience of solitude in an unfamiliar space to mind/body distributedness *in extremis*. *Inner Telescope* explores multiple dimensions simultaneously — tracking the physical phenomenon of extensibility to something

darker, stranger, more psychological in a challenging environment where everything unnervingly floats free.

The work, conceived for zero gravity and designed to be made in weightless space, was realized aboard the International Space Station by French astronaut Thomas Pesquet on February 18, 2017, following the artist's instructions. Constructed from materials available on the space station, its mutating shape—from the astronaut's floating perspective—has neither stable top nor bottom, nor easily definable front nor back. Viewed from one angle of floatation the French word "MOI" ("me," "myself") is revealed. From a different angle, the astronaut views a human figure with its umbilical cord cut. Seen by the earthbound Kac, "MOI" stands for the collective self, humanity, and the severed umbilical cord enacts the risky liberation from earthly constraints. While *Inner Telescope* manifests the awkwardness, even strange liquidity, of gravity loss, it focuses equally on the aquarium-like loss of subjective groundedness inside an otherworldly vacuum. It thus uncannily mirrors the sense of unmooring occurring on earth, in our increasingly human-free work environments. By conjoining an observational instrument with poetic reflection, Kac provokes meditation on fragility and inequality (in our differential relationships to others, the changing planet, and its suspended position in the

Figure 3.1 Astronaut Thomas Pesquet aboard the International Space Station, with Eduardo Kac's *Inner Telescope*, 2017. Photograph: Thomas Pesquet.

Figure 3.2 Artist's conception of a celestial body about the size of earth's moon colliding with one about the size of Mercury. NASA/JPL-Caltech.

universe). How to bring together all the elements, let alone viewpoints, between land and sky to create, through noticeable effort, an independent life?

Discussions of conjuncture have also infiltrated investigations into astrogeology. Heavy isotopes of iron are known to be more prevalent on earth than in other bodies in the solar system. The prevailing hypothesis has been that the anomalous levels are the result of how earth's core formed billions of years ago. But in 2017 geoscientists using a diamond anvil cell capable of matching the extreme pressures that marked that formation published a paper challenging that explanation—opening the door for alternative theories. One such hypothesis holds that earth's unusual isotopic signature developed later—possibly as the result of a cataclysmic impact with another planetary body that vaporized lighter isotopes and also led to the formation of the moon.

Certainly, in more ways than one, the implications of conjuncture are cosmic. Tyler Volk, professor of biology and environmental studies at New York University, coined the term "combogenesis" to describe a "grand sequence" of thematic development, from physics and chemistry to biological evolution,

and thence to cultural evolution. He views this assemblaging progression as moving through a series of levels, from elementary quanta to global civilization—thus cutting across chronologies, hierarchies, and taxonomies with an organizing principle of coalescence. Like Kac's performative extension of a shaping mindedness and a gravity-eluding handwork into outer space, what seems particularly relevant for the arts and sciences is Volk's emphasis on the haptics of combinatory creativity, the *"recurrent rhythmic order of material combination and integration, the creative sophistication of actually making conjunctions."*[10]

Implacable Dispossession

But the journey was not of my choosing. I was being conveyed,
never mind whether The Forest, or the whole valley of the shadow,
was watching me pass through.
—JOHN LE CARRÉ, *Our Game*[11]

The hidden operations by which collages of atoms, or congeries of bits and bytes, become functional fuels current debates on the potential of artificial intelligence (AI) to spur a new wave of automation, promising, or threatening, everything from autonomous vehicles to massive unemployment—all without prior deliberation and the exercise of judgment after public debates on the personal and economic implications of this race-without-a-policy.[12] Depressingly, it seems that the proliferating university and corporate programs studying ethics—from business, to biological, to governmental, to medical, to neurological, to you name it—are forever questioning the merits of a product, a process, a phenomenon after the fact. Not only that. I believe we are mired in a new sophistry that would put the rhetoric of Plato's Gorgias to shame. Increasingly, astute Silicon Valley entrepreneurs and expanding high-tech industrialists deploy the language of ethics and its social concerns—not for making more responsible civic-minded objects or entities but for selling more persuasively, targeting with greater neural impact. By contrast, it's revealing to consider how the United States diverges from Europe in attempting to integrate the general public into discussions about brain projects and research and innovation more generally *before they are implemented*.[13] One wonders if the EU's emphasis on "responsible research"—that is, incorporating society into conversations about the pitfalls of neurotechnology, advanced synthetic

materials, and "programmable stuff"—might not offer a workable model for policy co-creation in technology here.

Clearly the problem of responsible technological development and application is a global one. Consider this typically upbeat, if one-sided, rhetoric:

> Even in its simplest forms, there are many possible uses for programmable matter that *could* improve our lives. Imagine, for example, going to IKEA to shop for the next generation of origami robots: You buy a flat board, take it home, and instead of reaching for that little Allen wrench, just tell it to assemble itself into a desk or dresser. We estimate that for this innovation alone, humanity would save just over 800 billion hours of labor a year.[14]

To do what? It seems ironic to be told that the elimination of work will free us up for more "creative," "imaginative" occupations precisely at the moment when those manual/cognitive skills are being devalued and deactivated. Evincing a debased popular understanding of Romanticism as a kind of creation unbound, the technocratic community continually touts the imagination as something that springs from an unprepared, blank-slate mind. But as the arts have consistently shown, creativity does not arise from an unstocked mind, or from unprepared or unskilled mental wandering. Imagination is a capacity, not merely an impulse. To retain it requires feeding and training.

Artificial intelligence has made it possible to automate decisions for which human beings have, until now, been responsible. While many of these decisions are in the fields of entertainment and social media, automated decisions are increasingly prevalent as well in finance, education, the labor market, the insurance industry, and the medical and justice systems. And don't forget the specter of drone surveillance and autonomous weapons ("killer robots"), with their potential to take the emotional human out of even the most lethal decision-making.[15] This extinction of intentional practices has far-reaching social consequences and brings up a range of questions, from What will happen to the jobs involved in making these decisions in the past? to How can we guarantee that algorithms make the right decisions?

The widespread incurson of AI and neural-network deep-learning systems into our constrictive "sharing economy" pertains not merely to exploitive corporations but to the visual arts.[16] What implications do the new "intelligent" algorithms and the reductive "automation bias"—the lightning-quick marshaling of mountains of data from inscrutable operations—have on sensory-based skills generally, and the mind-sensitizing arts specifically?[17] As

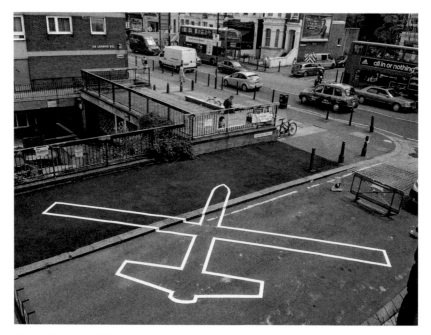

Figure 3.3 James Bridle, *Drone Shadow 007*, for Battersea Arts Centre, 2014. Courtesy of the artist.

I argue in my essay "Thought Gems," the artisanally "showy" arts and crafts (in this case, gemworking and jewelry) open the "black box" problem endemic to neural networks whose inner workings remain masked.[18]

It's important to underline that such implacable computer programs with their unarguable rules—or algorithms—are not produced as a result of human programmers analyzing a problem and then feeding precise instructions into a computer. They are the fruit of complex mathematical operations carried out automatically that look for patterns in an ocean of digitized data. Algorithms that are not explicitly designed by a programmer fall under the underanalyzed concept of "machine learning."[19] Are we to think of this as a sort of artificial "genetic process"—without the infinite patience of nature—quickly registering mutation upon mutation, or is its self-generated "aim" to produce more extreme entities leaving practical considerations far behind?

Slow, deliberative looking defies not only machinic speed but the current cultural glorification of amphetamine-fueled multitasking. While prior research had shown that performing several tasks at the same time reduces productivity by as much as 40 percent, a team of Finnish brain-imaging specialists recently found that changing tasks too frequently interferes with brain

activity. They used fMRI (functional magnetic resonance imaging) to observe particular brain areas of their research subjects as they watched short segments of the *Star Wars*, *Indiana Jones*, and James Bond movies. Researcher Iiro Jääskeläinen explains that the team cut the films into segments of approximately 50 seconds to disrupt their continuity. The subjects' brain areas, however, functioned more smoothly when they watched the films in segments of 6.5 minutes. What's noteworthy here, in relation to the visual, musical, and literary arts, and how they spur attentiveness, is the team's identification of specific brain regions. The posterior temporal and dorsomedial prefrontal cortices, the cerebellum, and the dorsal precuneus turn out to be the most important areas of the brain in terms of combining individual events into coherent event sequences. These loci of neural combinatorics turn fragments into complete entities (into unitary works, as it were), and they function more efficiently when we pay attention to one task at a time.[20]

Neuro- and developmental psychologist Elissa Newport's questioning of neuroplasticity ("Is everything endlessly plastic?" "Can anything go anywhere?") based on her research into infant strokes appear to have unlooked-for ramifications for adult brain development. Using perinatal imaging studies, her laboratory has discovered that after major strokes that damage the language areas of the left hemisphere (through injury—perhaps a placental clot—to the major cerebral artery), those abilities are reorganized to the right hemisphere. Significantly, this perfect homeotopic activation does not happen when an adult brain suffers a similarly massive seizure. Similarly, after a stroke affecting an infant's right hemisphere (where prosody, emotion, and voice recognition are located), these linguistic functions find their separate location next to the left hemisphere's functions for sentence comprehension, morphology, and syntax. These findings lead her to hypothesize that, in the absence of other co-morbid diseases, what's happening is evidence not for plasticity but, rather, for a broader cross-cortical distribution of function. That is, language (and perhaps other activities) is bilaterally organized from birth. In adults, the potential for such reorganization may still be there, but it's thought to be very limited.[21]

While Newport's work with adults is in its early days, to me it raises the fascinating question of artists, like William Blake, who have retained this childhood bilateralism not only for language areas but for the visual-spatial areas of the right brain. Blake's "illuminations" and "embroidered" poems exhibit a combinatoric inlaying of figured word and affective image, reflecting a visionary, childlike organization of language and spatial systems into a compre-

hensive bilateral whole. Just as different cognitive functions are not impressionistically blended, his lines and colors retain their formal and chromatic integrity while nonetheless creating a conjunctive unity. And what about synesthesia—might it be due less to a sensory system malfunction than to the retention (through some as yet unknown process) of a childhood capacity for the language centers to relocate alongside spatial centers or the auditory cortex to somehow form a tight mosaic with the visual cortex?

Beyond challenging algorithmic reductivism, the visual arts validate the claims of privacy, of slow looking, of the quiet hesitation that comes before comprehension. I have long argued that effortful genres (such as inlays, mosaics, emblematic structures, and collages) are among the few phenomena left standing to counter controlling platforms, autonomous targeting, and the paradoxical use of personalization in fully automated ways. If we accept that robots will have their own machinic urges and aims, what but art can save humans from being sifted out of the input-output battle? What but the arts offers contradictory metamorphosis—the chance to try on an unanticipated flamboyant form, to craft an unpredictably different skin—an indescribable range of constantly rethought pattern and design eluding automaticity? True, living tends to habit, to operating in narrow, stereotypical channels—seemingly suiting it to algorithmic predictability. But it's art that conspicuously interrupts the expected with chance and vision. It's sturdier than any imperialistic push-technology claiming to predict what individuals will or won't do since it often contradicts preexisting beliefs. It nudges us away from mere information acquisition and toward knowledge of what we don't know, especially the fact that we are constantly baffled by the increasingly uncertain present.

A Wind, a Dream, a Shadow

> When I was little I understood the world to be made of paper, and that everyone should step carefully or go through the paper. I wanted a notation for that, for the going-through. I thought, I still think, this notation is stored somewhere, above us in a sort of mist or secret layer.
> —ANNE CARSON, "Back the Way You Went"[22]

It's an August afternoon. Floating on my back I see two cerebro-cumulus clouds drifting far above against a metallic blue sky. Whether combining or

Figure 3.4 Raphaëlle Goethals, *Sky's Falling*, 2015. Encaustic on panel. 70 × 60 inches. Courtesy of the artist and Gail Severn Gallery.

separating, their fraying borders dissolve into barely perceptible gauzy tendrils or dissolve into molten wax that pools together or tears apart.

Intruding into both the real and the painted white matter are fissures, clefts, even inland seas whose fringes intersect with the invisible: the maelstrom of unseen emanations and luminous rays that crisscross around and through them.[23] Consider how the ridged or reticulated glaciers and placid lakes gaping inside these frozen interiors are similarly edged with filmy membranes that fleetingly coalesce or disintegrate into arabesques, chimeras, gro-

tesques. For me, this eternal shifting, approach and withdrawal, with its hazy dendritic in-betweeness is the unseizable image of the self-generating mind. And the occasional thunderheads threatening the tranquil scene contribute emotional depth, suggesting an appetite for the dark and visceral, providing a hint of the sphinxlike self.

What odder conjuncture is there than the still-open question of how three pounds of neurons can create subjective experience, consciousness, the feeling of interiority: powers coeval with the universe's oscillating energies. Theories abound, ranging from the hope that experiments will show that the affective qualities (qualia) of our sensory experience are produced by the structure of the incoming data itself, to the hypothesis from sensory-substitution research that the brain is organized along task-specific lines, to the notion that the self is a sort of driverless computer. Yet, as law professor and psychologist Stephen J. Morse declares, not much is, when asked what, among the astonishing advances in behavioral neuroscience, is relevant to the law. He comments that this is first and foremost because of a larger, field-transcending conceptual problem: "We have no idea how the brain enables the mind and action, although we know it does."[24]

Much postcognativist media art wrestles with this ghostliness. Whether pictorial, perceptual, or conceptual, the spectral has been synonymous with image and now with cloudy media images of images. The spectacular contribution of MIT's Center for Advanced Visual Studies (CAVS) to Documenta 6 in Kassel, Germany, in 1977—a massive outdoor installation based on an idea by the artist Lowry Burgess and designed at MIT—has become legendary. To celebrate that event's fortieth anniversary, and the original project's remarkable ongoing relevance in the era of radio waves, cell phone radiation, infrared pulses, X-rays, gamma rays, and particle accelerators, CAVS presented, in conjunction with the 2017 Documenta, a performative sculpture at ZKM in Karlsruhe.

But I remember the excitement of 1978. One year after the initial presentation, a second version was exhibited on the National Mall in Washington, DC, where I was fortunate to see it. I remember *Centerbeam* as an exuberant collaborative effort, exhibiting symbiotic cooperation among different disciplines as well as the revolutionary expansion of artistic means of expression through the embrace of the latest technologies. By day, the installation— reminiscent of a shimmering greenhouse or flowing pipeline—invited viewer participation with its beckoning watery reflections and eerie holographic effects. At night, in the words of Group Zero founding member Otto Piene,

Figure 3.5 *Centerbeam*, collaborative kinetic sculpture by artist-fellows of MIT's Center for Advanced Visual Studies, at Documenta 6, Kassel, Germany, 1977. Detail of Paul Earls's laser projection of György Kepes's *To Whom It May Concern*; image on steam by Joan Brigham. Photograph: Dietmar Loehrl. © Massachusetts Institute of Technology. Courtesy of CAVS Special Collection, MIT Program in Art, Culture and Technology (ACT).

Centerbeam metamorphosed into a "friendly inferno," a power-charged stage for laser projections, concerts, performances, and sky events.

The installation utilized what was then the newest media to detect and make visible the invisible. Laser beams, holography, steam, neon, video, and inflatables all came together to create a haunting multimedia "art machine." This numinous "aqueduct into the twenty-first century" linked the human optical and perceptual system—synthesizing the environment from the matrix of wavelengths and trajectories of light rays striking the retina—to the host of emanations critical to our understanding of the universe and, increasingly, to the stealthy functioning of our occulted tech-run society.[25] Strikingly, it also managed to reconcile, or find intersections with, the fluid aspects of consciousness by reconciling cloudy sense data coming from the outside with our ephemeral awareness of awareness—enabled by the neural pathways within.

The centrality of the question of unity—and the failure to find it within a convincing contextless cognitive ontology—restores the value of a relational aesthetics. On one hand, there is an increasing appreciation of the body's

role in cognition—the fact that the brain-mind is embedded in a physical, sensory-motor system interacting with the real world. Experts say this highly optimistic combinatoric challenges the dualistic straitjacket that has characterized "classical" artificial intelligence research. What is now being imagined is the unleashing of a technology platform using natural language processing and machine learning, such as IBM's Watson, in the physical world. The mandate is to give it eyes, ears, and touch, then let it act in the world with hands and feet and a face, not just as an action of force but also as an action of influence. This, it is argued, is real embodied cognition: the placement of the cognitive power of such a platform in a robot, in an avatar, in an object in your hand, or even in the walls of an operating room, conference room, or spacecraft. Watson's ability to understand and reason is thereby drawn closer to the natural ways in which humans live and work. The proponents of such a euphoric view claim that, by this conflation, we would augment the individual human senses and abilities, giving the technology platform the ability to see a patient's complete medical condition, feel the flow of a supply chain, or drive a factory like a conductor leading an orchestra.[26]

On the other hand, thoughtful ordinary people who are puzzled ask, What is happening to our brain in a time of cognitive automatism?[27] Culture and brain form complex systems of influence, control, and resistance. The brain today seems to have been invaded by technology: machines increasingly perform the previously human tasks of language, memory, and imagination, with our learning processes taken up by automated and algorithmic procedures. What are the philosophical, social and political implications of this pervasive automation for our brains and bodies? With the spread of algorithms, what is happening to our subjectivity, identity, and free will?

A Murky Totality: The Red in the Gray

> There are strange red depths in the soul of the most commonplace man.
> —ARTHUR CONAN DOYLE, *The Lost World*[28]

> Light is the left hand of darkness.
> —URSULA K. LE GUIN, *The Left Hand of Darkness*[29]

I've long been interested in the physical and metaphysical, literal and metaphorical concept-phenomena of shadow, shade, darkness. Far from delimit-

ing empty spaces, these obscure borderlands place us on the brink of ineffable being. Shadow is the ribbon of darkness running through the visual arts, the obscure blot or mystifying mark indicating what cannot be clearly seen or lucidly said. This strange becloudedness or occluded phantomesque offers an artful way of exploring the making of composites (compounds that are not one thing or the other, indeterminate as the nebulous weather), especially those that allow us to witness, however incompletely, brain-mind conjunctures in the making.

Shadow calls objects into question. It materially calls materiality into question. It deepens glitter into shimmer, brilliance into glint, and relocates outer glare into inner reflection. Hence the thrill of wild incognizability: remember the vertical Sublime with its infinite abysses, inhuman ravines, plunging chasms, gaping caves. But today not just a spectacularly feral nature or awesome special effects (like *Centerbeam*) exceed comprehension.

Patti Oleon's newest series of atmospheric paintings, *Neither Here Nor There*, reveals a sort of secular abstruseness, the umbraged indecipherability surrounding a cryptic domesticity. Oleon presents fantastic shadow-worlds, enigmatic decor surrounded with mystifying coronas of light, or eclipsed, sunk *in deep focus*.[30] In her preparatory visits to Budapest, Prague, Venice, Berlin, and Istanbul, she photographed the dim interiors of restaurants, hotel lobbies, museums, palaces, and theaters—all enveloped in silted layers of history that her paintings revisit and expose. Although these public venues often teemed with people, one would never guess it from the painted images—simultaneously scintillant and somber, transfigured and tarnished.

In a glazed window, crumbling exterior architecture palimpsestically mingles with gloomy interior detail. Creating a kind of labyrinthine carpentry, Oleon mixes, reorganizes, and welds the colliding elements into a phantasmagoric composition. As if projected onto a limbic screen, things snatched from afar appear close-up and those looming above are mirrored below. Not unlike the ancient crafting of *epitomai*, Oleon's "obscure objects" are the result of two basic movements, dismemberment and recomposition.[31] But instead of mere textual recycling with its onus of derivativeness, her paintings foreground the intellectual forging of synthesis, the profound connection between the practices of reconceptualization and making. Far from being merely shortened reproductions of so-called primary objects, her shadowy epitome establish complex, dialectic relationships, sometimes even undermining by obscuring the apparent meaning of the primary object.

Epitomization, as a kind of distilling encyclopedism, or collective mu-

Figure 3.6 Patti Oleon, *Window Dressing*, 2016. Oil on panel. 40 × 30 inches.
Courtesy of the artist.

seumification, or collapsing of archives, haunts Victorian imperial Romance. From Charles Dickens to Arthur Conan Doyle to Joseph Conrad, writers grappled with what they saw as the violent disorder at the heart of modernity. They seemed intent on conflating the monstrous present with the lost world of the primitive and with prophesying humanity's return to an irrational place of darkness, to what, today, might be called the return of the reptilian brain. Paul MacLean, in the mid-twentieth century, developed a theory of the triune brain. Although his compartmentalization no longer stands up to present-day knowledge of brain anatomy and physiology, his notion of the "reptilian" brain remains apt not only for the current unleashing of every appetite but for the spread of the inhuman.[32] According to MacLean, this lowest, rapacious level of cerebration represents the primal inner core, the uncontrolled illogical Freudian id underpinning animal urges that were to have been channeled into the rational context of the neocortex by the higher "mammalian" brain. From Bram Stoker's *Lair of the White Worm* (1911), with its repellant "living fossil," to the serpentine Loch Ness Monster, to Austrian artist Oliver Laric's surreal transhumanist polyurethane sculptures—the specter of a preternatural world composed of fantastical animal rearrangements abides.[33]

The Victorian vision of the decomposition of the historical present into a primordial chaos of rank forms, sooty manufacturing cities, criminal nomadism—spurred on by the rise of a fearsome global periphery—remains apt. Recall the dismal opening paragraph of *Bleak House* (1852)—"Fog everywhere"—evoking London's infectious mire and the Thames embankments' rotting pollutions. That great but grim urban center appears invaded by a dense amalgam of soiling grit, blackened drizzle, and ballooning coal smoke. These filthy November emanations creep under rusted bridges, defile pavements, drip from yardarms. Dickens laments that there is such a mountain of mud splashed in the streets, it looks as if the enormous rains causing the universal Flood had just retreated. Pedestrians, he claims, mired in this soggy, leaden afternoon, would not be surprised "to meet a forty-foot long Megalosaurus" lumbering "like an elephantine lizard" up Holborn Hill.[34]

As it happens, brooding intuitions about implausible creatures out of time were broadly shared. In the long wake of the publication of Darwin's *Origin of the Species* (1859) recall Conan Doyle's invention of the intrepid naturalist Dr. Challenger. Wandering in a newfound prehistoric outland somewhere in the Amazonian rain forest, he desires and, disastrously, meets up with the sluggish, dim-witted dinosaurs (mostly) from the Jurassic era. Dickens, Doyle, and Conrad conjure up the old hard places of darkness commensurate with

Figure 3.7 Oliver Laric, *The Hunter and His Dog*, 2014 (detail). Polyurethane, jade powder, bronze powder, aluminum powder, pigments. Three parts; each 90 × 66 × 6 cm. Photograph © Achim Hatzius. Courtesy of Oliver Laric and Achim Hatzius.

the small brains of great extinct animals and the predatory, imperial destruction of invaded and ruined tribes.[35]

What now constitutes our new shadow-land of metamorphic organic forms, of CRISPR gene-editing technologies, of integrated robotics with artificial intelligence—in short, of the feral red self sunk deep in the psyche or, updated for today, merged with our gray matter? Since the contemporary human brain is no longer seen as a tightly encased organ governing a self-contained, self-possessed, autonomous agent, what are the implications of the loss of a dualistic metaphysics (matter + spirit) when everything is in the process of being conjuncted with other bodies, species, entities, technological prostheses, synthetic materials, and their singular modes of being? Paradoxically, this destabilizing materialism is, at the same time, becoming hands-free, that is, bereft of the equalizing physical skills and irreplaceable muscle memory formerly required for well-crafted work.

And what of the drift to New Age spiritualism, to contemplative Zen, to Eastern mindfulness? These "movements" can appear withdrawn or otherworldly, blanking out what their adherents do not wish to see or hear, when what seems needed is engagement, an active encounter with the world. Certainly these self-listening, self-calming trends require mental energy, but

energy trained in an inward, even solipsistic direction. So I ask, can we retain the virtues and responsibilities of our former dualism—choice, decision-making, judgment, intellect imbricated onto a working practice—given the undoubted reality of our monadic materialism and the continuing effort required physically to change our minds and conduct our lives?

The question of cognitive ontology is really many questions. For neuro-ethicist Adina Roskies, it is unclear whether the questions are largely academic (and we are really not badly off), or we are instead in the neuroscientific dark ages, not unlike the position of alchemists prior to the development of modern chemistry.[36] The fact that she can't decide makes the topic doubly interesting for her, but for me there is much loss mixed with the glory. German scholar Eduard Zeller wrote in his 1883 *Outlines of the History of Greek Philosophy*, "The most important feature of the Aristotelian teleology is the fact that it is neither anthropocentric nor is it due to the actions of a creator existing outside the world or even of a mere arranger of the world, but is always thought of as immanent in nature." Grounded as we are in our Darwinian adaptationism, can we recast previous versions of that animistic *immanence* in terms of physical first principles, principles that may lie beneath our current understanding of nature's functional and adaptational design?[37] That is, can we somehow have our cake and eat it: retain the notion of design within nature as well as in our embodied understanding—impossible without the enactive performance of human hands?

Primatologist Robert Sapolsky's intriguing investigation into current research on the belief (or not) in free will is apt since recent advances in neuroscience appear to cast doubt on its existence. The role of choice and self-determination in shaping behavior is high in countries with high degrees of governmental transparency (Sweden, Japan, the United States) but does not hold for places like Somalia or Moldova, where corruption abounds and laws are opaque.[38] Yet as all our lives are increasingly surrounded by deception and corruption—especially from that shady reality, the internet—does our ethical compass simply turn passively laissez-faire in a technologically manipulative future?

Optimism, I think, is to be found not in the relentless American pursuit of innovative neurotechnologies but in the more philosophically based strategies of the European Union's Human Brain Project. Arlene Salles, a representative of this initiative, asserts that a fundamental prerequisite for such efforts is ongoing philosophical reflection conducted at three levels: "normatively, with the application of ethical theory to issues of applied neuroscience; em-

pirically, through the assessment of ethical reasoning; and conceptually, in the clarification of neuroscience linguistic and theoretical tools that bear on a human ontology."[39] This more intellectually and conceptually based strategy of determining how the nervous system underwrites human behavior is one that might well resonate with humanists. And its global vision also needs to be conjuncted with our culturally informed image-based expertise. As the noted graphic designer Milton Glaser so forcefully puts it, "Design is intent to communicate something to somebody so they move to action, and that includes practically everything in the world."[40]

4

Reconceiving the Warburg Library as a Working Museum of the Mind

In an article published in *Wired*, Nicholas Carr argued that the internet has made "skimming" our dominant habit of thought.[1] That is, the internet is simultaneously a connective net and an interruption or distraction system. The synthesizing World Wide Web paradoxically breaks focused attention through short reports, single findings, and brief encounters in the hot pursuit of the receding link. This brevity is itself a kind of marketing strategy—stripping away supposedly extraneous parts of communication to arrive efficiently at their functional essence. In today's consumption-wary economy, bites and bytes have become iconic. They shore up the popular rhetoric of sustainability—of achieving greater efficiency in using any resource, including information. By contrast, both reductivism and speed were alien to Aby Warburg, who believed no cultural object or symbol system could be understood without a careful study of its appearance and its context.[2] The baroque and endlessly ramifying network of natural and sociocultural interconnections is both too complex and too lengthy simply to outline.

Warburg was prescient in advocating a new understanding, one that represents the rich, variegated, interdependent fabric of many levels and kinds of explanation that ultimately get integrated with one another into an effective interpretation. Akin to Sandra Mitchell,

who in *Unsimple Truths* argues for a new epistemology ("integrative plural-ism") for biology and related "contingent" sciences, Warburg was interested in replacing standard cultural characterizations "with a more spacious and nu-anced conceptual framework."[3] He thus linked science with pseudoscience, astronomy with astrology, art with *pathos*, anthropology with myth, medicine with physiognomics.

This comparative or relational theory of cultural practices aimed to dis-cover how the combined natural sciences, the social sciences, and the visual arts create rule-based representations for the multilevel, multicomponent, dy-namic forms they study. His lifelong search for mytho-psychological evidence concerning the role played by memory in civilization acts as a useful foil to today's global culture of instant messaging, online appropriation, and data manipulation. Had Warburg lived to witness the twenty-first century's thin-ning of iconography, it is not unreasonable to suppose he would have coun-tered by citing the oscillations and polarities associated with the electrical signals emitted by the nervous system. These rhythmic pulses present a bio-logical countermodel to the fast techno-mashup or decontextualized pirating of rootless words, images, and ideas.[4]

I write this essay as a proposal, at the moment (2014) that this great and, in the best sense, idiosyncratic institution is in danger of being submerged within a larger, homogenizing repository. The issue remains vital today.

The Warburg Institute Library is a renowned treasury of books, but its singular holdings—in both word and image—have other functions as well. It is first and foremost a distinctive place. One of the things that makes it so unusual is Aby Warburg's characteristic spatialization of scholarship in un-usual intersective objects. Warburg's penchant for creating photographic and textual *ars combinatoria* interestingly resembles the earlier collecting habits of the founder of London's Soane Museum. This institute for all things archi-tectural has recently been refurbished and "improved" in an effort to "open" it up to new and broader publics.

Erected in a series of campaigns between 1792 and 1824, the Soane Mu-seum owes its present appearance to the successive demolishing and rebuild-ing of three adjacent town houses located on the north side of Lincoln's Inn Fields. Like the Warburg Institute, this Regency establishment possessed a novel, multipurpose, quasi-academic identity that allowed it, and continues to allow it, to function as much as a library as a museum. Books, casts, models, paintings, watercolors, and drawings were evocatively set within intriguingly syncretic arrangements: a Basement Crypt, a convex-mirrored Domed Area,

Figure 4.1 Façade of the Warburg Institute, University of London. © Philafrenzy/Wikimedia Commons. CC BY-SA 4.0 International, https://creativecommons.org.

a Pompeian red Library Dining Room, and the Shakespeare and Tivoli Recesses, to name just a few themed rooms.

Aby Warburg, like Sir John Soane, was a polymath. The stretch of their minds was great although the tangible effects of their multidisciplinary research ended up housed within small domestic interiors. In Warburg's case, these included books, certainly, but also caricatures, playing cards, postage stamps, posters, prints, and photographs. Notwithstanding the difference in scale, Ingrid Rowland's comment about the distinctive character of the Vati-

can Library also seems apt for these two intimate places of learning that manage to transcend their physical confines while, at the same time, requiring them. "It's not just that they have these things. It (the Vatican Library) has this kind of space, this civilization."[5] I propose, then, that it is impossible to imagine ambitious collections of this type—formed by inspired collectors whose unique mentality is a central component of what makes them significant—in any space or context but their own.

I am inviting readers, then, to entertain an analogy. Imagine the Warburg Library in all its specialness and peculiarity as a variant of the house museum, one conceptually resembling another notable London institution: that of John Soane. By their very nature, both libraries and museums aspire to motion: they stimulate a rush of interest, prompt user participation, foster immersion in an extraordinary environment, and encourage the categorization or ordering of things.[6] This analogy is not farfetched. To be sure, the Soane Museum possesses its own personal as well as esoteric period character—stocked as it is with architectural volumes recording changing eighteenth-century perspectives, archaeological ruins vital to the history of taste, and Grand Tour landscapes. But the Warburg Institute Library is equally personal, possessing its own hermetic period character shaped by the quest to make manifest the genealogy of human thought.

Sir John Soane desired that his home and collections be preserved for the larger benefit of "amateurs and students" in architecture, painting, and sculpture. Aby Warburg used similar broad strokes when dedicating his Library to every aspect of classical learning and its later receptions. The Warburg Library, too, has a provision for hands-on, open access to rare primary and secondary texts and assorted visual materials. No doubt this is one compelling reason for arguing that its holdings should be maintained as an ensemble.[7] But is it enough?

Given the growth of the Digital Humanities Project, the Kindle phenomenon, and the rise of other interactive technologies, this argument would appear insufficient for making the case that the Library "ought to be left as it is."[8] Yet despite the economic downturn and university downsizing, there are budgetary as well as intellectual arguments to be made for conserving intactness. These, however, require a shift in perspective. It is not only funding but also the Warburg Library's aims and objectives that need refreshing.

Taking up the gauntlet, I propose that a convincing case can be made for the Warburg Institute Library and its unique classificatory scheme (word, image, action, orientation) as a living and working example of an intercon-

nective system housing other ordering systems side by side on its shelves. What intrigued Warburg was less this or that disciplinary fragment or piece of data and more how they all intellectually hung together, their telling shapes and shifting parts.

His fascination for *Kulturwissenschaft*, or the science of culture, stemmed from a deep desire to understand the biological and psychological preconditions of human creativity including, especially, memory. (His motto, after all, was "Mnemosyne.") The task of historical retrieval was to gather those enduring remains persisting in the face of changing mentalities and to collect the primal types of cognitive order surviving despite their gradual evolution. On that basis alone, the contemporary Warburg Institute should be subtitled the Hippocampal Institute! What is Warburg's lifelong pursuit of the traces of classical antiquity and its transmissions—reflected in the intuitive connections sparked by the associative arrangement of the books and objects he collected—but an early neural-network model of the growth of connectivity? He wanted to understand how humankind learned to learn and continues to learn and remember.

Two claims so far contribute to the case for the Warburg Institute Library's persistence as an independent whole. First, it functions both as a repository of intertextual and interarts treasures and as a multistory gallery fostering visual and mental cross-views. The latter resemble the combinatorial prospects operating inside the Soane Museum. And, second, I propose that along with books investigating early church history or the Islamic invention of algebra, the Library contains something less tangible. In the age of an opaque internet, of contextless Google and depersonalized data skimming, the Warburg reveals in depth the myriad individual styles by which humans have systematically interconnected ideas. Recall that the archives of the Institute also contain the working papers of those other great, and very different, modern synthesizing systematizers of cultural symbols, methods, and concepts: Ernst Gombrich, Fritz Saxl, Edgar Wind, and Frances A. Yates. As an American doctoral student in the early 1970s, I vividly remember trembling in advance of probing questions on the psychology of perception posed by Gombrich, my thesis advisor, or sitting mesmerized across the messy refectory table from the formidable, supposedly "retired" Frances Yates—who had popped in for tea before retackling the Rosicrucians. These distinguished scholars weren't remote professorial avatars but striking characters whose physical presence left a lasting impression. No one exposed to the fearless adventuring into the higher arcana by the splendidly disheveled Yates or the impeccably suited

Gombrich, whose tailoring mirrored his mind—can forget how they embodied unique ways of thinking housed in a specific place at a specific time.

Ironically, the flawed rhetoric of economic efficiency constitutes a third reason for maintaining a freestanding Warburg Library. The Warburg Institute has already been merged into the University of London's "School of Advanced Study." Consequently, the holdings of the Warburg Institute Library now face physical incorporation into the London Research Library Services and, with it, loss of the Library's distinctive identity *as an interrelated ensemble*. Given present-day budgetary constraints, it is difficult to argue for maintaining the status quo, no matter how wonderful and unique the collection.

We therefore need to articulate a new rationale, one that involves redesigning the Warburg Institute Library in concept.[9] I suggest that we begin in terms of the Warburg *experience* and show how irreplaceably important it is. That experience, as those who have undergone it can attest, makes visible, as no other experience in the contemporary world does so well, a lengthy trajectory of systems of order and organization. If the volumes and their attendant images get dispersed, drowned, or otherwise absorbed—in the name of efficiency—these myriad shapes of order will be lost exactly at the moment when we most need their guidance, their models, their templates. It is the *cognitive* richness, those possible patterns of interactivity, those latent forms still lingering in the modern unconscious, that would be lost.

Efficiency, moreover, is not all it is cracked up to be. In 1865 the Englishman William Stanley Jevons, in his book *The Coal Question*, showed that there was a general and hitherto unnoticed problem with efficiency gains. Paradoxically, improved efficiency in the production of a resource lowers the relative cost of its use, thus increasing demand and counteracting whatever savings we would expect from increased efficiency. Take the case of American refrigeration, where, through efficiencies meant to conserve energy, costs got pushed down at every level of production, leading to the unintended effect that the number of houses air-conditioned all summer long vastly increased.[10] As a result, total energy consumption actually rose, rather than diminished, driving costs up again.

This "Jevons Effect" is central to current debates spanning everything from educational programs to energy conservation. Jevons importantly underscored the paradoxical inefficiency of supposed efficiencies—an unlooked-for effect amply documented not just in the present but in the history of past civilizations. Following his lead, we may then ask, if, in the name of fiscal efficiency and cost-cutting, the Warburg's books and photographs were dis-

persed throughout the London Research Library system, what would realistically happen?

Predictably, a diminished consumption of these decontextualized materials would result. Whatever temporary economic "improvement" would occur through consolidation would be offset by decreased research efficiency. Ultimately, higher costs would inevitably return since unused materials are reckoned as more expensive to store and maintain than materials that are frequently used. Further, even when a single volume gets called up (problematic in such a distributed library system geared to fewer books and more ebooks), the costs of locating and retrieving it would be more.

In sum: what the Warburg Institute Library needs is not a reorganization but a cogent redescription. To that end, I propose, first, that since this collection must preserve its intactness so that the books get consulted in the intersective ways intended by Aby Warburg, the intimate adjacencies fostered by the house museum should serve as a possible model. I cited the Soane Museum because it, too, had a founder who created a distinctive syncretic system on a similar scale. The intellectually demanding categorization of books and photographs at the Warburg Library obliges one to move among the shelves just as the visitor to the Soane Museum follows an intricate network of visual connections. Second, this performative system of shaping information visualizes the more general strength and uniqueness of the Library: the ways in which the *content* of the books is fundamentally about system-building, the grouping and structuring of variable data, or what today we would call the science of informational complexity. Third, and finally, the current dilemma of the Warburg Library exposes the unexamined fallacies in our culture's ubiquitous rhetoric of efficiency.

Ineffability

5

From Communicable Matter
to Incommunicable "Stuff"

Extreme Combinatorics and the Return of Ineffability

Since Kant, there has been an intense debate around the question of the location of the Sublime: Is it in the object or in the subject? In this essay, I tackle what I see as a fast-growing, indeed ubiquitous, sociocultural phenomenon, namely, the imagistic, linguistic, and ontological inability to configure the rising tide of confounding "objects," leading to the vacuous usage of the nondescriptor "stuff." Today, I argue, the viewer is deliberately presented with experiences, "entities," that are not only without a concept but without the possibility of a concept, thus producing a failure of intuition—that is, not a soaring ascent into comprehension, but a bewildering descent, into ineffability. I will examine this cognitive and emotional impassability from the perspective of ineffability's dark side. By this I mean its fall from Neoplatonic awe at radiant unity into the current shambling inexpressibility. Focusing on a handful of telling cases—both particular and exemplary—ranging from the invasion of the unexamined digital absolute, to terrifying transplant surgeries, to extreme scientific experimentation and its uptake by BioArt, I ask, What does it mean when we sever action from reflection and judgment? If the object world is now permeated by the IT and media world, does the "scientization of art" inherit not only science's undoubted wonders but also its ethical ambiguities, the violence of its experimentation,

the opacity of its aims, its indifference to social or cultural impact when personal promotionalism is at stake, and its inscrutable darkness or incommunicability?

> **ineffable:** Latin, *in*, not + *effabilis*, utterable. 1. too overwhelming to be expressed in words 2. too sacred to be spoken — *Webster's New World Dictionary*

> Also: inexpressible, indescribable, indefinable, unutterable, unspeakable, unwhisperable, unmentionable, uncommunicable — *Roget's International Thesaurus*

Combinations Beyond Name

> Stuff happens.
> —JEB BUSH[1]

> About me, I make stuff, predominantly for museums and galleries but also for commercial clients and occasionally private individuals. This stuff is often digital or new media, as with my research into AR, but is often very physical, making furniture or landscaping a playground for example. . . . Making stuff [is somehow allied with] the pressure for early stage identification of end product [and] is also at odds with the much more organic developmental processes that form part of the core methodologies of fine art and design higher education. . . . [So] many graduates are poorly equipped to engage with creative/tech industries that are pursuing a marketable, commercially realized concept.
> —LIAM JEFFRIES[2]

If our age is anarchic in mood and rife with nebulous situations — even horrifyingly indescribable scenarios — no wonder material culture studies are booming, embracing a wide range of traditional practices in art and design both inside and outside the art school, as if such object-oriented media and hallowed genres could move us toward making things matter again.[3]

At the same time, we find a common concern voiced by art and design communities. As the by-no-means unusual internet post above indicates, "traditional" craft materials and an empiricist pedagogy are in crisis, chal-

Figure 5.1 Olafur Eliasson with Einar Thorstein, *Model Room*, 2003. Wood table with steel legs, mixed-media models, maquettes, prototypes. Installation view, Moderna Museet, Stockholm, 2015. Photograph: Anders Sune Berg. © 2003 Olafur Eliasson.

lenged by a network of overlapping simulacra.[4] This essay attempts to formulate a key question: How do we make sense of this novel, experience-oriented, indefinite stuff that is seemingly everywhere, resulting from the vagaries of everything from the "technologies of the extended mind" to "biofictions" to "multispecies intra-actions" to, more generally, the "naturally hypernatural"?[5] How do we touch it, speak it, image it? And, in light of the new rule of information technology, is it still worth fitting together, constructing a definite, viable something given the fluid essences of subjects and objects in the twenty-first century?

Think of the arcane processes required to manufacture "living technology" (i.e., microbial organisms from scratch), or the computational "superpositioning" of quantum entities to be in two states at the same time, or the lightning-quick "entanglement" of electrons, or the conjuring of hypothetical "zombies" that may or may not inhabit the machinic brain bereft of self.[6] As we sink deeper into a haunted period where "real" assets or concrete objects with discernible physical properties that have lasting power depreciate or vanish, the veil of representational opacity descends.

Beyond any ethical constraints imposed by the academy — whether in the science fiction outback of game design, or in the apocalyptic artificial intelli-

Figure 5.2 Suzanne Anker, *Vanitas (in a Petri dish) 8*, 2013. Archival inkjet print. 20 × 20 inches. Courtesy of the artist.

gence industries, or in the wilderness of open-ended synthetic biology labo-ratories, or in the esoteric theater of transformative surgeries — a disturbing question lingers. Are we (or, rather, the adept "they") just making a lot of equivocal stuff that cannot be identified and is of no discernible use — or is even useless — by design? Figuring out what these undecidables "are" and why and to whom they appeal might be dramatic enough. But I propose an even more fundamental issue. How should we tackle the massive breakdown in communication between those who are initiates into the production of weird phenomena and those who are merely confounded users or awestruck be-holders of spooky effects and elusive methods?

Consider just one medical "new frontier": head transplants, coming hard after the previously "unthinkable" face transplant. Clearly the uncanny sight

of a "small black mouse with a new brown head" announces a troubling expansion into super-strange domains. Xiaoping Ren, the Chinese microsurgeon who performed the stunning transplant, asserted afterward that "he always dreamed of fixing the seemingly unfixable." And when contemplating the proliferation of motley organ transplants, he simply asked, "what's the next frontier?"[7]

In the global fiscal and conceptual merger or piecemeal "gig" economy there seems no limit to our imaginative tendency to exceed the real and materialize the most jabberwocky thoughts as bizarre reality. Not unlike *Through the Looking-Glass, and What Alice Found There* (1871)—in which the heroine walks into a shady wood where things have no name ("to step into *what*?")— we can't summon the words for the host of alien objects ("stuff"?) surrounding us. Like the mystified Alice under the secretive trees, even our own identity escapes us. ("Then it really has happened after all! And now, who am I?")[8]

Although, and perhaps because, repellently gruesome, the transfigured mouse—for want of a better word—embodies a quasi-metaphysical vision of duality willed into oneness. It also visualizes the presence of the nonpresent— the absence of the real residue of that other, now unreal, contributing mouse. In essence, the engineering neuroscientist performs like the shape-shifter alchemist, metamorphosing fleshed and unfleshed things (animal + animal + wiring, etc.) into dysfunctional "stuff." Recall that the dichotomous "mouse" represents only a prophetic stage in a cyclical process where revelation follows upon revelation. This fleetingly alive grotesque, we are informed, will soon be replaced by a convergent monkey, and so onward and upward to the ultra-reconstruction: the perfect Homo sapiens synthesis, forged through an infinite series of unfathomable transmutations.

Such hard-to-define collages—much like Lewis Carroll's "whiffling" Jabberwock or "frumious Bandersnatch"—arise both from the hypervirtuosic skill of the magus-operator and from his soaring speculation, the future-oriented recombinant simulations he runs in his head.[9] We frequently hear the admonition advantageously multiplied to become incantatory: because one can think it, one can do it. Mattering is not in question.

The tinkered mouse—as a what's-its-name kind of conjuncted thing— stands, I believe, for a vast emergent class of utopian puzzle-creatures manifesting an extreme physical and cognitive undecidability. One might call it an esoteric incommunicablity in terms of ordinary language or descriptive imagery adequate to the heterodox perceptual experience.[10] Is this perplexing phenomenon a *corporeal* product of a second creation or a Coleridgean

"secondary" imagination (that "dissolves, diffuses, dissipates" the images held in the mind "in order to recreate" them)?[11] What in fact is this fearful vision: organism or chimera, reality or ideal construct, natural or supernatural ensemble, correlative with no objective?

Self-stimulating speculation and its resulting imaginary products, then, perturb or disrupt reality-based codes of representation whose historical touchstones were mimetic form, stability, harmony, cosmic order. These intricately layered mental blends also become more repeatable over time. That is, they come to inhabit a closed or autonomy-producing system, one following a continuous circuit of repetition wherein every conceivable solution to a question or problem becomes the starting point for another, heightened repetition, over and over until and unless the whole formal structure collapses or is violently overturned.

Intriguingly, then, we find here the systematic structural features characteristic of palimpsestic late Neoplatonism—externalizing as ritual the brain's overlay of self-generating processes. The unitary nature of this idealizing system owes to the self-perpetuating activity of its multiple components. The looping brain, uncorrected by experience, thus resembles an enclosed sanctuary wherein plausible illusions of coherence are spun and respun for the preprogrammed initiate. Unchecked autopoesis is like living inside an esoteric cult within whose confines the most radical mental leap is indistinguishable from a verifiable proof.[12]

The extreme uncertainties surrounding the new vaporous materiality—captured in the popular adoption of the cloudy nonconcept or unterm "stuff"—are culturally destabilizing and cognitively bewildering.[13] This spread of foggy undecidability—perhaps announcing some general change of being—is furthered by the rapid growth of uncoordinated scientific discoveries (for example, the still mystifying connections between micro and macro phenomena, single neurons and behavior). Then there is the puzzlement aroused by increasingly complex technological "assets," shored up by bigger and bigger, but always invisible, "Big Data." This engulfing information is not only always already consolidated in transcendent data assemblages but often gathered without assessing the ethical, social, and political consequences.

So what is this ubiquitous stuff that leaves the viewer speechless and overwhelmed? Is it merely an ephemeral residue of something more solid, more uniform? Or is it the latent remains of an ancient Neoplatonist "invisible reality" that magically films different surfaces, miraculously possesses different properties at different locations, and dissolves in different ways?[14]

Figure 5.3 Image from the GeoDa-Web cloud mapping platform. Courtesy of the Center for Spatial Data Science, https://spatial.uchicago.edu.

Are we somehow still channeling the unpredictable and nameless remnants of an ancient cosmological or theological system rooted in the belief in an all-pervading subtle energy, vital breath, and light or dark presence. In our digitized universe, stuff—as a sort of residual effluvium whose essence can only be guardedly determined—strangely lives again in the yearning for wondrous connectivity, infinite data malleability, and the eternal return of the self-reflective. The result is that shifting stuff seems to subsist in a cosmos now so indefinably diffuse that diffuseness has become a sort of absolute.

Magical Thinking

> Gerard had always recognized his friend as being, in some radical, even metaphysical sense, more solid than himself, more dense, more real, more contingently existent, more full of being. This "being" was what Levquist had referred to when he said of Jenkin, "Where he is, he *is*."
> . . . Whereas Gerard, who was so much more intellectually collected and coherent, felt sparse, extended, abstract by contrast.
> —IRIS MURDOCH, *The Book and the Brotherhood*[15]

Like the marvel-mouse, insofar as it signifies some thing or any thing, misty stuff represents a negative: disconcertingly embracing both an ideal vague-

Figure 5.4 Derek Brunen, *Plot*, 2007. Still from HD video, 6 hours, 15 minutes. Courtesy of the artist.

ness and an impossible unity. Unlike the venerable theological and philosophical ineffables of the past (God, the One, the Absolute, the Unconditional, the Hidden, the Invisible, the Good, the Beautiful, Light or Darkness), the blurry secular ineffables of the present are about the unspeakability, the unsignifiability, of a stream of indefinable and conflicting substances.

If "matter"—with its connotations of something that is real, interconnected, potentially assemblable or disassemblable—suggests the cognitively demanding and thus communicable, what does unimageable, limitless "stuff" evoke? The word has become ubiquitous, all-encompassing. But the question remains: synonymous with what?

In the epigraph heading this section, the distinguished British novelist and scholar of Platonism, Iris Murdoch, gives an optimistic, animistic definition of matter in her succinct characterization of the down-to-earth Jenkin, whose groundedness reminds us that "you can't bypass where you are by an imaginary leap into the Ideal."[16] Jenkin is the quintessential pick-and-shovel dirt man—preferring empirical lessons gleaned from delving into history to the rarefied knowledge favored by Western intellectuals. Unafraid to face the material fact of humanity's ultimate fate, Jeff Wall features this reality in lightbox tableaux that commemorate "moments in a cemetery." Derek Brunen's ontological video *Plot*, however, goes farther in demonstrating the dualism at the heart of the varieties of Platonism. If Murdoch embodies this oppositional metaphysics in her contrasting characters (the cerebral Gerard and the

gritty Jenkin), Brunen conjoins them in a single materialist-idealist image. In the video, the artist is shown at hard labor—digging and gradually subsiding into a grave—yet all the while he is incongruously embedded within an idyllic Poussinesque setting.

Even Jenkin's eternally questing Oxbridge opposite, Gerard, is repulsed by the alienness of "quasi-mystical, pseudo-mystical, Platonic perfectionism" to which he is nonetheless attracted. Gerard confesses he is "made continuously restless by a glimpsed ideal far far above him; yet at the same time, the glimpse, as the clouds swirled about the summit, consoled him, even deceived him, as with a swoop of intellectual love he seemed to be beside it, up there in those pure and radiant regions, high above the thing he really was." All mud and matter, by contrast, Jenkin declares, "I am a slug. . . . I move altogether, if I move at all. I only stretch myself out a little, a very little."[17]

According to his friends, and especially the schoolmaster Jenkin— accustomed to molding grimy, restless boys—Gerard is forever sensing eternity in the present while always looking at something intangible, "much farther off."[18] Thus he lacks the immediacy, the nowness, of a shaped object or graspable thing, finds himself ill at ease with being incarnate. Jenkin, on the other hand, feeling embedded and living fully within society, is not translatable into flimsy stuff—a disposable "product" or labile "brand." Nor does he waste his energy in idealist acrobatics, trying to vault into the unknown.

Murdoch weaves her acute observations of persons, things, objects to capture the contrasting facticity of her two moral agents. Her novel does not describe, but rather embodies, this distinction: between the constructive method of a truthful fiction and its late Neoplatonic magical reverse. This metaphysical fascination with a difficult-to-speak invisibility—a preoccupation of mine since the publication of *Body Criticism: Imaging the Unseen in Enlightenment Art and Medicine* (1991)—embraces incorporeality, unperceivability, the yearning for luminous transparency, as well as for all those optical technologies past and present that open up unseen dimensions to which we aspire.[19] The central condition of these desires and devices is beyondness— their capacity to exceed the natural world and its expressions so as to attain unnatural vision into the otherwise hidden elements of our bodies, mind, matter, the universe. Today, we are engulfed by new invisibles—neurons, molecules, genes, viruses, pixels, voxels—often made distortedly visible by hyper-instruments. Yet unlike the prisoners shackled in Plato's Cave, mistaking the shadow-play on the wall or the splotch on the ground for Ideal Forms, we can see or say almost nothing about the matter that matters.

Figure 5.5 Thomas Roma, *Untitled* (from the series *Plato's Dogs*), ca. 2011–2013. Archival pigment print, 2016. 11 × 14 in. Courtesy of the artist.

The Digital Absolute

digitize
from the Latin "to finger
or handle" as if

to sink your fingers
deeply

into this
flood of light
—MONICA YOUN, "Goldacre"[20]

Today the digital is absolute. Without regretting the rise of e-readers and laptops, one still question this mighty revolution: what other foggy action-at-a-distance has been so unconditionally accepted with so little scrutiny of either its apparently limitless, if ill-defined, benefits or its drawbacks? A data-

hungry public, we are told, tautologically, requires constant feeding. And satisfying this need requires, among other things, an ever-broader wireless spectrum—that eerie ether or incandescent net of invisible radio frequencies that transmit high-speed information to and from proliferating mobile devices. Entrepreneurs and investors bidding in auctions for licensing and "zoning space" argue that current 4G technologies and existing bandwidth will be quaintly inadequate as hordes of consumers upgrade to near-instantaneous 5G smartphones, tablets, wearables, and multitudinous other connected apps. The digital is more than a technology driver, rather it has become a habit, a reflex, an impulse concurrent with the Internet of Things.[21]

This questionable invention—whereby even the human brain is distributed and manipulated like any other algorithm—alludes to the accelerating pro-growth economy of as-yet unrealizable "stuff" produced through the click or touch of a screen. The trouble with too much pointless automation ranges from the laughable to the grave. Witness Apple, Google, and Samsung rolling out preprogrammed "smart-home" technologies that frequently add thoughtless complexity and frustration to otherwise simple tasks like turning a light on or off. Or, more sinister, the turning of the brain into a product through technologies that invade the privacy of our thought.

That digital data has become our daily diet is apparent also in video games—ranging from nonstop pattern-processing puzzles that monopolize our cerebral resources to immersive 3-D life games that numb us to our own surroundings. Yet the lucrative gameification of everything hardly frees the mind. Rather it "habituates us to the tidy mechanisms of effort and reward, to established paths, and to prefab narratives."[22]

Coming to grips with the ominous dynamics of tailoring more and more automatic-control applications to a subject's behavior patterns is one of the many challenges faced by the multidisciplinary fields of media, communication, and culture. By definition, these future-oriented investigations continually reposition themselves to respond to a metamorphic and unseizable landscape. Indeed, they have shifted considerably in response to the rise in digital and open media, the turn to affect, and the ways in which we are now trying to articulate the relations between bodies, images, and environments as fuzzily permeable and algorithmically interconnected.

Given the drift to undecidability, how have manual objects been exploded by an economy of unseen wireless networks and hidden infrastructures? Nothing underscores the disaggregating power of such simulated mixtures more than the attempt to make virtual reality an actual reality. As one propo-

nent put it, "to try to do things how we would do them if we didn't have any physical laws governing how we do them." And again, "It allows you to experience anything, anywhere in the world with the fidelity of real life."[23] The growing market for virtual reality consumer products tellingly shows how boundless IT and enthralling digital stuff have created a new orthodox universe, within which the established world exists merely as a heterodox space. The systematic, and often unexamined, invasion by IT of every phase of contemporary life involves a reciprocal causality in which local causes produce global effects that cause those local operations to produce precisely those effects. Consequently, this supposedly "transparent" technology has become the largely invisible reflexive engine not only of all interpersonal relations but of any action whatsoever.

Suzanne Anker and Sabine Flach write that the claim to newness draws meaning from what is supposed to be the peculiar nature of digital technologies.[24] This progressivist narrative is mirrored in the analysis of a historical shift from an industrial age, based in the logic of factories (i.e., the mass production of material objects) and mass consumption, to an information age centered on the production and communication of immaterial information. In an industrial logic, "material" refers primarily to a critique of a utilitarian political economy of real objects, "immaterial" to a politics of identity and culture. Anker challenges this definition by arguing that what is evident is that so-called new media does not simply and definably extend the notion of "old" media.

Multiplicative and additive technologies and their arresting, if unnamable, stuff continue to yield uncanny mergers and unforeseeable outcomes. Graphic designers as well as new media industries are investigating the actual and economic viability of tailored or privately produced objects. Testing, for example, is looking into the constraints and potentials of 3-D printing with metal powders, to produce near-exact replicas of everything from auto parts to coffee cups. But do-it-yourself consumer products—especially alluring to hobbyists who would like to print their own collectibles instead of purchasing them—also raise the specter of increased digital piracy and counterfeiting, as was the case with the digital distribution of music.

Such fears about lack of control over licensed or copyrighted products are exacerbated by the broader problem of indefinition, because 3-D printed stuff—what else to call the product of data hovering between becoming and being?—exists in the digital ether before becoming tangible. It is difficult,

legal experts acknowledge, to determine who exactly is guilty of infringement when a design is digitally duplicated: the person who wrote the code or the person who operated the printer.[25]

This conundrum—now extending beyond the entertainment industry—highlights the fragility of the online marketplace, with its astounding ability to produce endless quasi-exact or mutated reproductions at top speed. It sheds light as well into the murk surrounding collisions between the immaterial world of digital technology and the conventions governing the physical materiality of sculptural form.

Creating Undecidables

> One may understand that no matter how wide the perspectives which the human mind may reach, how broad the loyalties which the human imagination may conceive, how universal the community which human statecraft may organize or how pure the aspirations of the saintliest idealists may be, there is no level of human moral or social achievement in which there is not some corruption of inordinate self-love.
> —REINHOLD NIEBUHR, *The Children of Light and the Children of Darkness*[26]

So wrote one of the great Protestant theologians of the twentieth century. Reinhold Niebuhr, whose interests lay in Christianity's social and political ideas rather than in its theological doctrines, rejected liberal Protestantism's rosy view of man and willfully blind optimism about human progress. His observations thus seem especially apt as we ponder a range of art/science situations vested in desires for human perfectionism and social utopianism.

Certainly, one of Niebuhr's "unhappy realit[ies]," were he alive now, would be the restless fabrication of impossible objects through swarming, merging, morphing, cantilevering, imploding, and exploding all manner of substance into matters-of-fact. Think of the ongoing conflation of the technological with the human, or animate/inanimate "stuff" compounded through pattern generation, or random aggregates caused or brought into ephemeral existence by themselves.[27] Perhaps there is a larger formal insight to be gained from the tangles characteristic of Alzheimer's disease, in which tau and amyloid proteins misfold or bunch, sticking together in confusing, medically hard-to-define ways. The resulting plaques—like the pathological alpha-synuclein

aggregates of Parkinson's and the clumping prions of mad-cow disease — defy description, in contrast to the orderly geometry and performance of undamaged proteins.[28]

Unlike medical researchers investigating these progressive neurological disorders, the focus of BioArt is not on identifying or speaking the name of the toxic aggregation or misshapen groupings of cells or on asking what has gone awry to produce them. Bioartists are, however, pragmatically as well as conceptually interested in biomedical laboratories as experimental places with apparently limitless synthesizing capabilities.[29] This vision of a creativity unbound raises a central question: not so much what these science-fiction entities can do but what such conglomerates *are*, as a matter of fact?

In museums, in artworks, as well as in digital and biotechnologies, we seem today to be witnessing the rise of new cabinets of curiosities. Unlike the boxed *Wunderkammer* of the sixteenth and seventeenth centuries, however, these heteroclite collections of singular objects no longer display cosmic relations and far-flung powers of attraction or repulsion, sympathy or antipathy. Chaotic juxtapositions, seemingly without rhyme or reason, have replaced the idiosyncrasies of early-modern natural history classificatory systems — where even the oddest specimen had the hope of eventually belonging to some as yet undiscovered taxonomy or undefined family of objects.[30]

Consider the crafting, arrangement, and display of dislocated biological materials and strange morphologies made for difficult-to-articulate reasons. We have BioArt, Neolife, Alien Art, Enstranged Objects, and so on — yielding disturbingly fuzzy compositions inhabiting labile gray zones. The Dadaesque groping for new, often hyphenated, names for collaged forms indicates the pursuit of a convergent concept to match the weirdly commingled end product. In the contemporary festival of bizarre and extreme unions or technological panspermia — unlike the cross-fertilization fables of antiquity — there are no mythic dragons and chameleons, chimeras and harpies, giants and minotaurs.

In 1962 — in a timely and suitably vicious update of Mary Shelley's *Frankenstein* (1819) — Anthony Burgess prophetically defined *A Clockwork Orange*. "That's a fair gloopy title. Who ever heard of a clockwork orange?" asks his narrator, Alex, who then reads from the manuscript of the writer whose home his gang has invaded:

> The attempt to impose upon man, a creature of growth and capable of
> sweetness, to ooze juicily at the last round the bearded lips of God, to

attempt to impose, I say, laws and conditions appropriate to a mechanical creation, against this I raise my swordpen — [31]

Burgess intended the compound term — one of many in a book full of merged words, like the droogs' "synthemesc" and "drencrom" (for scary drugs) — to stand for the application of a mechanistic morality to a living organism. Since the late 1980s the seemingly more straightforward, scientific-sounding name "BioArt" has become familiar in art practice. But what is BioArt? How do its aims relate to BioDesign and, more significantly, to the biological sciences, to their freewheeling research and their ambiguous ethics?

In a "real horrorshow" age in which alterations of nature produce immortal strains, how is biotechnology changing what it means to be human when we split into two, three, on to infinity, or even to an indefinable "it"? As Primo Levi has Trachi — "born of a secret union between a man and one of the numerous Thessalian horses that are still wild on the island" — say in his short story "Quaestio de Centauris," about all the innumerable couplings that are possible in these sorts of second creation: "I am changing. I have changed. I have become another."[32]

Chris Salter, artist, professor, and codirector of the Hexagram network, tackles such far-from-lucid entities in his *Alien Agency*.[33] The book examines three projects in which the materials of art — behaving in "self-organizing" ways "beyond the creator's intent" — become unknown, surprising. Among the key researcher-creators he identifies as organizing the conditions for these experimental assemblages, one of the most influential is SymbioticA. The team, housed at the University of Western Australia, comprises an "artistic laboratory" noted for its fabrication of the equivocal, as in its multiyear project growing "Tissue-Engineered Muscle Actuators" (TEMA).[34] This ambiguous "semi-alive" stuff far outreaches surreal "bio-life" design. Witness the fact that these nonviable entities (are they, therefore, "mortal"?) are given some elementary rite of passage by the lab technicians before being disposed of at the end of their real-time existence.

Bizarre "semi-alives," then, belong to a growing class of what Warren Neidich and Barry Schwabsky term "enstranged."[35] A seminal idea formulated in high modernism, *ostraniene*, or estrangement, is the process or act of endowing an object or image with strangeness by removing it from the network of conventional, formulaic, stereotypical perceptions and linguistic expressions. As we have seen, times have conspicuously changed since the term's coinage, and so has the surrounding discursive environment. Can the updated concep-

Figure 5.6 Ionat Zurr, Chris Salter, Oron Catts, and Devon Ward, *Futile Labor*, 2015. Tissue-engineered mouse muscle (C2C12 myoblasts), glass, Perspex, custom-designed electronics, wood, steel, plastic tubing. Courtesy of the artists.

tion of "estrangement," Neidich and Schwabsky ask, be used as a foundation on which to collage a multiplicity of contemporary metaphysical and epistemological practices and terminologies? "The Anthropocene," "speculative poetics," "cognitive capitalism," "accelerations"—can any of these help find an answer to the core question of estrangement? Or was Burgess right: are these elaborate organisms "lovely with color and juice but in fact only a clockwork toy to be wound up by God or the Devil or (since this is increasingly replacing both) the Almighty State."[36]

From Transfiguration to Configuration

> The critical question for our time seems to be: "how to follow, how
> to connect, find in the thick of the tangle what clear line persists.
> The strands are all there: to the memory nothing is ever really lost."
> —EUDORA WELTY, "One Writer's Beginnings"[37]

How aptly Eudora Welty's remarks on the way-finding practice of writing
resonate with the activity of the nearly hundred billion neurons and their
multitudinous and as yet uncharted dynamic electrical and chemical con-
nections. In both instances, integration is the fundamental challenge—the
riddling processing that interweaves thought, emotion, behavior, mood. In
closing, I want to signal some exciting coherence-investigating work that
moves us forward in understanding how Welty's mental things—crafted from
physical phenomena like post offices or golden apples—arise from a host of
biomolecular processes.

Of all the transparent-rendering imaging technologies—from the origi-
nal dye-staining of cell types, to the use of electrodes, fMRI, and transcranial
stimulation, to the advent of vagus-nerve stimulation (VNS)—optogenetics,
it seems, offers a previously unthinkable level of experimental precision.
Christof Koch of the Allen Institute for Brain Science in Seattle calls it "one
of the most momentous developments in neuroscience in the past hundred
and sixty years" for the investigation of the mysteries inhering in this primal
connective tissue.[38]

But perhaps the most intriguing news relevant for the ineffable combina-
torics we have been analyzing comes from artificial neural-network research
focusing on the repetitive compounding process of the human brain and on
the resulting compound imagery. It also raises fascinating questions about
the nature of choice, free will versus determinism, and the role of spatial con-
sciousness. How do we decide what is what or what to link to what? And what
constrains our decision?

"Inceptionism," the neural-net architecture deployed, points to what
neuroscience can tell us about the way we invent storied images on the basis
of incomplete information. It makes a stab at rationalizing how we formulate
decisions when confronted by ambiguous, tricky, or incongruous data. In this
experiment, the neural network is trained through exposure to many images
of rocks, animals, plants, architecture, and more complex scenes. It then sets
about extracting the quintessence of what is being visualized.

Not stopping with copying what it has been fed, it then amazingly goes on to generate analogous forms: what first appeared to be rocks turn into turrets, birds and insects into leaves, horizon lines into pagodas, animals into other animals. But how does the neural net pick or settle upon a specific pattern? Since this "compulsive" iterative process can be initiated even using random-noise images, it seems as if the uncanny results emerge from some "imaginative" activity on the part of the neural network. But do these nonresembling shapes in fact reflect the network's choice, judgment, or calculation? Is it "free" occasionally to take its own path outside the program?

This flurry of machinic overinterpretation or exaggerated variation begins when the researcher shows an existing image to the neural net, instructing the network to produce more of what it "sees." Surprisingly, what occurs is a reimaging or rearticulation of the primary elements. "If a cloud looks like a bird, the network will make it look more like a bird. This in turn will make the network recognize the bird even more strongly on the next pass and so forth *until a highly detailed bird appears, seemingly out of nowhere.*"[39] Apparently, the mistaken or deceptive results are a hyper-remix of the learned features. Importantly, applying this algorithm repetitively leads to an endless stream of extravagant combinations. Within the system's constraints, such extreme assemblages explore the set of things the network knows about—but out to infinity.

The unanticipated stuff produced is intriguing—even a relatively simple neural network can be used to overinterpret, freewheel, or imagine, that is, to re-repeat, an image. The process of association modeled is not unlike that found in children or adults who enjoy watching fantastic clouds and projecting something else or additional into the changing shapes. The experiment is fascinating as well for illuminating the brain's process of sensory integration—touch, vision, and many other types of internal and external information that mold our experience of interiority.

Along the same lines, computer scientists more generally are arguing that computers should be able to perform induction, allowing them to go beyond what they have observed or been taught to discover, to formulate laws that apply to all instances of something—even though, like the inceptionist bird, insect, or rock, they have observed only a few examples. Since none of us, not even a machine, can observe all possible objects or see all possible outcomes, a leap of induction or generalization from specific instances is warranted.[40] As in the case of "inceptionism," one key way of teaching computers induction is through the use of back-propagation neural networks. In back-prop systems,

artificial "neurons" take information from some kind of input (say, an image file) and then generate an output. In addition to the supervised training they receive on a given data set, they are capable of adjusting themselves internally without intervention from the computer scientist.

But these back-prop systems, like the combinatory organ they mimic, can be fooled. When the sense-making process goes awry, the brain—like the neural net in these experiments—is forced to choose which of various possible representations best anchors the image of the object or body viewed. But because the neural-net data is auto-stored at such a high level of abstraction, its misleading results are a weird assemblage, not a copy, of the originally learned features. Nonetheless, the conflicting data persists unresolved inside the system, as it were, "unconsciously" or virtually. This dualism of congruent (matching) and incongruent (mismatched) information can surface seemingly spontaneously as an aberrant combinatoric, not just as one "correct" representation.

Teaching computers to learn, like teaching humans to learn, involves inductive reasoning. It also requires a plausible account of the relation between the known and the unknown, the visible and the invisible. Freud was perhaps the first in a long line of investigators to feel not only astonished but uneasy when confronting that great inner unknown, the unfathomed associating abyss of the elusive unconscious. Despite the fact that the unconscious is now identified with him, the existence of myriad meaning-producing unconscious mental processes was recognized long before him. What Freud introduced in 1915 was a unifying framework and the revolutionary notion of a dynamic unconscious, working in a wayward fashion, unlike the task-oriented executive consciousness, that is, obeying its own kind of associative, wandering logic. He posited the existence of this subterranean mental universe from evidence of secretly "wishful impulses," childhood experiences, and libertine thoughts hidden from conscious awareness yet motivating our actions, indeed incongrously cutting into and fragmenting our apparently willful behavior.[41]

A century after Freud, and even with the advent of neurocognitive approaches to epistemology, one key unresolved question is in what ways viewing images and other material representations improves our ability to interpret another's occluded mental states. This capacity for intuitive insight or imaginative mirroring is referred to as Theory of Mind (TOM). More to the point: what kinds of images help us achieve access to the architecture of another person's elusive inwardness?

Architect John Peponis defines a configuration as "the entailment of a

set of co-present relationships embedded in a design such that we can read a logic into the way in which the design is put together."[42] This definition implies a doubly expressible understanding of what kind of configuration the particular design is, that is, a concrete realization as well as an articulatable conceptualization. He foresees the discovery of a new potential design world requiring us to engage with presentational forms of symbolization as well. Citing C. S. Peirce on induction, Peponis reminds us that this cognitive process obeys a logical formula that expresses the physiological process of formation of a habit. Importantly, along with Peirce, he argues not only that there is a peculiar sensation belonging to the act of thinking but that each of these acts has unique predicates inhering in the subject.

Peirce importantly reasons that generative principles entail pragmatic criteria of judgment. What Peirce is after eludes those seeking a master algorithm that would allow computers to effectively program themselves. Filtering and going through vast amounts of data automatically is not the same as human problem-solving, either in its complexity or in its reliance on personal judgment. In other words and to our purpose, it would seem that to make the ineffable effable, to consciously escape our creative as well as neural autopoietic systems—continuously producing themselves with recurrent, intensifying circularity—the sensuous and the empirical must infuse, as touchstones, every act of thought. This means paying close attention to the way a thing is actually constructed, to its material and logical assembly, "so that its relevant properties appear to derive from a compositional principle."[43]

Like Iris Murdoch's skaters roughing up a frozen water meadow, patterns that exhibit how they arise from application mindfully configure, and do not just mindlessly blend into, the environment. Not unlike artificial neural networks, all of us can automatically generate designs that have never before been seen and may never even be realizable. They may indeed be too complex to understand immediately or thoroughly, while still arising from our embodied craft, from the gestures and postures we have previously internalized. The trick is to turn an automatic performance into a self-aware performance. Effortful iterations visibilize the ongoing struggle to wrest definition from indefinition. As Murdoch's skilled skaters or conscious agents leave their trace upon the world by scraping and drawing upon the clouded surface, they are, in fact, "working . . . upon the hidden ice, making it, by their quick weaving, more visible, instinctively cutting the still unmarked snow with their sharp feet."[44]

Murdoch's epistemological lesson, I think, is one of configuration, not transfiguration. To be human means constantly confronting the challenge of how to bring forth any substantive composition from boundless surroundings. Murdoch's illuminating image of the moment-by-moment patterning of vacancy, then, reminds us that what we most want to know is not some ineffable whitish stuff but the constructive configuration of some communicable thing.

6

Impossible to Name

Performing the Ineffable

Staging Givenness

> . . . I was watching the thing
> you had just said to me still hanging in the air between us . . .
> —MONICA YOUN, "Brownacre"[1]

The concept of ineffability has a rich theo-philosophical history. It's an idea central to complex visual cosmologies, invented or imaginary worlds, Pythagorean number theory as the principle of all things, Neoplatonic processional systems, elementary landscapes rooted in brute geometry, and rhythmic abstractions (resulting either from extreme object reduction or extreme compounding) that abandon representation. More intimately, ineffability is identified with being and becoming, with quietude or metempsychosis—the recognition that "all things change, nothing perishes."[2] The misty unitary soul, for example, has long been thought to pass "hither and thither, occupying now this body, now that, passing from the body of a beast into that of a man, and thence to a beast again."[3]

In the visual arts, skeletal formal elements teach us how to look beyond and below description.[4] Thrusting line, repeated shape, arrayed pattern—rather than surface narrative—exhibit meaning lost

in the noisy rush of a story. Consider George Stubbs's reticent painting *Zebra* (1763), given to the young Queen Charlotte.[5] This complex work embodies not just a pre-Darwinian interest in classification, anatomical exactitude, and the graphic capture of the natural order, but a fascination—not unlike Goya's— for the secret influence on perception of the covert images hiding beneath overt imagery. Like synaptic junctures, these compositional jumps from un- formed to formed flash into consciousness, rewarding the intent scrutiny we give to the frontal plane. On close inspection, however, Stubbs's densely con- figured surface reveals hidden depths. The muddy puddle, mysteriously dark- ening the foreground where the zebra stands, is in fact teeming with anamor- phic creatures. These sinister grotesques—lurking under the conscious scene, as it were—secretly address our affective system, arousing feelings of unease, forlornness, vulnerability. This monstrous seething thus formally and emo- tionally undermines the zoological specimen's most stunning characteristic: the serene geometry of its repetitively striped fur.

One of the many things that remain viable from late antique philosophi- cal systems is the difficult-to-articulate countermanifestations of desirable qualities (for example: beauty as ugliness, ugliness as beauty). This nega- tive strategy (knowing things by their opposites) defies the splurge of speech through images that subversively, stealthily, redirect our hardwired percep- tual system.[6] Closest to antiquity—because of their consistent inversions of the Neoplatonic desire to build a changeless world out of beautiful ideas—Jeff Wall's monumental backlit transparencies have long wrestled with creating contemporary situations that embody indescribable moments in near docu- mentary photographs. Exploring these uncanny zones within phenomeno- logical experience, his profoundly unsayable works make us feel we could embrace them intuitively, while they remain sufficiently strange so as to in- spire wonder.

Typically encased in fluorescent light boxes and often referring or point- ing toward technically difficult and intellectually challenging pictures from the art historical canon, Wall's lapidary "cinematography" plays with num- ber, symmetry, geometry. Stunningly clear images of deceptively mundane scenes—replete with arresting juxtapositions, unexpected relationships, and halting fragmentation—they readily draw us in while resisting translation into words. By embedding sharply focused, if ultimately perplexing, subject matter into a feedback loop of enigma and association, the artist transfigures what at first looks to be the straightforward capture of an actual scene.

Looked at from a philosophical perspective, Wall's confounding realism

authoritatively undercuts such Neoplatonic absolutes as Beauty, as in *Morning Cleaning, Mies van der Rohe Foundation, Barcelona* (1999), with its lone figure incongruously mopping the eternally figured marble; or Infinity, as in *After "Invisible Man," by Ralph Ellison, the Prologue* (1999–2000), with its array of apparently endless, glowing lamps hovering radiantly above all-too-human chaotic living and working quarters. In 1952 Ellison and photographer Gordon Parks again tackled the black experience in postwar America with Harlem as its nerve center. Wall captures not only the estranged look of their joint picture-text project, "A Man Becomes Invisible," but the silence of its photographs, which turn race into a larger, universal issue about what cannot adequately be said.[7] And then there is Wall's reconsideration of transmigratory Change in the oddly soundless *A Sudden Gust of Wind (after Hokusai)* (1993). Restaging the Japanese printmaker's genius in forming repetitive patterns, Wall shifts our memory away from the original's colorful traces of courtly life and Edo-period taste, asking us instead to focus on its enduring performance, its choreography of gestures: enfleshed arcs, arabesques, horizontals, and diagonals, as well as on a combinatorial aesthetics that merges spatially and temporally remote actions within a magically unified space.

Economy, Unity, and Mathematical Truth are similarly invoked by their opposites when Wall appears to call into question Plato's attempt to identify and distinguish the four elements (Earth, Air, Fire, and Water). *Property Line* (2015) undramatically claims to stage the exact time and place—a hot afternoon north of Los Angeles—where inhuman nature is transformed into personal property. Instead of vastness or sublimity, we are shown two surveyors and their fragile equipment, small against the stillness and unremarkable laterality of the California desert. They stand amid hardscrabble scrub near the vanishing intersection of two roads overblown with sand, doomed to endless iteration—measuring this shifting stretch of dusty land over and over again only to confront its paradoxical immeasurability.[8]

Wall's doubly mute photographs are Orphic in showing how language is insufficient when compositions dissolve into riddling fragments. By arranging grand collisions between "high art" and prosaic reality, he negates the core intuition of the Neoplatonist vision, namely, that even the life-world must contain glimmers of a transcendent whole and its enduring qualities.[9] Wall's juxtapositional style combines images into conundrums, in contrast to the Minimalists, whose embrace of a quantum universe forced them to new levels of abstraction. Given the current fascination for weirdly collaged, heterogeneous digital or biological stuff, it might seem ironic that the austere, light-

Figure 6.1 Gisela Colon, *Oblate Ellipse (Blue)*, 2018. Blow-molded acrylic. 57.5 × 41.5 × 12 inches. Image © Gisela Colon. Courtesy of McClain Gallery.

sensitive artworks created by James Turrell, Dan Flavin, Larry Bell, and, especially, Robert Irwin during the 1960s and 1970s have now become fashionable. But as I proposed with regard to Wall, the Neoplatonic reverse of an extreme combinatoric is an extreme luminous oneness. Turrell recently commented in an interview, "My work is about space and the light that inhabits it. It is about how you can confront that space and plumb it. It is about your seeing, like the wordless thought that comes from looking into a fire."[10] Contemporary artists who immerse the viewer in "radiant space" engender optically phantasmagoric emanations that glitter and reflect.[11] Installations by Bell, Gisela Colon, and Christian Eckart shine with scintillant color, emitting an auratic glow. Their tubes, scrims, gels, cast polyester resin, glass, stainless steel, and polished metal flicker, soften edges, and open our senses to an infinite spectrum of indefinable brightness.

Robert Irwin's *Excursus: Homage to the Square³* (1998–1999) initially presents itself as a hallucinatory homage to Josef Albers's small-scale prints and paintings of chromatically interactive squares. Yet, unlike the Bauhaus master's chamber works, *Excursus* is both elusive and enormous (72 by 67 feet),

distributed through a maze of gridded rooms at Dia:Beacon.[12] Nearly monochromatic, it orchestrates dozens of buzzing fluorescent tubes mounted vertically in ghostly fashion against semitransparent white scrims painted with gray bands. Resembling lambent apparitions, this nebulous constellation of smoky light and spectral forms appears to arise from the wooden floor and disappear into a bank of filtered skylights. But this means that, along with Dia:Beacon's windows, Irwin's incantatory installation is flooded with a draining natural glare. More hollow shell than atmospheric mirage, the foggy installation, in this inhospitable context, lacks the numinous power to make its surroundings eerily appear or disappear.

Equally allusive and elusive is poet and visual artist Jen Bervin's interdisciplinary practice, which explores indefinite domains. She proceeds as if some cosmic secret might be hidden within the intimate formats and silent genres of poetry, archival research, and artist books. Witness her flair for capturing the ineffables left behind by like-minded poets, such as the faint traces of Emily Dickinson's "envelope poems" gathered in *Gorgeous Nothings* (2013).[13] Bervin echoes Dickinson's spare and encrypted style both here and elsewhere, clamping any tendency to expansiveness in the straitjacket of scarcely expressed sound or fragile picture. Other image-books where words dissipate into jottings, then gaps, and finally blanks include *Draft Notation* (2014), *The Silver Book* (2010), *A Non-Breaking Space* (2005), and *Nets* (2004). Equally barely, her diaphanous *Silk Poems* seemingly inhabit the outer edge of artistic possibility. This experimental "book," marvelously nano-imprinted with biosensors on gossamer silk film, weaves together old and new media and draws on research developed in nanotechnology and biomedical laboratories, medical libraries, global textile archives, and sericulture museums.[14]

If Bervin allows us a glimpse into a usually invisible, hyperthin version of reality stirred by the slightest breath, two remarkable websites of Jack Ox, an artist who works in the area of visualization and metaphor, situate us solidly and robustly within Kurt Schwitters's sonorous *Ursonate* (1922–1932), as presented in full stage-sound renditions by Ox and performance artist Kristin Loree. Recalling not only Merz productions but the collaborative, intermedial aims of Fluxus and Dick Higgins's insistence on evanescent performance, the goal is creative renewal, the making of something audible and visible again.[15] Unlike modernist explorations of chance and discontinuity, fragment and fragmentation, this process of recuperation and reenlivening results in a work that is possible to experience but difficult to describe.

Becoming Wild

> Qualia are ineffable.
> —DAVID LODGE, *Thinks* . . .[16]

> The Orchard quivered around him. Under the sun all was gloom and growth, green things, stalks, lichen, rot and wrack. He stared into the thorns and sodden mould, drenched leaves, the purple hearts of roses. His flesh crawled. Then he saw the snails. They were everywhere in the wet on the leaves, the trees, glued along slender stalks of grass, gleaming silver and black brutes straining and weaving. It was a dance. The snails were dancing.
> —JOHN BANVILLE, "De Rerum Natura"[17]

The nonhuman surrounds us with dizzying variety. Although the expanding microchip universe is indeed novel, for centuries people have made art and enacted rituals designed to transcend the human-animal barrier. The ancient practices of animism and totemism are replete with shamans and magi who interact with a vast muffled universe of buzzes, whines, whinnies, whoops, howls, screeches, squeals, and trumpets, as if subjectivity resides not in language-based thought but in an inchoate cosmic performance beyond words. As Frank Gillette's digital print series *Lascaux Redux* (2016) makes plain, prehistoric caves and the ongoing discovery of fossils provide ample evidence of an enduring belief in the coexistence of species, hands-on magic, and the talismanic power of animals.

But today, something more singular is afoot, underscoring the ultimate mystery and inaccessibity of animal life as well as the human longing for intimacy and shelter. Given our exposed existence, who doesn't yearn for safety and dream of protection from ill winds? Some find it—perhaps eccentrically—while cradled in earthen hollows with interlocking tree roots all around. Becoming wild changes our perception of agency, atmosphere, and the physical world. It also profoundly changes our concept of shared spaces in the life-world. By radically questioning the inevitability of existing in parallel universes, the act of turning wild is a protest against worn-out language, false public gestures, and product-based crowd-think.

A host of blurred hybrids—creatures that promiscuously intertwine—populate Greco-Roman fables and legends, Romanesque Bestiaries, heraldic symbols, New World myths, and, now, Anthropocene unresolvables (see fig. 3.7). The dual derivation of the word, indicating an unnatural ingenious cre-

ation, comes from the Latin *hybrida* (mongrel, bastard) and the Greek *hybris* (pride, arrogance). Today, Belgian artist Dany Danino's flamboyant ink drawings of exquisitely fantastic couplings reawaken visions of past delirious interbreeding and the illicit bursting of boundaries.[18] Yet those margin-defying gorgons, griffins, and hippocamps seem quaint in the face of more extreme unions.

I am not thinking of the rapturous accounts of unheard-of creations emerging from synthetic biology laboratories, or scary tales of outlandish genetic mutations among plants, humans, animals, and devices, resulting in amorphous entities. Although certainly these transformations are undecidable enough. Neuroscience, bioengineering, and science fiction appear to have entered into a relationship of tacit complicity, shattering the once socially agreed-upon borders between natural and artificial domains.

No, the new edge of inquiry investigates a revolutionary *intimacy*, the rewilding of the human animal—a kind of creature + ambient fusion. To be clear, I'm not referring to the controlled "having and holding" typical of aquaria and zoos but to an extreme sinking-into-another, an interspecies becoming-one.[19] In fact, it's easier to say what this phenomenon is not than to describe what it is. Imagine it as an attempt at absolute immersion into a world free of humanness yet pulsating with surging life. Interestingly, the members of this strange group of experimentalists do not belong to a lost or remote tribe. Neither, it seems, are they merely jaded ecotourists nor— like epicurean gastronomers questing for culinary rarities—do they trawl the globe looking for unheard-of auditory, olfactory, gustatory, and tactile experiences. We must imagine, instead, an individual tired of worldly sophistication and fleeing the existential angst of the human condition, who desires to become a "simpler," less intellectual beast. For these multisensory explorers, the attraction lies not with exotic or threatened National Geographic fare—huge, lumbering, empathetic elephants or voraciously stalking Bengal tigers—but with mouse-hunting foxes, tunneling badgers, browsing deer, scrambling goats.[20] The worth of such humble beasts lies in their directness, approachability, even imitability, since they belong to a familiarly rural, even Constablesque, landscape. For the neurophilosophically minded, perhaps these radical empiricists offer a novel response to Thomas Nagel's enduring question, what is it like to be a bat? Or if not a bat, a goat or a badger.

Thus, in the spring of 2013, Thomas Thwaites began quite literally to inhabit the mental and physical life of a grazing goat. Living in a herd, chewing regurgitated meadow grass, scampering on four sawn-off crutches, wearing a

Figure 6.2 Publicity photograph for *Being a Beast* showing author Charles Foster living like a badger.

goatlike helmet-head, he finally achieved the near-impossible: seeing "a word [signposted] without reading it."[21] To achieve this transhumanity, Thwaites used TMS (transcranial magnetic induction) applied to his temporal lobes specifically to impair his speech ability and so become more goatlike.

In *Being a Beast*, British barrister, medical ethicist, and theriomorph Charles Foster tells of a similar monadic quest that began over two decades earlier. Already in his youth, woods and streams were his natural habitat, as were rural activities such as fishing, hunting, searching for bird's eggs, and chasing moths. As an adult, his interests lay with more easily imitable animals, those ready-to-hand like the lodge-building beaver and other rodents, such as the muskrat, feeding on cattails and aquatic greenery, and living in burrows not muddy marshes.[22] But it was the fierce and solitary badger that was to become his preferred fusion-beast. While crawling naked six inches above ground as this hermitic mustelid, the occasionally cardboard-masked Foster bumped into, rather than saw, his food: wriggling hairy worms, tart lichen, crunchy beetles, snails, larvae, and lizards, all the while warily alive to his aromatic surroundings: the muddy damps, the green slime, the rotting heat, the flooded cold, the strong muskiness of weasels, and fishy stench of river otters.

In publicity photos Foster is shown (clothed) pillowed on green moss and lying on dead leaves. The supine pose in a ditch renders plausible his account

of the badger's finesse in distinguishing scents at different temperatures and times of day. Recent research in olfaction has shown that odors elicit impulses in the brain that fundamentally impact the ways we perceive the world. Astoundingly, fully 3 percent of our entire genome is devoted to genes for detecting different odors. And each of these genes makes a receptor for a particular molecule.[23] Smells are primitive, basic: they help all creatures survive by indicating food or the silent presence of danger. Most importantly, the sense of smell bears quiet witness to our fundamental animality, to the deep evolutionary record of human history as fish, amphibians, mammals.

To be sure, Thwaites's and Foster's unmediated adventures in creaturely otherness are also driven by curiosity and the thrill of estrangement. Yet what strikes me most about their extraordinary performances is the deep attraction of observant muteness, of all that cannot be named or represented. How is one to put into words the escape from speed to slowness, from an ego-directed consciousness to the disappearance of the subject—engulfed by randomness, inarticulateness, a totally different sensory universe? Reclusive, feisty, and not without humor, their amazing experiments suggest that the only antidote to our overmediated world is the anarchic destruction of language-based identity.

Broadly speaking, if we consider the chronological range and diverse scope of comparative anatomical studies, landscape paintings, even the biomorphism of Surrealism as, among other things, a flight from anthropocentric autonomy into a performative commonality, it's understandable why the biological realm has historically provided a significant resource for artists. More recently, BioArt has emerged to wrestle with how the biological sciences can be incorporated into the plastic arts. Of particular importance is its call to "awareness of the ways in which advancing biotechnologies alter social, ethical, and cultural values in society."[24] The morally dubious reverse of humans "becoming" animals can be found in the cognitive enhancement of mice, rats, and chimps in order to give animals advanced human capacities.[25] It seems the entire institution of animal research is in need of serious reform—from the need for more firsthand encounters in the wild to questions about the scientific as well as artistic validity of employing raw biological matter as a medium, not only in neurological and other biomedical research on nonhuman creatures but in ethically equivocal processes such as tissue engineering, plant breeding, and transgenics.

As challenging as BioArt and its animal-science offshoots are, they are rarely about emulating the receptive openness of animality, the ordinary rites,

the strange behaviors of eating, prowling, killing, reproducing. What's missing from current research on mimicry, and what contemporary pioneers into fusive bonding seem to be after, is an immersive way to understand the diffuseness, the chanciness leading all creatures from one thing to another in an ever-shifting environment. Supplanting our daily routines and decision-making processes, these showmen seem to be in training for something ineffably other: living episodically, through a narrow set of instincts, while showing the rest of us exactly how nonhuman creatures live in the moment.

Growing Indication

Episodes are like land mines. The majority of them never explode,
but the most unremarkable of them may someday turn into a
story that will prove fateful to you.
—MILAN KUNDERA, *Immortality*[26]

Milan Kundera, in *Immortality*, his postmodern assemblage of a novel, ponders how, in Aristotle's *Poetics*, the episode is an important concept. Aristotle did not like episodes. According to him an episode, from the point of view of poetry, is the worst possible type of event. It is neither an unavoidable consequence of preceding action nor the cause of what is to follow: it is outside the causal chain of events that is the story. It is merely a sterile accident, incapable of making a permanent mark upon the life of the characters, and can be left out without loss to the story's intelligible continuity.[27] On the contrary, I find that an episode is essentially about showing, about pointing out, about noticing, about not skimming or covering up. In fact, it is precisely nonverbal and indicative.

Robotics has entered the lists of the prelinguistic. Studying the origin of language in the performance of focused noticing, that is, in the use of the body's indicative gestures, roots speaking in nonverbal compressive demonstratives. This act of physical designation episodically singles an object or event out from the crowd. Consider a little robot who utters "Bolima," and whose neck squeaks in turning to his neighbor, who is also a robot. The second figure peers past the oversize building blocks that lie before them and finally points to a blue cube. The first robot nods—the language game has proven a success. From now on "Bolima" is the word for "blue cube" in robot-speak. "What's happening here is somewhat magical," says Luc Steels, linguist,

computer scientist, and convener of the focus group "Biological, Cultural and Social Origins of Language" at the Institute for Advanced Study in Berlin. "The two robots don't see the same way, each views the world from his own perspective. And yet they are able to agree on the designation for a certain object."[28] Steels is convinced that it is only when robots themselves generate the terms by which they communicate with one another that they are able to develop intelligence. And this helps us understand how it was that humans first learned to speak.

Steels's focus group has concluded that there is no such thing as an in-born instinct for language—that the influential MIT linguist Noam Chomsky is wrong. "No one would contest that language and speaking are dependent on innate abilities," explains linguist Holger Diessel. "Our concern, though, is whether or not these abilities are only there for language. And we're in agreement that this is not the case. We're not born with any particular sense for subjects, objects, verbs and relative clauses. The capacities that we employ so as to learn to speak are the same ones that we use to walk and drive cars."[29] Language-emergence, then, is an action-based or performative process that builds on already existing organs such as the discriminating nose, the light-capturing camera eye, and the moving gels and bending hairs of the inner ear.

Showing someone something must have been of crucial importance in bringing humankind to utter its initial words. By analogy, very young infants can have their attention diverted through the gaze of other people looking at something without speaking. Significantly, before they voice their first words, infants start to point and direct the attention of others as well. As Diessel emphasizes, when children finally do begin to speak they tend to utter demonstratives such as "There! There!" rather than denotatives such as "Mama!" and "Papa!"

In their examination of grammars from around the world, members of the Berlin focus group have discovered that many important words are based on such indicatives: "From the start of communication to the most complex of linguistic structures, everything has its start in showing."[30] And showing certainly plays a central role in the language games of Luc Steels's robots. Just as new research on corvids, especially ravens, has found that they point with their beaks and that alarm and feeding cries are linked to where they cast their gazes and turn their bodies, so too Steels's robots first nod at a blue cube, which subsequently becomes the word, "Bolima."

If human beings have no particular aptitude for speaking, then the question as to why humans learn to speak and other animals do not would seem

to be all the more exigent. The answer apparently lies in the dual evolution of communication and cooperation: "Animals communicate through the here and now whereas humans plan what they will undertake together in the future."[31] I wonder. With the proliferation of mobile devices, the presence of the screen in everyday life is ever more pervasive, personal, and immersive. In the last five years, for example, the digital tablet has become a must-have device. With children raised as "screenagers," one in ten three- and four-year-olds now have their own tablet, typically used as a pacifier, educational aid, and entertainment source. Meanwhile our urban spaces continue to offer up new forms of continuous interaction as the numbers of screens multiply. Via the screen—large or small—we navigate an evolving media and cultural landscape that is increasingly interactive, intuitive, and always on, if rarely "real," as the animal-becomers would desire it.

Whatever else they may be seeking, Thwaites, Foster, and like-minded comparativists are in pursuit of an absolute presence, a purely nonmediated life located in activities ordinary animals enact every day. The Neoplatonic countermanifestation of humanity within civil society is humanity immersed in authentic wildness. This essay examined three episodes in contemporary ineffability that make the case for the irreducibility of brute existence. Situational and performative, these revealing instances each reflect the belief that we connect most deeply not at the level of language but in the indication of what otherwise would remain unsayable and unnamable. Thus they are neither sterile Aristotelian episodes nor merely noncausal explosions. They range from demonstrating how visual artists configure a primal geometric or luminous structure prior to and below narrative, to exhibiting how our inner biological "zoo" can be tangibly connected with the rest of nonspeaking creaturely life. These two episodes are joined by a third that may yet grow into a theory undergirding it all: the origin of communication in wordless showing.

7

"Totally Visual"?

Op Art's Neural Iconography and the Engineered Picture

The thing you learn is, you don't have to go outside yourself
and paint what you experience. You learn that you can generate
a painting in its own terms, by setting up a program for it. . . .
The rigging is what I like.
—JIM QUINN, "Driven to Abstraction"[1]

A language allows its speakers to construct and understand an
endless supply of new expressions. We might say that it *licenses*
and *sanctions* their formation. However, it does not give speakers
license to do whatever they want. To be considered normal or
correct, expressions have to be put together in certain ways and
not others. . . . The rules and restrictions of a language reside in
large numbers of *schemas* arranged in *networks*.
—RONALD W. LANGACKER, *Cognitive Grammar*[2]

Edna Andrade's rule-governed, mathematically precise, seductively
interactive paintings have much in common with machine and com-
puter art that sets software into storms of motion. A similar, if covert
and "cold sober," desire is lodged within the meticulous composi-
tional process she uses to create a lively art without apparent human
agency. Once the aesthetic investigation is launched and the key de-

cisions are taken, her perceptually intricate work seems to graph itself "square by square, just like life."[3]

Painting becomes one among many dynamic or generative systems in the universe—including self-duplicating fractals, deterministic chaos, autonomous agents, cellular automata—that operate with minimal intervention once they are set in motion. In this spirit, the strangely atmospheric *Turbo 1* combines a periodic structure of alternating, crisp turquoise and orange zigzag stripes that suddenly disappear down the rabbit hole of a spontaneously emergent form: a misty and intensely vibrating vortex. The labyrinthine abyss, virtually sinking into the center of the flat canvas, seems no less deep than the cavernous black void punched into one of Lee Bontecou's projecting wall reliefs.

Given the implicit three-dimensionality of her work, Kenneth Snelson's tension-compression models from the 1960s also spring to mind. Like Andrade's hot blocks and cool circuits, even his most technologically abstract Tensegrity sculptures exhibit an underlying passion for nature: evoking the delicate filigree of crystals, snowflakes, and spiderwebs, the effortless fling of suspension bridges.[4] Andrade, too, is obsessed with noticing connections. The tumultuous twist of the watery maelstrom lurks behind the contained channels and descending spiral of *Turbo 1*. Her pared-down compositional units, dressed in a riotous palette, thus joyously reconfigure primary structures—whether belonging to our inner or outer universe.

Akin to Op art's formal interests and reactive focus, Andrade's perceptual/conceptual motion graphics from the 1960s are uncannily prescient of current neuroscientific interest in the brain's permutable hardwiring. At a fundamental level, her work is not about anything the beholder knows in advance but, rather, something she or he reacts and adjusts to. Designing the picture plane so it functions as a complicit event, compelling the viewer to merge with the oscillating surface, mimics the brain's self-organizing ability, its capacity to synthesize the discrete components of the sensorium into an illusory whole.

Significantly, Op art models knowledge about the dialogical *acts* of seeing. It obliges us to perform—not merely witness—the tension existing between the continuous stream of consciousness and its random rupture. The beholder viscerally experiences the brain's dizzying confusion when facing dissonant or ambiguous signals. Playing with geometric transformations in scale, rotation, warping, reflection, or shearing, as well as color or value gradients and Gestalt figure/ground reversals, the hypnotic compositions of Richard Anuszkiewicz, Bridget Riley, and Victor Vasarely manifest at a gut, not just a retinal, level the

collapse of harmonious order and its dislocation or decay into the nausea of disorientation.

By conditioning the viewer to feel, not just see, how art happens—that is, how form and content taken together neurophysiologically impact us— Andrade foreshadowed emerging research into the performance of design-based automation and genetic or evolutionary programming. Unlike the often ego-driven agendas of the Abstract Expressionists, Andrade belonged to a phenomenologically inflected generation of artists fascinated by the distribution of consciousness, that is, by its dissemination beyond the closed borders of the self.

Despite their differing aesthetic agendas, Donald Judd, Dan Flavin, James Turrell, Robert Irwin, John Chamberlain, Robert Smithson, Bridget Riley, and Victor Vasarely all wrestled with unpredictable third-person phenomena (color in space, afterimage, retinal reaction to light and shade, repetitive patterns of all kinds from geometric to topographic) that ultimately yielded controllable results. Moreover, they all insisted that the maker function democratically in the everyday world of anonymously constructed or naturally occurring objects, leaving the rarefied space of the studio-bound genius behind.[5] Not coincidentally, these Minimalist, Pop, Op, and Earth artists escaped the white walls of the museum either by converting those spaces into a laboratory for their enactive experiments or by locating their investigatory activity out-of-doors at the human-environment interface.

Merely manipulating the eye was never foremost for any of them. What mattered was revealing that the narcissistic first-person consciousness of the Abstract Expressionists constituted an illusion of the mind. The beholder's— or better, the performer's—attention was instead riveted on various internally perturbed neural systems and the events they produced. These excitatory retinal-mental pyrotechnics magically summoned the visual illusions, parade of memories, stream of thoughts, occasional hunches, feelings, and sensations (all neuronal firing patterns) that appear to spring miraculously from nowhere. The eye, then, was not merely "responsive" but cognitive, creating a fleeting correspondence between the carpentered world of edges and the viewer's nervous system. As the Op artist Julian Stanczak remarked about his own paintings, with "the behavior of colors, shapes, lines, I try to create relationships that run parallel to man's experiences with reality."[6]

Shimmering, vibrating, vertigo-inducing Op art, in particular, because of its demonstration of the close connection between the visual and motor cortices, inaugurated the comeback of the efficacious image. Rooted in ancient

shamanism and mimetic body ritual, this performative presentation, not representation, actively *does* something as opposed to passively being something. Op art, then, has a lot in common with computer art and Conceptualism insofar as it is predicated on presentation, combination, permutation, and variation — all coded practices fostering interactivity.[7]

Painting's potential for engineering positive action within the individual and in the outside world brings me to contemporary cognitive science and the paradigm of the "creativity machine." This smart device enables the autonomous design of ideas by means of highly augmented machine intelligence.[8] Stephen Thaler's pioneering example — a powerful artificial intelligence (AI) engine — is composed of "mated" synthetic neural networks capable of generating ideas. Amazingly, this combinatoric apparatus can "spontaneously dream" patterned information that transcends what the two networks (the "imagitron" and the "perceptron") already "know."[9]

Like the intricate patchwork or interlace of Andrade's geometric *ars combinatoria*, once the computational algorithms are set in motion, the logic of artificial invention kicks in. In both cases, a universal grammar or global system of rule-based automation takes over. This process of self-assembly apparently holds in the great scheme of things whether one is speaking of the repetitive and rudimentary geometric patterning on Navajo pots and Islamic tiles or the compounding tendencies of tesserae-like binary code.[10]

The anonymous, artisanal inlay formats Edna Andrade favored (camouflage, mosaic, wood intarsia, grids, quilts, piecemeal murals) are thus in line with the connectionist paradigm of artificial neural networks in which eye-logic mirrors brain-logic. From the perspective of the computational cognitive neurosciences, discrete logic, fuzzy logic, intuition, and the most elevated thoughts are all abstractable to the same numerical activation patterns of neurons. Like today's augmented machine intelligence, then, Andrade's work moves beyond mere pattern recognition to pattern generation, combining those schematic tokens into new compound pictorial ideas in a process akin to analogy or juxtapositional invention.

Just as Andrade's first creative gesture is always to divide the chaotic painterly and ambient worlds into their most frequently recurring geometric archetypes — the line, the circle, the triangle, the rectangle, the square, the vortex, the arc, the ellipse — so an artificial neural network spontaneously divides and categorizes more complex scenarios into their primes. Even her final, beautifully detailed pencil drawings from the 1990s — charting every fissure splintering the crumbling surfaces of monumental boulders and eroding

Figure 7.1 Edna Andrade, *Cliff and Pebbles 10-10-96*, 1996. Graphite on paper. 29.3 × 41.3 inches. Private collection. © Estate of Edna Andrade. Courtesy of Locks Gallery.

rocky outcrops—are telling in accepting a priori the mathematical rules of the formal or structural game.[11]

Throughout her long life, Andrade consistently demonstrated the profound relation obtaining between the artificial realm of reverberating bars of contrasting hues and ideally symmetrical shapes and the natural realm of fractured stony masterpieces etched with an insistent *craquelure*. Unlike ideally perfect Platonic forms, however, the crystalline faceting and secret geometry characteristic of myriad landscape formations fragment and blur into the open-endedness of sublime ruins.[12]

Andrade's mesmerizing formal abstractions—hovering between the architectonic and the contingent—are prescient of a detailed, labor-intensive, immersive kind of contemporary painting that similarly invokes autoformation and the inexhaustibility of pattern. Fred Tomaselli's "chemical celestial portraits in inner space and outer space" combine actual hallucinogens, sleeping drugs, and decongestant pills to depict, among other things, the infinity of "stars in the night sky on the days they were born."[13]

As was true of Op art's willingness to entertain new constellations of perceptual experience, Tomaselli is not just smitten by acid-dropping. Experimenting with chemical substances, paradoxically, offers the novel opportu-

Figure 7.2 Fred Tomaselli, *Echo, Wow and Flutter*, 2000. Leaves, pills, photocollage, acrylic, resin on wood panel. 84 × 120 in. Courtesy of the artist and James Cohan, New York.

nity to show the behavioral connection between the logic of vision and the autopoietic brain. Like Andrade's resistance to "personal calligraphy," Tomaselli exploits the countless design possibilities inherent in basic geometric patterns.[14] His meditative collages, or pharmaceutical hybrids, are composed of innumerable tiny color mashups cut from magazines and books. These selfsame modular units get welded together into a galaxy of concentric rings—itself composed of innumerable stroboscopic target-circles recursively looping the dark hole at the picture's core.

In the mid-1990s, Damien Hirst, in conjunction with David Bowie, similarly recalled those psychedelic nights in his *Beautiful, Hallo, Space-Boy Painting*. The effect here, too, is at once poetic and kinetic, illusory and haptic, obsessive and necessary. Along the way, the viewer gets transported to an imaginary dimension while rooted in the material moment.

On one hand, there is something mechanical and conventionally mindless about such funky computer-scanned images, an automaticity that completes one aspect of the incomplete Op art project. As Andrade commented about her own efforts, once the painting is set in motion, the logic of selforganization seems to take over. On the other hand, the insistent structure

of the work induces the viewer to pay attention, to linger in the graphic performance. Compelling the beholder to witness the "containerization" of the infinite thus completes the wake-up call of the Op art project, its summons to create dynamic events meant to be enacted by the participant. That is, for Tomaselli, like Edna Andrade, *perception*—not just retinal vision—lies at the heart of "all good art, all interesting art."[15]

The concept of Op as a democratic form of situational research links Andrade's synthesis of art, science, and technology equally to Olafur Eliasson's myriad installations conjoining interactive optics, everyday physics, and experimental psychology. In these protracted events unfolding both inside and out-of-doors subject-object dualism is similarly broken down. As with the flickering Op works of Stanczak and Riley, and Andrade for that matter, an iridescent and trembling nature has again become the point of departure for stimulating the viewer's body and merging it with mind. But, today, the visceral, pulsating, and mutating canvases of the 1960s have given way to more cumulative, even quietist, effects as our environment becomes ever more fragile. The sensational has grown up and become mindful. The binary language of cybernetics and Gestalt principles has likewise evolved. A new introspection is being elicited by new realities. It's no longer just the picture but our very states of being and the human condition itself—expanded, distributed, episodic—that can be rigged.

8

Dark Wonder

Belowness, or the Ineffable Underground

> "Yes," said Dalgleish, "We're so sated now with scientific wonders
> that it's a bit disconcerting when we find technology can do
> everything except what we want it to do."
> —P. D. JAMES, *Devices and Desires*[1]

Why does the dark underground fascinate us so? And why do we willingly descend into its unfamiliar depths? I think it's to experience the real real, to feel however obscurely that we exist beyond mere apparatus. Down under, with stunning exceptions, the everyday world stands undressed, stripped of color and light. We sink below the obvious to get in touch with the naked, the inscrutable, the ineffable. Unlike the ocean of digital hardware, software, technological devices, and prefab constructions vying for our attention on the surface, you don't have to explain this enfolding wonderland or rationally understand it or solve its mystery. What you do is experience the protective thickness, the freedom of not being seen.

Wanting shelter defines our exposed times. Embedded within this physical and existential density, you escape scrutiny, you know nothing of surveillance. Imagine, rather, being surrounded by a panoramic oneness, an Emersonian correspondence channeling among the three kingdoms—transcendentally unifying the animal,

Figure 8.1 Sir John Tenniel,
illustration from *Alice's
Adventures in Wonderland*
by Lewis Carroll. London:
Macmillan & Co., 1865.

vegetable, and mineral domains. With no familiar distractions, we sense a
deep interconnectivity with the rawness of nature that defies analysis. Think
of it as liberating: profound involvement without responsibility. No beautifi-
cation is required of this vast subterranean universe. Dust or chunk, mud or
rock: the brown/gray earth just is, present but unfamiliar in its frightening re-
moteness, its uncompromising strength, its ultimate impenetrability.

Groping downward as well as tunneling inward is actually a good analogy
for the perpetual movement by which we viscerally—not merely intellectu-
ally—connect to the past. I had spent much of my life as an art historian in
love with showing slides in warm and enclosed dark rooms. But, some years
ago, while crawling into an abandoned Colorado gold mine at dusk, I discov-
ered something else. If Kant refashioned the Sublime to incorporate astro-
nomical heights, thus attempting to overcome the divide between the real and
the ideal, the chasm between our limited understanding and the unknowable
thing-in-itself, he neglected an equally remote realm. The starry cosmos is
unthinkable without its vertical antipodes: the downward infinity of the noc-
turnal mine, cave, or cavern lying beyond reason's reach.

On that memorable day in the rugged mountains above Denver, it was

rapidly growing dark. The chaotic scene of long-exhausted mining stretching all around was marked by solitude, silence, and desolation, and stamped by my own cold fear. Sinister industrial debris obstructed the broken door to the fallen-in shaft. Lengthening shadows, the amorphous silhouettes of rusting equipment, and the wreckage of a single-gauge railway were intensified by the sun's last rays. Transfigured because divested of their prosaic character, rotting log piles, ruined tracks, and obsolescent machinery dangerously barricaded any easy entry into what had become an enigmatic temple of darkness veined with mineralized special effects.

As I quickly learned, lowering oneself into unmediated depth encourages encounter-thought: the primal processing of space and time into traumatic oneness. In this alien territory glimmer, touch, smell, sound assailed my instincts in sensory bursts beginning with the first onrush of chill dank air. The winding tunnel constituted itself only step by step. Amazingly, it lurched into visibility or invisibility with the sudden rake of a flashlight on the maze of blackened walls. Disorientation, even hallucination, were constant sensations as I groped my way through this echoic, bat-infested region. As my body became progressively shrouded in matter, minutes stretched into one long, unspeakable night. But there were also miraculous moments of epiphany, the revelation of a secret and strikingly sculpted landscape.

Rare experiences are increasingly becoming virtual and mainstreamed. So it's useful, I think, to conjure up the ancient power of immanence—this

Figure 8.2 Mrs. Moore looking into the Marabar Caves, film still from *A Passage to India* (Columbia Pictures, 1984). Director: David Lean. Based on the novel by E. M. Forster.

prehistoric and analogical ability, if you will, to look at all aspects of existence as not divided from each other. For thousands of years, dark-wonder realms, from the slimy karst tunnels and stalactite-draped cenotes of the Yucatan Peninsula to the painted passages of Australia's Northern Territory, nurtured human life. It's not surprising, then, that the primordial cavern—"black below shine" and "closer down," in poet Les Murray's words—has long been synonymous with mind. Such terrifying obscurity is also synonymous with ineffability, the sublime incapacity adequately to express what one perceives. Pervasive dimness arouses strong feelings that are beyond coherent speech.

A bottomless sinkhole and dark crater rolled into one, the holistic morphology of this geological underground is simultaneously crystalline and aquatic, eternally stony and flowing. Both an aural and a mural architecture (scratching mice, scrabbling lizards, flapping batwings, night-hunting birds) resonate against distant walls and reverberate in narrow byways attuning us to the intricate landscape of enclosure (see figure 10.6).

In this material environment pervaded by the earth's relentless encroachment, the experience of the conscious self as localized within the perimeter of the body breaks down. Not surprisingly, then, religious ritual and initiatory ordeals were often rooted in sensations of beyondness: the attainment of an extraordinary dimension above, below, alongside, or outside one's ordinary corporeal boundaries: the enduring wonder and thrill of subject-object fusion.

9

Still Deeper

*The Non-Conscious Sublime or the
Art and Science of Submergence*

However late that may already be which we can grasp with aid of
names that have been handed down, it is a piece of mastery—of
giving shape to and bringing into view—something that went before
and that is beyond our reach. . . . Everything that man gained in the
way of dominion over reality, through the experience of his history
and finally through knowledge, could not remove the danger of
sinking back—indeed, the longing to sink back.
—HANS BLUMENBERG, *Work on Myth*, 1979

[One] way of phrasing this theory which I am arguing against
is to bifurcate nature into two divisions, namely into the nature
apprehended in awareness and the nature which is the cause of
awareness. The nature which is in fact apprehended in awareness
holds within it the greenness of the trees, the song of the birds,
the warmth of the sun, the hardness of the chairs, and feel of
the velvet. The nature which is the cause of awareness is the
conjectured system of molecules and electrons which so affects
the mind as to produce the awareness of apparent nature.
—ALFRED NORTH WHITEHEAD, *The Concept of Nature*, 1964

It seems striking that those two major interpreters of Western humanistic and scientific traditions, Blumenberg and Whitehead, similarly invoke a sublime archaeology of unearthing. Making the submerged emerge permits that which is excessive, or mentally beyond reach, to loom into view. This essay argues that what makes the early-modern version of the Sublime still relevant across current disciplinary divides is that it instantaneously integrates what otherwise remains, in Whitehead's apt word, "bifurcated." It does this by exhibiting how those "causes" become attached to, or enter into, our awareness. By the Sublime, I refer specifically to that overwhelming psychophysiological intrusion, which—like love's fury—transiently manages to merge the personal awareness of our affective and cognitive states with the otherwise concealed and impersonal neurophysiological mechanisms underlying them. With our resistance in shambles, we are also able to perceive how this subjective raw experience is actually conjoined with objective nature, that is, bound up with the tormented or roiled topography to which it secretly corresponds.

From Burke to Kant, the notion of the Sublime entailed the sudden and involuntary stimulation of terror and pity, the spontaneous psychophysical reaction of viewers, listeners, and theater audiences to dark, uncultivated, and rugged landscapes, black crimes, and passionate scenes: climbing to the heights of love or sinking into the gulfs of remorse. In this material monism, where mind and matter acted instantly as one, flesh crawled, hair rose, hearts pounded, and tears streamed, without the intervention of conscious reflection.[1] The overwrought universe in which the Sublime operated was hyperdynamic: sensing, feeling, and knowing resulted from an eroticicized gravitational process whereby physical body and material world were pulled together into a resistless conjunction.

Unlike the numinous Longinian Sublime of Hellenistic antiquity, the formulation of the late eighteenth-century material Sublime is predicated on the art and science of the emergence of the submerged: the restoration of what has sunk from view. In the *Peri Hupsous*, Longinus contrasts what he considers to be the rather pedestrian, lowly type of invention that marshals facts into "the whole tissue of the composition," with "the well-timed flash of sublimity" that shatters everything like a bolt of lightning revealing the full and elevated power of the speaker "at a single stroke."[2]

In contrast to this epiphanic apparition, striking from above (and resembling the Enlightenment fascination for exposing and lifting the ruins of vanished monuments from out of the depths of the earth), the modern anguished Sublime is more a material elevation from below. The eruption of novel or rare

Figure 9.1 Charles Doolittle Walcott (*left*) working in the Burgess Shale quarry with his wife, Helen (*right*), and their son, Sidney, ca. 1913. Smithsonian Institution Archives.

cultural treasures (as well as of a sort of cataclysmic insight) from under the lava finds a significant parallel in the material monism of much contemporary neurophilosophy and neuroscience. The neuroscientific collapse of the mind into the brain is mirrored in the mental and emotional confounding triggered by the Sublime. The transfixed beholder—in the grip of nature's *terribilitá*—is transformed into the matter that is entirely occupying her senses.

The nervous system—when overstretched and overexpanded by extreme stimulation—becomes resistless to intrusion. Free access to the viewer's mind and feelings (by someone or something else) arises precisely when volitional attentiveness and emotional control are destroyed. Significantly, the disintegration or ruining of first-person consciousness by a powerful third-person "other" is both a biological and a psychological event: the shattering that perceptibly welds together the brain-mind continuum. This excessive situation can be useful contrasted with Alfred Gell's concept of agency. To be sure, this notion of agency is also relational and context-dependent but always in connection to a "me" who includes other persons, things, objects, even machines, only insofar "as I am a [controlling] agent with respect to it."[3]

In fact, I am arguing that such incursions cause the singular self to become distributed. It is while under the influence of these visual and sensory bursts that we directly *touch* the invisible mind-body, feeling its material oneness, just as the archaeologist palpably experiences the intense merger of past

and present when holding an unexpected find. At that instant, whatever form our "identity" might have possessed a second before now becomes emptied out and filled by some larger or greater force obliterating any illusion of freedom of choice.

Importantly, this rhapsodic aesthetic, as well as neurological condition, embodies a master problem endemic both to the arts and the sciences. The Sublime is nature's brutally material *coup d'état* leveled against the Winckelmannian rule of beauty conceived as rational, spiritual, harmonious, measured, balanced. It addresses that other, agonistic, side of nature and human psychology: the war of turbulent elements, the tragedy of annihilation, the celebration of emotional torment, the darkness of unknowing. Whether considering the obliteration of the self-conscious self—as in the dispersal of our unified awareness into a fractured landscape—or the dissecting of the holistic brain into its modular fragments, the key and still unresolved dilemma is the same.

The question becomes: what could possibly galvanize these heterogeneous components to form a unity—given the absence of any immaterial binding medium? Just as field archaeology puts disparate debris in physical contact with other, conflicting debris, theories of brain localization are predicated on neural parataxis—the setting side by side of discrete dedicated brain regions from whose direct—if mysterious—contact self-consciousness is thought somehow to spring. Does our rich inner associative life emerge via synaptic junctions, neurochemical transmitters, the synchronization of brain oscillations, the creation of a global workspace, the Darwinian dynamics of reentry, or is it merely an epiphenomenon—a persistent illusion intrinsic to our biological machinery that must be ruthlessly reduced to its material parts?

In its modern incarnation, the upwardly directed vector of the ancient Sublime became inverted to feature what was below. For both its charismatic apostle, Burke, and its skeptical analyst, Kant, I believe the Sublime retrieval of traumatic experience was implicitly founded on the model of archaeological excavation. Bringing the distant, the remote, the alien to the surface was the perfect analogue for how nonconsciousness wells up into consciousness. Painfully digging out the remains of Herculaneum and Pompeii from the Vesuvian tufa, or scraping the vestiges of the Colossi of Memnon from the Egyptian sands, exposes cultural artifacts as soiled, that is, always already at one with the matter in which they inhere. And nature, in turn, is exposed as remote and radically material, stretching far beneath the ground. This earthly, performative nature is blindly autocratic, sublimely demolishing anthropo-

centism. Humanity is knocked off its pedestal in a reversal of power relations. As Georg Simmel aptly remarks in his reflection on ruins: it is the wrath of nature that continuously overpowers the works of man: periodically "washing" them of the artifices of paint and patina, stripping them of their metal, wood, or ivory ornamentation, to make those vainglorious artifacts its own again.[4]

Not surprisingly, then, the Sublime finds its objective correlative in the subterranean drama of demolition. It is not accidental that the late eighteenth century was also an era enamored of nested cosmic epics: Dante's multilevel Inferno, Milton's fiery gulf of Hell, Michelangelo's cavernous and scabrous Last Judgement. Grottoes, chasms, holes, cracks in the ground: all these barbaric and fissured "natural" ruins are the antithesis of Winckelmann's holistic, luminous, and Apollonian Hellenism. They fly in the face as well of the placating Picturesque mode—with its praise of pleasing decay, rolling vistas, and life lived on the sunny level.

The Sublime, by contrast, stages nature as catastrophic, peopled not by Classical Greeks or Augustan Romans. Think of Johann Heinrich Fuseli's Iron Age heroes and Eddic rhapsodes, or William Blake's pre–Noachian Flood giants and chorus of Celtic Bards, or the vanished Germanic tribes buried in Caspar David Friedrich's Neolithic tumuli. These mythic figures inhabit an extreme, anxiety-producing environment littered with monstrous jutting rocks, fathomless abysses, and cliffs that fall endlessly away. The viewer of such demonic drawings and violent paintings is plunged into a corresponding state of anxious expectation. The act of beholding is fraught with danger since we virtually mirror, and thus incorporate, that which is intrinsically destructive to our own psychic integrity. The Sublime in art thus unnervingly highlights the phasic and episodic character of identity: that is, the fact that we apparently do not always pay attention as we please. Rather, the conviction of our psychic intactness gets periodically wrecked by self-ruining incursions coming from the outside.

We may well ask what made, and continues to make, this dramatic obliteration of the ego, or emptying out of the cave of the self, so attractive? Like the Romantic longing to grasp prehistoric origins, primordial legends, or irrecuperable myths, the Sublime offered a way to arrive at a radical, pre-epistemological condition anterior to all conscious acts of knowing.[5] As in Whitehead's "unbifurcated" philosophy of organism, a sublime thought is "a tremendous mode of excitement" dramatizing the unity underlying the diversity of the universe.[6] The theory of the Sublime thus goes beyond any simple distinction between the natural and the cultural to foreshadow the mathema-

tician/metaphysican's concept of the "superject." As this futuristic term suggests, Whitehead forecasts the emergence of a new entity under the sun, one capable of overriding the longstanding ontological dualism of subject/object.

The philosopher goes on to claim that when an "actual entity" encounters a "physical datum" and reacts to that thing which is not me, the intrinsically relational nature of all experience stands revealed. Bizarre neologisms notwithstanding, Whitehead is making an important point about the bridging of polarities. Not unlike what happens when one is under the spell of the Sublime, for Whitehead, a particular individual comes into being only when he or she is put in intimate relation with an external event that is radically unlike, and yet like, the experiencing subject. Further, he coins the word "prehension"[7] to indicate how the discrete self can come to contain other spatiotemporal "quanta," that is, how we are able to incorporate mentally and physically the many disjunctive singularities, operating at radically different scales, encountered daily.

Without mentioning the Sublime, Whitehead nonetheless appears to have implicitly understood one of its major contributions to the contemporary intellectual scene. Like its key theorists, he adumbrates a theory of distributed consciousness. Selfhood is a dynamic relational process, and identity possesses a dominant directionality whereby the one becomes many and the many one. The how of the process is what makes it significant. To come together, the experiencing self must be drawn inward and downward, entering into and being penetrated by the otherwise unattainable situation. In the process, the rising hierarchical order of Platonic ascent becomes dramatically inverted.

Recall that what drove the early-modern beholder of rugged scenery, eroded architecture, or melodramatic theatrical performances to bouts of ecstasy was the fact that such deliciously disturbing sights obliterated everything else inside or outside the mind. This possession resulted from being unwittingly and irresistibly forced to attend to something simultaneously outside and inside oneself without the labor of comparative and concurrent reflection. Stunned, the viewer abruptly becomes proximate with the viewed, escaping the constraints as well as the framework of Enlightenment ruminative rationalism.

Phrasing this aesthetic phenomenon in terms of the science of the Sublime: our metabolism appears to drive ideation and not the other way around. The Sublime, defined as a profoundly disturbing and insatiable "enthusiasm," is a good example of embodied "hot thought." The behind-the-scenes

homeostatic adjusting and regulating system gets thrown out of kilter when overstimulated and strongly inflected by events that overwhelm its delicate balancing act. One aspect of current neurobiological research, focused on proving that all thinking is infused by the emotions—running the gamut from cold to overheated and observed at the molecular, neural, or behavioral levels-—has much to learn from our fatal attraction to what is maddeningly unattainable and yet infinitely desirable.[8] In addition, what makes the Sublime of the humanist especially pertinent to that of the scientist is its construction as an undeniable material fact. Conversely, the Sublime is a healthy reminder that more nuanced and subtle feelings do not just hit the spectator but require practice. They are, in fact, the result of social refinements and cultural reiterations.

The apparent naturalness, spontaneity, and convincing sensation of unavoidablility that are characteristic of the Sublime correspond to the intensity with which we are seized by the sensible intuition that the mind is something internal, special, and different from the brain. In this scenario, our first-person consciousness resembles an eruptive separate faculty embedded in our depths—precisely because it so vehemently insists it is so. This phenomenological mode of welding our private and buried flow of perceptions with the atomic continuum of nature represents the attempt to overcome what Isabelle Stengers has called the "radical, proudly exhibited, incoherence . . . plaguing modern thought. Such a conflict pervades all domains where some kind of 'objective explanation'—be it neuronal, linguistic, cultural, political, or social, or economic—may parade as a 'nearly sufficient' condition," ignoring what could escape such explanations.[9]

As Antonio Damasio, Christoph Koch, Paul Thagard, and Douglas Hofstadter (among others) argue, neuroanatomy, evolutionary biology, and cognitive psychology have variously shown how sensory and motor maps that represent the natural and artificial environments they interact with are enriched by ongoing evolution. Such augmentation or energizing by other entities and shifting situations furthers organismal complexity. Paradoxically, this emergent, newly participatory mind also tends toward solipsism since the neural networks recursively begin to speak to one another.

Hofstadter refers to these sets of interacting structures in the brain as constituting "the Godelian swirl of self."[10] That is, what we take to be a deliberative act of consciousness is actually a fluid "dance of symbols" auto-generated deep inside our brain. Like the eighteenth-century proponents of the inevitable automaticity of the Sublime, Hofstadter (following the neurophiloso-

phy of Daniel Dennett) claims we are unable to see, feel, or sense the invisible microforces that underlie either our selfhood or our thought. The "I-symbol" is just profoundly (and sublimely) locked in the feedback loop of human perception. Indeed, he speaks in the anti-empiricist Romantic fashion of Fichte or Schelling. Although our sense organs supply the brain directly, "I remain primarily myself" because "most of our perceptual input comes from our own perceptual hardware."[11]

Hofstadter's sublime "strange loop of selfhood" is reminiscent of the visionary science deployed in Percy Bysshe Shelley's epic poem *Prometheus Unbound*—which incorporated the dynamical ideas of Erasmus Darwin, Joseph Priestley, and Humphry Davy.[12] Like these Romantic natural philosophers, we feel Hofstadter pulling farther and farther away from the surface of appearances, as if his starting point were the extreme, innermost limit of Shelley's celestial "all seeing Circle of the sun."[13] Once the sensory influx has gotten beyond the retina, perception has entered a sunless cave to become wholly an internal affair. In this metabolic underground, the "I" is merely a hallucination, an illusion, mirage, or episodic trick emerging from the autonomous nervous system.[14]

I have been arguing that the lowering of the Sublime—already perceptible in embryo in the late eighteenth-century archaeologically inspired model of unearthing—has become intensified in the downward plunge of much twenty-first-century scientific research. The neurosciences are not alone in favoring a steeply descending infinity. Perhaps this predominant focus on a single plummeting vector—encapsulated in the tunneling imaging probe—owes to the ever-receding vistas of genetics, the spiraling perspectives of the nanoscale world, and, above all, to the compression of information technology. For it is IT that made all this data mining and digging for information feasible. IT's progeny—electronic and digital imagery—is the result of shrinking, compacting, and condensing the cogent image until it vanishes into pixels. In principle, because there are no directions in cyberspace, rampant fears of omnipresent "cyber peril" torment our real lives.[15] How can one feel secure with profoundly embedded "logic bombs" and rogue "botnets" covertly threatening the World Wide Web? These buried intruders, capable of mounting sinister offensives against computational circuitry, are tellingly lodged in a virtual "space" whose sovereignty extends well below visibility.

Analogous to the cybernetic model of plummeting, research into the bottom-up roles of nonconscious perception continues to plunge deeper be-

neath the frontal and prefrontal lobes, probing under the cortical layers into the amygdala, thalamus, hippocampus, insula, and the nucleus accumbens. Left behind, like waves rippling across the face of a pond, is research into the sorts of things that top-down consciousness actually does. I mean research that goes beyond recording whatever happens to be stimulating a particular sensation to asking how these multitudinous sensations are bound into the aesthetic unity of apperception.

Today, what seems to fascinate the neuroscientific community and the popular imagination as well are the roots of impulsive addictive behaviors, the hypnotic images that spring up in dreams during both early and late (REM) sleep cycles, and the subliminal seductions proffered by the electronic entertainment technologies of the blink.[16] Not unlike the Sublime, what all these unconscious behavioral-guidance systems do is instantaneously link sight with its object, bypassing considered thought.

I believe this is the kind of experience Hofstadter refers to when he states that there are patterns imbued with fantastic "triggering" power. Paul Thagard does not extol this automaticity, arguing instead that it is important to evaluate the choices emotion-suffused thinking leads us to make, to distinguish good from bad, productive from nonproductive, decisions. In support of this distinction, he cites Antonio Damasio's analysis of somatic markers (i.e., *covert* emotional signals tied in with previous emotional experience that are spontaneously reactivated in subsequent similar contexts). When somatic markers are passed on to the nucleus accumbens (NAcc), the latter acts as a gateway allowing only context-consistent behavior (as determined by the hippocampal input to the the NAcc) to pass through.[17]

To my mind, this fact highlights the critical need to understand the kinds of patterns that increase, not decrease, our cognitve options. By this I mean what sorts of images summon us up, out of the depths of our recursive and impulsive mechanisms, to further consideration. The larger aim of my book *Echo Objects: The Cognitive Work of Images* was precisely to provide such a demonstration of willed seeing. I argued that brain scientists and neurophilosophers cannot afford to ignore the cognitive work performed by non-illusory and hence non-automatic genres: those that do not simply mesmerize but knowingly engage us.

The repertoire of images currently featured in scientific experiments or mustered in support of scientific hypotheses about brain function must be seriously expanded to include non-illusory patterns of organization. If the

Sublime represents a second step beyond pure, appetitive responsiveness to engage in a fleeting and brusque relationship with the world, Whitehead's "concrescence" would seem to be the logical third step.[18]

The mathematician/philosopher defined this higher vision as one that would entail *knowing* how plural feelings and multiple forms actually crystallize into a cognizable or *faceted* unity. Like the exponents of the late eighteenth-century Sublime, he wanted to get beyond the Humean stringlike contiguity of associationist assemblage to arrive at a form of composite integration.

But, paradoxically, Hume was on the right track. It is precisely in the performance of relationship that congruency-making intarsia unifies self and world, not by overwhelming or swallowing the one in the other. Whitehead, I believe, was searching for just such a revolutionary system of mosaicized planetary order. That sensory, hence aesthetic, order—based on taking the world apart to see what makes it tick and then piecing it together anew (that is, not just giving the "impression" of reality)—is available, I propose, in the long tradition of anti-illusory "inlaid" artistic genres. These compressive, conspicuously seamed formats cut a wide swath in terms of the morphology of their raw stuff: historically, geographically, and in the variety of media they employ as building materials for combinatoric constructions.

To name just a few: recall the courses of blue tiles marching across the Babylonian Ishtar Gate, the floral or scenic wood intarsia lacing Gothic and Renaissance choir stalls, the grotesquely stitched-together emblem whose heyday did not end with Goya or even Manet, and on to Cubism's synthetic collage and Dada's perplexing photomontage. The act of inlaying—which forces us to mentally follow suit—obliges us to lift up out of our internal autopoietic processes and forge a relational selfhood instead. This creative interaction between an existing work and the conscious viewer, who continues to work upon it, produces true co-knowledge. One might say with the Russian Formalists, the viewer *specifies* the distinguishing features that make such a connection formally possible.[19] Unlike the cognitive meltdown instigated by the thunderbolt of the Sublime, the viewer of non-illusory patterns remains cognizant that she is actually fitting organism to world.

Intuitability

10

Strange Shadows/Marred Screens

Shadows Old and New

The shadow of Newfoundland lies flat and still.
—ELIZABETH BISHOP, "The Map"[1]

Lucent screens and the shadowy traces that mysteriously stain their surfaces are as much ambassadors from the twenty-first century as from the early-modern period. Take William Kentridge's somber *danse macabre* video projection for Lichtsicht—relying on simple magic lantern technology—of a South African brass band. Instead of a white wall or fluttering linen cloth, Kentridge's magnified, outspread procession is mapped onto the sublime ten-thousand-meter fortification of the historic saltworks at Bad Rothenfelde, Germany. This, at first (from a distance) neutral-seeming oversize stony banner—recalling the hand-dyed textiles deployed in Javanese shadow plays—presents the starting point for an extraordinary range of dreamlike visions unfurling on a complexly discolored ground.

As accustomed as we are to thin monitors and compressed smart-device displays, this elongated, thick surface doubly shocks. First, by its power to disturb expectations of lightness and, second, by opening up a territory beyond human discourse. As a twice-marred sup-

Figure 10.1 William Kentridge, *More Sweetly Play the Dance*, 2015. Eight-channel HD video, 15 minutes. Installation view, Lichsicht Biennale 5, Bad Rothenfelde, Germany. Photograph: Franz Wamhof. © 2018 Artists Rights Society (ARS), New York/VG Bild-Kunst, Bonn. Courtesy of the artist and Marian Goodman Gallery, London.

port—visually hefting ethically "heavy" images and oozing discoloring min-erals—it reminds us—as its two-dimensional shapes do—that some things cannot be faced head-on.

The lavish, even excessive, stretch of wall (built of spruce and black thorn seventeenth-century timber construction, pitted with congealed petrifac-tions, and wet with trickling brine) echoes—in the manner of all luminescent media—the invisible cognitive formats driving as well as shaping our per-ception of things. As a resonant echo object—a type of mottled mirror—it correlates with our neurobiological affective systems, responsive to awe, fear, shame.[2]

Not unlike the graphic composure and frisson-inspiring wonder of Eliza-beth Bishop's northern map, the inscrutable screen of the saltworks gives rise to emotion that far exceeds its cause. Visually as well as ontologically, shadow presents the intensified "epitome" of an integral shape. An epitome is not merely the shortened or terse reproduction of the principal shape but a novel organization that lays bare its underlying life. It saves us from the mere self-identity of things. Tim Otto Roth's tautly composed *Javanese Shadow Play*, for

example, creates dynamic tension between the gauzy memory of an embodied performer and the crisp conjuration of what is absent as a pared-down, and thus extreme, form. As I've argued elsewhere, this abstracting method is typical of other concentrating projective technologies that keep their descriptive secrets even when meant to be seen in the dark.

Consider again Kentridge's archaically new work at Bad Rothenfelde — that is, a gigantic media installation by a contemporary artist steeped in the knowledge of seventeenth- and eighteenth-century optical technologies. He is a genius at exposing the persuasive "reality" of the unconventional hyperlateral screen with its rough mineral inclusions producing dramatic stains, bizarre iron or gypsum crusts, and streaked limestone deposits (again, Elizabeth Bishop: "The world is a mist. And then the world is / minute and vast and clear").[3]

All this enduring murality paradoxically bears the unreality of diagrammatic portraits and wraith-silhouettes, thwarting viewer expectation. It's revealing to contrast this horizontal weightiness to film's lightness of being, to unspooling cinematic and video phantomization — relying on the painterly manipulation of light and the "brushy" application of color. Abraham Palatnik's misty cinechromatic experiments from the early 1960s spring to mind. So do Robert Seidel's haunting contemporary video projections. In his lyrical

Figure 10.2 Robert Seidel, *Tempest*, 2017. Multichannel video projection on architecture, vegetation, fog, and water fountains. Digital Graffiti Festival, Alys Beach, Florida. Courtesy of the artist. http://robertseidel.com.

Lithops, mutant plants morph into rocks—blooming in midair, as it were—
in front of the sandstone façade of the St. Salvador Church in Gmund, Ger-
many. By contrast, in a recent park-embedded installation, blazes of artificial
lightning and bursts of translucent color explode over the projecting glazed
bays and stone walls of a villa to ignite the reflecting pool and trees. This fiery
phantasmagoria gives the illusion of the real, meterological *son-et-lumière* an-
nouncing the approach of a spectacular storm.

Shadows seem magical insofar as they invite rituals of distillation, of repe-
tition, or serve as provocations for reenactment. They also invite celebrations
of interpretive openness from an audience in search of stable patterns and
customary symbolic forms. Screens, as incitements to excessive display, are
also "existentialist" insofar as they reveal the ongoing tension between un-
ruly graphic surfaces (i.e., animate, resistant material substances) and their
abstracting frames.

Take, for instance, the unintentional strangeness resulting from the clash
between artistic conventions and chance environmental incursions. Consider
a typical seventeenth-century natural history study—say, an illustration of a
capybara from Frans Post's Brazil Sketchbook (1638), which exhibits a sort of
two-world unrelatedness. This eerie disconnection stems from the Dutch art-
ist's awkwardness in rendering space and his short-circuiting of atmosphere.
Despite the charm of the exotic subject, Post's timid graphic overtures are not
convincing as a situated reality, one that rises above the workmanly copying
of an unfamiliar object. Viewing the sheet at length, however, uncovers more.
Something eccentric enters our broadened field of vision. The meager shad-
ows cast by the forlorn and solitary rodent are perceptually overridden by the
saliency of an explosive water stain—accidentally invoking the much-traveled
sketch's dramatic material history.

While this is a telling instance of the engagement, in the Renaissance
and after, with media of recurrence, my larger interest lies elsewhere: with
shadows that upend conventionalized displays through daring, geometry-
challenging appearances. I'm thinking of something like Tim Otto Roth's
Sterea Skia 3—a virtual anaglyphic shadow picture that induces the immer-
sive sensation in the viewer, *not* of standing among the vertical mesh of trunks
in a forest, but rather of hiding within the speckled shadows cast by the trees.

Existential Shadow, or the Fleshly Screen

The point of view in which this Tale [*The House of the Seven Gables*, 1851]
comes under the Romantic definition, lies in the attempt to connect a
bygone time with the very present that is flitting away from us.
—NATHANIEL HAWTHORNE[4]

No less a literary figure than Nathaniel Hawthorne wrestled with marring
shadows and contaminated surfaces — cultural concepts that still deeply reso-
nate. Consider, for example, how an obscure imprint — at once seductive and
dirtying — ambiguates that fundamental normative surface: a woman's lumi-
nous and unpainted skin.

Hawthorne, like his fellow American Romantic-Goth, Edgar Allen Poe,
often depicts states of visual extremity in which the human body becomes a
tender screen minutely registering loss: obsession, blight, fatality (that is, loss
of reason, loss of health, loss of life). Conversely — not unlike the young Primo
Levi of *The Periodic Table* — his tales repeatedly come to the philosophical
conclusion that "in order for the wheel to turn, for life to be lived, impurities
are needed."[5]

Indeed, the obscurantist aesthetics of disease — along with its accompany-
ing pathological tinge, tint, taint — is central to a cluster of Hawthorne's tales.
Think, for example, of the psychoactive botany — that satanic "Eden of poi-
sonous flowers" — running riot in the sinister alchemist Rappaccini's gorgeous
and depraved garden (1844). Here an "adulterous" environment of abomi-
nable plants — dizzyingly perfumed and artificially enhanced — forms the
backdrop to lethal blooms that stamp a "purple print" on the hand of any in-
truder who dares touch them. A writhing death also awaits the besotted insect
instinctively alighting on the sweet gemlike palette of its opioid blossoms.[6]

Or, consider the less malevolent screen of icy glitter whose evanescent
drifts inspire Hawthorne's "The Snow-Image." In this twice-told fairytale
(1852) about two children building a figure out of a substance always on the
verge of vanishing, the initial purity of the medium is transformed into a
dimmed screen. The "delicate print" of Violet's indenting fingers darken the
snow girl's pristine neck and foreshadow her imminent dissolution.[7]

My main interest, however, lies with Hawthorne's allegorical story "The
Birthmark" (1843). I find it an especially rich archive for reflecting on the
contemporary fascination with maculation and on the implacable biology

Figure 10.3 Peter Fischli and David Weiss, *Snowman*, 1987/2016. Copper, aluminum, glass, water, coolant system. 218 × 128 × 165 cm. © Peter Fischli and David Weiss. Courtesy of Matthew Marks Gallery.

relentlessly morphing dark into light. His moral fable reminds us that the neuroethical debates surrounding biometrics — the use of innate physical characteristics (iris, retina, face, fingerprint, odor, vein) to ascertain someone's identity — has as its background the involuntary impulses of Adam and Eve in Genesis.[8] In Hawthorne's surreal philosophical tale, Aylmer, a brilliant organic chemist and pharmacological magus, becomes obsessed with compounding an experimental elixir to remove a grating imprint from the otherwise perfect canvas of his wife's face.

His in no way uncommon attitude toward the lurid blackening of white features belongs to an expansive culture deeply influenced by Lavater's physiognomics of faulty or "peculiar marks." These fibrillations disturbing a smooth screen are central to the Enlightenment critique of muddying skin diseases: smallpox, syphilis, the deceptive "beauty" mark. This inky taffeta patch conceals, while inadvertently highlighting, the grotesque venereal blotch swelling underneath. The fashion for applying such misshapen spots is satirized by Goya who shows it infamously adorning the ravaged face of the depraved Queen Maria Luisa in his *Portrait of the Family of Charles IV.*

As Hawthorne's narrative unfolds, this unique, tiny, physical imperfection grows in the chemist's mind (and his wife's) to monstrous proportions, obscuring the otherwise "faultless" beauty of her radiant skin. It becomes the visible token of an invisible stigma: the murky emblem of original sin, of inevitable physical and spiritual corrosion, the disquieting sign of alluring fallen flesh.

> In the center of Georgiana's left cheek there was a singular mark, deeply interwoven as it were, with the texture and substance of her face. In the usual state of her complexion — a healthy though delicate bloom — the mark wore a tint of deeper crimson, which imperfectly defined its shape amid the surrounding rosiness. When she blushed it gradually became more indistinct, and finally vanished. . . . But if any shifting motion caused her to turn pale again, there was the mark again, a crimson stain upon the snow.[9]

This spoiling "tiny hand," impressed by an unseen nature on a unique living countenance, prompts Hawthorne to devise a set of telling analogies. First, to art: to call Georgiana's luminous face blemished, the narrator claims, would be as reasonable as to say "that one of those small blue stains which sometimes occur in the purest statuary marble would convert the Eve of [Hiram]

Powers to a monster."[10] This remark, again, reflects the longevity of the Neo-classical ideal of porcelain skin, that ethereal surface doomed to register any material attack.

Then, second, to a godlike laboratory science and its arrogant claim to correct the "fatal flaw of Humanity." Decomposing and recomposing sub-stances into a new unified structure demanded not only mechanical but artistic genius. The Romantic era popular science lecture accustomed both audience and performer—as did the watercolor visions of William Blake—to isolate a singularity and thus fix a volatile particular of the universe. Such far-ranging combinatorial "popular recreations" also did much to shape an active model of the creative mind (such as Aylmer's) whereby the imagination was jolted by powerful sights—much as the body was shocked by the inscru-table electric power of a voltage battery or the inescapable effect of an alarm-ing sight.[11] But the greatest danger of a confounding chiaroscuro was that it might impress itself upon the delicate fibers of the female mind and deform the impressionable fetus. Recall this famous passage from Jorge Luis Borges, "The Total Library" (1939):

> One of the habits of the mind is the invention of horrible imaginings. The mind has invented Hell, it has invented predestination to Hell, it has imag-ined the Platonic ideas, the chimera, the sphinx, abnormal transfinite num-bers (whose parts are no smaller than the whole), masks, mirrors, operas, the teratological Trinity: the Father, the Son, and the unresolvable Ghost, articulated into a single organism.

Aylmer's one thought is to engage in tireless experimentation in order to erase this besmirching "deformity," this "visible mark of earthly imperfection." Clearly, more than aesthetics is at stake: this defilement awakens the existen-tial fear of chemical and spiritual affinities, the terrifying possibility that the mark on the pale complexion "goes as deep as life itself." Aylmer thus sees an inherent wickedness in our primordial origins, one still reflected in the sinful internal seat of existence, that post-Edenic most extreme of fleshly screens.

Hawthorne's third analogy evokes the magic lantern's ghostly proces-sion of "absolutely bodiless ideas": To divert Georgiana "from the burden of actual things" during her recovery in the sumptuous sunless apartments and sedative-suffused ambient Aylmer designs for her, his magical mechanical science unleashes entertaining "forms of unsubstantial beauty." A burning "pastille"—its intoxicating aroma penetrating heavy curtains "falling from

Figure 10.4 Nineteenth-century magic lantern "slipping" slide of a girl skipping rope.

ceiling to floor in ponderous folds"—creates an intimate panoramic screen "by appearing to shut in the scene from infinite space." Then, "with perfumed lamps, emitting flames of various hues, but all uniting in a soft, empurpled radiance" these purely optical illusions "came and danced before her, imprinting "their momentary *footsteps* on beams of light."

On one hand, such ghostly appearances are delusory ephemera, mere magic lantern mist that "flitted across a screen." Such apparitions seem perfect representations but with that "bewitching yet indescribable difference" that always makes "a picture, an image, or a shadow so much more attractive than the original."[12] On the other hand, these shadowy "footsteps" across a glowing screen are instances of Paradise lost, of a tainted, sinfully sensuous "external existence"—like that intimated by the sullying birthmark. Casting shadows thus becomes an analogue for Georgiana's mortal scar, thrown by Providence onto an exquisite screen of dewy flesh. This powerful image of ruthless decay recalls Blake's sick rose: Its velvety "bed / Of crimson joy" harbors the sinful rot lying at the core of being.[13] Existential soiling thus becomes the sublime metaphor or fateful code for something secret yet authenticating—destructive and dark—hidden below otherwise unbroken skin.

From Mortal Stains to Biomarkers

> No, the greatest pleasures of the flat fell into that category of the ineffable
> to which I have already made a reference: it felt as though people had been
> happy there. As though, like sweat, or perfume, that happiness had suffused
> the upholstery and misted upon the surfaces; or, like lint, as though it lurked
> unreachable in the undusted corners.
>
> —CLAIRE MESSUD, *The Hunters*[14]

Claire Messud memorably evokes those furtive odors and secret motes that
rise from once-potent furnishings to reawaken past sensory experience.
These dulled interiors still exude exhalations, the now vaporized atmospheres
shrouding moody decor and vanished bodies. Think of Daniel Goldstein's
highly personal response to the HIV/AIDS pandemic both as an activist and,
materially, in his artwork. *Invisible Man*, for example, with its eight hundred
syringes and flashing red crystals suggests riverine droplets of blood perfus-
ing thinned skin.[15] But with no person attached, the apparatus becomes a
brooding symbol for the nearly not there, for the onset of imperceptibility, for
the legions of individuals who sank out of sight.

No work affects me more, however, than the ghostly stigmata of his
Icarian series, an anguished archive of brown leather workout-bench covers
("the relics of his generation")—collected by Goldstein over a twenty-year
period—from gyms frequented by gay men in San Francisco during the 1970s
and 1980s.[16] Still redolent of the briny tang, the secreted musk of their living
and breathing source, the oiled or acidic penumbra of long-vanished male
bodies stamp themselves into our consciousness.

The artist compels us to stare hard into this marred space filled with clouds
of scratched, scarred, or blistered skin, pitted craters of flesh, and scabby welts.
These carnal as well as poetic prophecies of oblivion arouse intense feelings
of human connectedness, flooding the viewer with endless longing and sim-
mering remorse. Such diminishment evokes other strange shadows that can't
be seized, that can be indicated only through their darkening remains. Saul
Bellow (in a 1957 essay about Native American people) similarly strikes a note
of foreboding when he surveys the large-scale drift of an entire race into the
void: "They have left their bones, their flints and pots, their place names and
tribal names and little besides except a stain, seldom vivid, on the conscious-
ness of their white successors."[17]

In the context of today's "social genomics revolution," the human face

Figure 10.5 Daniel Joshua Goldstein, *Icarian II/Incline*, 1993. Leather, wood, felt, acrylic, sweat. 73 × 37 × 6 inches. Collection of Richard Gere. Courtesy of the artist.

and body—considered either as a flat, artificially manipulable surface or as a descending series of physical strata reaching down to the nano scale (recall Hawthorne's quest for "the internal seat of existence")—are the intense focus of at least three biological-improvement industries: plastic reconstructive surgery, interventionist gene therapy, and neural identity authentication.[18] The latter two concern me here with their maze of unspoken assumptions about the beneficial intersections of natural growth processes with synthetic biology and the invisible merger of brain-function with reaction-detecting devices.

This glide into an enticing unknown waiting to be materialized belongs to our culture's behind-the-scenes push-technologies: always wanting to push further.

These foggy "new screen mythologies," imbued with futuristic faith in scientific progress and human perfectibility, still seductively promise to identify and rid our postnatural world of its somatic eyesores—eradicating them through the creation of untarnished surfaces as well as unblemished depths.[19] In the case of biometrics, a new wave of neurotechnology heralds not only the penetration of the brain's most intimate performances, but the temptation to use personal brain data commercially—searching for damaging private information or criminal tendencies, and identifying the stimuli that goad individual impulsivity—all without the consent, or even the knowledge, of those being analyzed.

As for the use of DNA as a corporate commodity, consider the potential nightmare of CRISPR (Clustered Regularly Interspaced Short Palindromic Repeats) becoming just one more expensive biological product. CRISPR comprises DNA sequences found in bacteria that help ward off virus attacks. Neuroethicists are worried in particular about Cas9—an enzyme produced by the CRISPR system that is now widely used to cut and edit DNA in a test tube (and could do so in the wild). Biochemist Jennifer Doudna, in a recent book, frighteningly claims that her laboratory's work has the potential to make an organism's DNA "almost as editable as a simple piece of text."[20]

The promise here as elsewhere is, once again, improvement, the removal of flaws, defects, unwanted disfiguring effects by altering, inserting, and deleting genes from small to vast animal populations. (One such proposal concerns the white-footed mouse, a host for the deer tick—or, rather, the tick's immature nymphs—which has spread Lyme disease to humans up and down the eastern seaboard and now the Midwest.) Inevitably, the stakes continue to be ramped up. Given the discovery's lucrativeness and the onset of patent battles, the question arises of whether to permit human germ-line editing— changing sperm, eggs, or embryos as a means of removing destructive genetic mutations.

Where is the public discussion before these hypotheses become reality? And what is to stop the science-fiction scenario of future editing/breeding— for greater intelligence, for blond hair, for a clear complexion, for a sanguine temperament?[21] It seems Ovidian metamorphosis has returned with a vengeance. Technology-armed experimental scientists not infrequently assume the role of the Roman poet's capricious gods. Geneticists, in their behind-the-

scenes efforts, increasingly resemble Zeus, concealed inside a cloud, turning the Titans into stone, Orion into a constellation, Arachne into a spider, Leda into a swan.

Shadow Mythology: The Strange and Subtle States of Matter

If we accept the view of complete symmetry between positive and negative electric charge so far as concerns the fundamental laws of Nature, we must regard it rather as an accident that the Earth [and presumably the whole solar system], contains a preponderance of negative electrons and positive protons. It is quite possible that for some of the stars it is the other way about, these stars being built up mainly of positrons and negative protons.
—ANIL ANANTHASWAMY, *The Edge of Physics*[22]

Until quite recently, organization primarily meant geometry. And geometry still rules in the study of entoptic phenomena as well as in abstract art forms fascinated with tessellation, moire patterns, grids, mosaics, paper marbling, and fractals, among other repetitive patterns. An important link between past and present geometrical systems is current research into synesthesia, hypnagogia, migraine, and other altered states—ranging from divination (especially crystal-gazing) to near-death experiences to opiate ingestion. It's significant, then, that the biological nature of William Blake's crystalline "visions" has undergone new analysis in the context of developments in the neuroscience of hallucination. David Worrall argues that many of Blake's visual images in his paintings and illuminated books provide evidence of the retinocortical mapping of entoptic percepts. That is, Blake would have "seen" his "visions" as a result of propagations from the hyperdynamic screen of his networking primary visual cortex. Worrall reasons that these coalescences and dream-like assemblages—compellingly manifest as if thrown on a screen—were probably the consequence of an early onset experience of migraine with aura. Later, they appeared in association with hallucinations evincing the percepts of Kluverian form-constants (lattices, honeycombs, cones, spirals).[23] Despite his scorn for Newtonian rationalism, one wonders if Blake's great intuiting powers and predilection for geometric figures—think, among many examples, of the glowing central spiral set against the nocturnal background of his *Jacob's Ladder*—are form-constants as well.

Picture, as the French eighteenth-century founders of the science of crys-

tallography did, the neat lattice in a crystal of table salt and the more general influence of the crystalline as an Enlightenment compositional principle. In Paul Dirac's compelling picture of a symmetrical universe (alluded to in Ananthaswamy's epigraph above), however, a strange new elusive dimension emerges. In his Nobel lecture (he and Erwin Schrödinger were jointly awarded the 1933 prize for physics), antimatter was envisioned. This turned out to be one of the strangest predictions of the so-called Dirac equation. Dirac inferred the existence of a particle like the electron but carrying a positive charge—a shadowy *double* to matter that should have vanished after the Big Bang yet, tantalizingly, might still exist in other galaxies. Add to this puzzle the other, and perhaps, greatest darkness in our light-shot cosmic system: dark matter. Apparently visible stars, gas, and dust are a mere fraction of the universe's total mass. The remaining unseen mass emits no light. Like a gigantic silhouette whose contours do not touch its volumetric object, this vast unseen mass barely interacts with visible matter.

In light of the visionary ideas recently put forward by Nobel laureates David Houless, Duncan Haldane, and Mike Kosterlitz, contemporary physicists now routinely recognize that organization can be subtler, composition more elastic, structure more nebulous than previously imagined. Our commonsense view is that the absence of light should present itself as unmoored blackness—an experience akin to floating in a sensory-deprivation tank. In cosmological terms, the Void is space that is as empty as imaginable. Yet "the Void" is not really nothingness since it contains our shadowy twentieth-century fields—Faraday and Maxwell's electromagnetism, joined now by phenomena like the Higgs field. As those fields settle into equilibrium, emitting their obfuscating mists and vapors, "they liberate energy, which powered the Big Bang and gave rise to reality as we experience it."[24] Even in older systems like chemistry—witness Nathaniel Hawthorne or Primo Levi—there were disruptions and opacities calling attention to the ways that matter "ancient as the All and portentously rich in deceptions" only periodically conforms to the scientist's ideal of mathematical "elegance."[25]

My guess is that the artificial correlative to the cosmological blackness of the Void is Vantablack. It has been described as the darkest man-made substance. This is a coating developed for calibrating "black-body" systems that apparently absorbs almost all of the light that strikes it, "produc[ing] startling optical effects; when it's applied to a three-dimensional object." [26] The magical ability of this substance to create flattening optical illusions on a reflective

Figure 10.6 Diana Thater, *Male Gyr-Peregrine Falcon (Grim)*, 2012. Flat-panel monitor, DVD, DVD player. Dimensions variable. Installation view, *A Beautiful Darkness*, London, October 28, 2015. © Diana Thater. Courtesy of the artist and David Zwirner, New York/London/Hong Kong.

spherical surface, as well as its quasi-mythical darkness, makes it attractive to contemporary artists interested in a black-box universe that is otherwise opaque to ordinary human understanding. Anish Kapoor, notably, has used Vantablack material in a number of deep-cave sculptures that, not surprisingly, evoke E. M. Forster's fictional Marabar (really Barabar) caves in the state of Bihar, India.

This extravagantly saturated hue captures the aesthetically extreme existential blackness of Forster's bird- and bat-echoing live-rock chambers with their exquisite pink granite shadings and gray nebulae. (For an analogous contemporary experience—both hypnotic and threatening—one might conjure up the still or rustling raptors enshrined within Diana Thater's exhibition *A Beautiful Darkness*.) In Forster's novel *A Passage to India* (1924), the polished, match-lit walls induce hysteria by mirroring darkness to infinity. These psychogenic screens magnify the fears and desires of the visitor, who feels imprisoned within a deathly architecture that opens, indifferently, onto an eternity of organic mutations. In these self-obliterating caves, the neurasthenic Mrs. Moore—like the dragon-father of the chthonic monster Grendel

Figure 10.7 Use of 3-D imaging to see a fourth dimension. 3-D print and photograph by Henry Segerman.

in the early English epic *Beowulf*—is suddenly possessed of a wholly different kind of mind. She experiences the ultimate dark side: a terror so deep "we see in one instant a passionate vision and the blowout."[27]

Shadow, in contrast to hallucinatory Vantablack, is more nuanced, more humane, while nonetheless proposing that nature has a bizarre, recondite side. This oddness is currently being made apparent through digital printing and mathematician Henry Segerman's novel use of shadows from 3-D objects to visualize a fourth dimension. Clean geometric contours and sharp edges get cunningly crushed and yield non-resembling shapes that call into question what is surface, what is depth—or indeed, what is object, what is screen.

And what about the dark energy of the brain, that still mysterious force residing in our material bodies about whose exact nature we remain unsure? If the great percentage of the mass of galaxies is made of unseen and unknown matter, what can be said about neuroscientists' efforts to understand the brain-mind from a small fraction of human experience? In an installation for the Freud Museum, London, Gavin Turk graphically evokes a difficult-to-define theory closely related to the Viennese psychoanalyst's ideas about

the unconscious. More in line with the attractive or repulsive forces endemic to our expanding universe than with hard-edge geometries, hazy, relation-questing *Parapraxis* (2013) forms the subject of Turk's dramatic large-scale photograph hung above Freud's notorious couch. Plumes of feathery smoke act as the visual analogue for the intuitive tendency to associate muffled patterns and dilating forms with something real, concrete, and familiar—much in the same way as we do with the blue luminescence of dreams.[28]

This associative tendency to reformulate feelings and events from stored knowledge has received a compelling update from the University of Edinburgh cognitive scientist and philosopher of mind Andy Clark. Recently, he has turned his attention to the emerging neurocomputational study of predictive processing. This approach looks at the brain as a multilevel, multi-area engine that uses continuously self-generating prior information to interpret the incoming sensory stream. Crucial for understanding the relation between top-down prediction and bottom-up sensory evidence (when all goes as it ought) is what I identified in my book *Visual Analogy* as the constant weighing, adjudicating, or balancing act going on between two opposing systems. What Clark adds to the equation is the hypothesis that when too little weight is assigned to the sensory aspect of experience, hallucinations of patterns that are not there result (like those occurring in the nocturnal shadows of the Marabar/Barabar caves). He makes a convincing case that auditory, olfactory, and visual delusions occur because we strongly anticipate or predict them. In fact, he argues, we exist in an abiding state of hallucination.[29]

I want to challenge this claim by asking, doesn't the surprise of art, the stun of love, the shock of stain put you in the presence of the real thing? It seems to me that, because of the velocity of the sensory impact and the flare of the unexpected, these breathless occasions allow us to come face-to-face with the raw and the unpredictable. As Australian writer Helen Garner says of the psychophysical power of *eros*: "the quick spirit that moves between people—quick as in the distinction between 'the quick and the dead.' . . . It's the moving force that won't be subdued by habit or law."[30]

Shadow—as both arresting structure and dramatic style—is capable of provoking this phenomenological rush of aliveness, directly materializing object properties that otherwise remain unexperienceable. Light is never enough; it takes contrastive darkness to make it startling. Yet, as in Clark's hallucinatory metaphysics, shadow can also transform an apparently unadulterated signal or a glaring sensory experience into an intimation of beclouded data—to information always dimmed by expectation.

Figure 10.8 Gavin Turk, *Parapraxis*, 2013. C-type print. Courtesy of the artist and Live Stock Market Ltd.

Shadow thus shadows both the how and the what of cognition. If it's beguiling to think shining light into obscurity yields unclouded truth, it's refreshing to recognize the myth of the perfectly clear. Lingering, instead, with the mysteriously overcast and the inscrutable uncanny not only makes luminous images vivid and concise but surprising and unfamiliar—something penumbra-loving artists have long intuitively known.

11

Thought Gems

Inferencing from the Impersonal Crystalline

Perception and Agency

The idea from the cognitive revolution that the mind is a system of universal, generative computational modules obliterates the way that debates on human nature have been framed for centuries.
—STEVEN PINKER, *The Blank Slate*[1]

Stones are alive where I come from.
—A. S. BYATT, "The Stone Woman"[2]

Clearly, colored stones do not possess what neuroscientists and neurophilosphers call "consciousness"—the still baffling phenomenon in which, as Susan Greenfield succinctly puts it, "the water of brain functioning is converted into the wine of subjective experience."[3] But not unlike viewing pictures—of which the Argentine fantasist Adolfo Bioy Casares writes—gazing into precious and semiprecious gems causes "new objects" to appear "in an endless succession."[4] The magical realist is not referring just to the filmic stimulation of the eye. As Carl Jung makes clear in his study of the "psychification" of rocks across world cultures, "dead matter" everywhere seems imbued with life.[5] We routinely say that stones stand,

fall, heave, mound, rush. Lava flows, glaciers are gravelly, silt becomes crusty, clay dries into mosaic, sand compresses into boulders. Formerly organic substances change into inert solids while durable solids disintegrate into shifting heaps.

The question I propose is, do gems have agency? Do they incite the brain to infer the existence of a hidden order inside the reflective mass? Are actual transformations of substance possible (as Ovid believed)? That is, does their structure provoke mentalizing (theory of mind) and are they in some way "minded" (tending toward something)? As Steven Pinker states, it's the combinatorial modular organization of the brain (i.e., the brain as crystal) that generates an unlimited set of thoughts and behavior. What is it about crystal-chunking that encourages inferencing from the seen to the unseen, generating intense emotional and hypnotic states? Is there something special about such compressive modularity that synchronizes our inner situations with outer realities? If so, the eternal allure of gems consists in more than reward-system response to consumer-flash.

Holding Light/Capturing Color

> Original forms. Solid ideas.
> —JOYCE CARY, *The Horse's Mouth*[6]

Spring 2017 arrived dramatically with Sotheby's announcement of the sale of a polished pink rock for a record $71.2 million dollars. Not your typical colored bauble, the gigantic 59.6 carat Pink Star Diamond now ranks as the world's most coveted gem.[7] While the media focused on its lavish price and couture desirability, scientists noted that it was not only glamour that rendered such supremely hard stones important. For physicists of light, the diamond's beauty lies in its amazing ability to slow things down—especially the fastest cosmic phenomenon of all.

Not only is light refracted as it enters, traverses, and exits the diamond, twisting and turning such that opposite facets sparkle; its speed slackens, to 41 percent of what would occur in a vacuum.[8] The Pink Star's rosy cast owes to the diamond's unusual underground formation. Apparently, enormous volcanic pressure produced a minute shift in the crystalline structure, and its unique blossom-hue is the visual signature of this invisible organization,

Figure 11.1 Hawaiian lava flows. © Basil Greber.

Figure 11.2 "Pink Star," 59.6-carat diamond. Vincent Yu/AP.

the way striking solid wood or porous rock reveals the acoustic interior by making "it sing its structure for all to hear."[9]

The miracle and the mystery is that light—as it drives into translucent crystal—does not go straight through but swerves. The subsequent twists and turns of refraction mean that the greater the change in light's speed during its progress downward, the greater the change of its direction.

A similar internal splintering of signal affects myriad other systems that "scale" or relate across very different quantative and qualitative domains. Consider a solar cell, where light goes in and current comes out, or, conversely, an LED (light-emitting diode), where current goes in and light comes out.[10] Both sides of this phenomenon are simply captured, for example, in Olafur Eliasson's Little Sun Diamond. Simultaneously useful (providing individual night light to thousands in Tanzania and other African countries) and attractively designed to be taken everywhere (fitted both with a lanyard and an integral stand), it is a solar-powered piece of sunshine—scaled up from a jewel and down from a furnishing. Consider, too, a related problem involving scale: the staggering traffic problem caused by a hundred billion neurons and a hundred trillion synapses oscillating in our anatomically clumped, yet networked, brain. Picture a stored, then retrieved, signal—erupting into consciousness after multiple cortical crisscrosses—then exiting into the world bright with a uniquely subjective slant.

Not just rare diamonds but other gorgeous jewels are remarkable in allowing us to touch and attend to what is otherwise intangible, imperceptible. These gems are embodied behaviors in light and color: the vibrations and emissions of multiple different wavelengths. Possessing different densities and opacities, gems require that the Newtonian rainbow traverse them at different speeds—from lingering violet to strident red, with the rest of the spectrum hastening between.

When it comes to dramatic celestial events and historic attention paid to the vagaries of light, I think of the solar eclipse whose cone swept across the United States in August 2017. Rosemarie Fiore's *Smoke Eclipse #52* (2015) is literally composed of layers of residue from fireworks smoke deposited on paper in glowing disks suggesting planets and orbits, along with sunspot-like burn marks. As a performance piece as well as a real chromatic presence, the work resembles both the translucent depths of a color photogram and the irradiated volume of a golden/viridian topaz. Importantly, the human brain is habituated to such shiverings, dancings, or "doings" of color—the slowing

and swerving of light—until these wayward energies, taken in by our eyes, become molded by the perceptual and motor systems into a unified experience.[11]

This optical distortion of seemingly imperturbable reality (i.e., the bending of each ray at fixed angles) invites inferencing, the intuiting of an invisible agency operating inside the stone. Color, like sound or scent, is thus a creation of the brain—spontaneously seeking to impose structure on random waves and chaotic particles as they impinge on various bodies descending the scale of creation. Giulio Tononi terms this conjunctive process "phi" (the fact, for example, that color cannot be perceived separate from shape) and identifies consciousness with the amount of integrated information in the brain.[12]

Gemstones are an exceptional instance of integration precisely because they are "lapidary": a physically and perceptually concise mass. But they are not alone. Think of the conceptual/affective impact of Ernest Hemingway's use of "monosyllabic" words or Paul Cezanne's watercolor sketches and oil paintings employing the cabochon-like patch (irradiated color + space + time). Whether literary or pictorial, these artists' work is marked by an eliminative structure of intelligible nuggets.[13] Writer and painter create their intense, attention-arousing effects through gemlike brevity—with passage work moving from one pattern or shape into the next—resulting not only in verbal or painted eloquence, but mystery. Intensification diminishes swerve, creating the magical synchronicity of sensing the whole (surface + depth) directly.

Scattering Stones/Thinking in Bits and Pieces

> Life on earth . . . constitutes a remarkably thin glaze of interesting chemistry on an otherwise unremarkable, cooling ball of stone.
> —PETER BRANNEN, *The Ends of the World*[14]

According to scientists, when you hold a diamond, you are holding a piece of light. Lithic debris contains traces of our universe's apocalyptic origins. Meteorites are echoes of the "Great Dying," the mass extinction that occurred at the end of the Permian period, 252 million years ago, when an asteroid crashed into earth. What can such palimpsests of violent planetary history mean to our tactilely bereft era—rife with screens and swipes and the outsourcing of physical contact?[15]

What material is better suited than stone to carry within at least a hint
of incorruptible dignity, of permanence, yes, of eternity? Stone—removed
from the dizzying shifts of time, freed from all weakness and all life. . . .
The most ordinary pebble will survive infinitely longer than every realm
and every conqueror, will lie peacefully in the shadow of a crevice or in the
soft clay floor of a cave long after all the palaces of an empire are in ruins,
their dynasties rotted.[16]

Scaling our focus down: what can this vast pavement of colored stones tell
neuroscientists about our intuitions of the numinous?

Sand, near the ontological bottom of the mineral kingdom, ranges from
the most common granitic, quartz, silica, gypsum, or glassy natural aggre-

Figure 11.3 Liz Barber, *Summer Song 1*. 2018. Mixed media on canvas. 48 × 48 inches.
Courtesy of the artist.

gates—mountainous, marine, or molten volcanic sands—to mutable landforms composed of crushed shells, granular dolomitic marble, and pulverized Australian or Indian garnet.[17] Although a humble substance in terms of organization and magnitude, shimmering sand is a primeval and globally dispersed type of light-shot volumetric color. Despite its tiny chromatic mass, it foretells in a nutshell the evolution of outsize gems and miragelike illusory images (whose recent instantiations include holography and virtual reality). Lowly sand thus offers additional proof that beauty, not just Darwinian adaptation of the fittest, drives both natural and artifactual evolution. This argument-from-beauty was recently made for birds by Yale ornithologist Richard O. Prum, citing, for one, the satin bower bird adorning its nest solely with royal blue bits and pieces.[18]

Might such seemingly nonadaptive, creative traits not only form the cognitive ethology of astounding birds but extend to artificial entities (AI, AL)? Or, as the Ovid of the *Metamorphoses* thought, descend to the impersonal shaping power of the very stones? Christoph Ransmayr, in his wonderful evocation of the life and work of the great Augustan poet, Publius Ovidius Naso (43 BC–17 or 18 AD), traces his exile from Imperial Rome to the rock-strewn wilderness of Scythia (present-day Romania). While wandering above the Black Sea, Ovid—in his never-completed *Book of Stones*—meditated on amber hunters, brook emeralds, pooling opals, and the monolithic menhirs rising above steep ravines. Tattered banners fluttered atop the monumental cairns—alive with snails busily reanimating dead matter. Their gelatinous ooze blurred the figured mineral surfaces inscribed with remnants of his revolutionary poetry, prophetic visions of our earth's convulsive creation and evolution. Imagine, then, this metamorphic scenery composed of stained scatterings of morselized poetry glinting, moving, crawling across a fractured panorama of postdiluvian ruins.

I think of Ovid's fantastic scene when looking at Icelandic painter Eggert Pétursson's energetic "world of lava." In 2011, Pétursson began exploring the scorched fields around his summer cottage in Uthlid. Eventually tiring of them, he moved further up the mountain of Bjarnafell with its patchwork of ravines, mosses, lichens, ferns, and pristine light. Interestingly, in these maplike aerial images, it seems as if the viewer is looking down into a blackened caldera, gazing into an emergent iridescence, an enveloping primeval landscape of stone, water, flowers.[19] Pétursson's shimmering paintings conjure up A. S. Byatt's sculptor Thorsteinn Hallmundursson and his gleaming marbles. This change artist of facets, chips, and rubble explains to Ines—the woman

whose diseased white flesh is slowly metamorphosing into opal, geyserite, labradorite, barite, fluorspar, azurmalachite, carnelian, serpentine, and other "winking gemstones" — that turbulent "Iceland is a young country." It, too, is a dynamic site where the organic continually meets the inorganic. In "our land the earth's mantle is shaped at great speed by the churning of geysers and the eruption of lava and the progress of glaciers." Hallmundursson continues: Icelanders live like lichens" clinging to rolling, rattling, and flying stones.[20]

The Last World—Ransmayr's novel about Ovid's famous book of trans-formations—also demonstrates how men and women might turn to stone or how, for animals, "petrifaction was the only way out of the chaos of life."[21] In his trenchant retelling, the Austrian writer recounts Ovid's central origin myth of Deucalion and his wife Pyrrha tossing pebbles behind them after the cataclysmic Universal Flood. From these flung stones sprang a new race:

> And human beings rose up out of the morass, a host from every pond—
> a brood of mineral-like hardness, with hearts of basalt, eyes of jade, with-
> out feelings, without a language of love, but likewise without any stirrings
> of hate, sympathy or grief, as implacable, as deaf and durable as the rocks
> of this coast.[22]

The cognitive science of religion—inquiring into our social interactions with gods and their manifestations—has much to offer contemporary jewelers. While cognitive psychologists study the humanly anthropomorphic, an Ovidian "pro-miscuous anthropomorphism" revises the borders of the psychological.[23] Ovid tapped into a rich tradition of animism attributing agency to trees, animals, rocks, minerals. This transformative anthropomorphism assigns mental agency as well—the sympathy and antipathy of charmed stones, the attraction and re-pulsion of metals, the dazzling combinatorics of the multifaceted solitaire.

Today, the explosion of technological artifacts and the meltdown of genres and media call for a new defense of the generative power of art objects— not only as configurational but as cognitive.[24] Jewels as chromo-haptic ma-terials place a premium on seeing-as-sensing. In a predominantly visual age, they awaken the imagination to touch, to color-volume, to the unknown that seems to hang in the air inside the reflective stone. Yet the neuroaesthetic medium of thought gems has still to make its grand cognitive debut. The urgent project at the moment is not fashioning more stuff for our addictive re-ward systems; it's understanding how thoughtfulness can be brought out like the lights and shadows in a crystal, the design growing in transparent depths.

12

The Jewel Game

Gems, Fascination, and the Neuroscience of Visual Attention

I begin this essay on visual attention with a personal story, one that I believe relates to the neuroscientific problem of identifying the ways in which the brain selects what we want to see. Each time our gaze strikes a surface a small miracle occurs. That which was nothing becomes something for a few moments, and then nothing again once our gaze is averted. In particular, looking at jewels can push everything into the pinhole of the moment, making us aware that we are aware, integrating the mind with the body at a particular instant in time, while simultaneously incorporating the nonhuman world into our inmost being.

Flow, the cognitive psychologist Mihalyi Csikszentmihalyi remarks, is that mental state when we are so involved in an activity that nothing else seems to matter. Objects in this scenario are scaffolds to support moments of reflection. The present is extended indefinitely, prolonged until it is broken or interrupted. His observation takes me back to one of my earliest memories of my mother: I am a little girl sitting at her knee in a darkened room in Fort Monroe, Virginia. It is 1947, and we are peering into a leather jewel box. She and I had immigrated to the United States from war-torn Vienna with my stepfather. During the often-repeated ritual of opening and closing this box—a veritable memory palace—I relive her past experiences

as if they are mine in an intense intimacy that will never come again. We sit alone. She weeps and speaks low in German of things I cannot understand as she fingers a brandy-colored topaz necklace, a square-cut aquamarine ring, a floral spray of diamonds. Seeing and doing is undergoing. Old joys and pains are repurposed by dint of pondering and paying close attention.

My mother, now dead, lay, demented for several years, in a nursing home. I remember her also there: when she speaks it is a muttering mixture of English and German and, increasingly, strange words of her own devising. On my visits, I bring bright baubles and jingling trinkets and always try to wear something she will desire: a brass belt with inlaid glass stones, a rope of resin beads, a metal cuff. She reaches out smilingly and strips me—no doubt seeing in this faux finery a Brazilian mine of amethysts and smoky beryls, a pellucid ocean of Japanese pearls. Miraculously, in a cognitively darkened world, where all other meaning has fallen away, jewels still attracted her attention and remained somehow comprehensible objects. If dementia of all kinds is often accompanied by difficulties with depth perception, translucent gems—because they invite close examination and collapse near and far without confusion—allow the viewer to distinguish their liquid depths from their reflection-patched surface, as my mother's evident delight demonstrated.

A major neuroaesthetic question then: why, when all else, mentally speaking, is gone, do we still notice mirroring crystals or translucent gems? I propose it's because their brightness and shine so fundamentally engages our awareness that whatever is left of self-consciousness comes to the fore as a momentary, but total, involvement in the present. Turning now from the realization that individuals—whether for ill or well—inhabit incredibly rich inner worlds that get triggered by special objects, I raise a related question. How does your brain work, for example, to locate a coral necklace in the tangled depths of a jewel box or discern a broken bead of yellow amber on a gem-cluttered baize table in a darkened room? The perceptual/conceptual problem is not unlike singling out the punctured bubbles in a sheet of ghostly plastic drifting in an aquamarine ocean (captured in Hrafnkell Sigurðsson's photograph *Revelation*). Or, try to spot the iridescent radiator bars in Yayoi Kusama's chromatically explosive *Obliteration Room* (2002).

While Rudyard Kipling's metaphysical spy story *Kim* (1901) is about many things in colonial India, it is fundamentally about the arduous training of visual perception. Significantly, jewels and gems play a critical role in Kipling's informative account of a relentless education of the senses. Consider this passage evoking the dim curiosity shop in Simla run by the top British

Figure 12.1 Hrafnkell Sigurðsson, *Revelation IV*, 2014. Archival pigment print. Courtesy of the artist.

spy master Lurgan Sahib, where the young boy Kim has gone to sharpen his visual acuity and so too become a spy. Kim muses that while his native Lahore Museum was larger, here there are more wonders:

> ghost daggers and prayer-wheels from Tibet; turquoise and raw amber neck-laces; green jade bangles; curiously packed incense-sticks in jars crusted over with raw garnets: the devil masks of Buddha and little portable lacquer altars; Russian samovars with turquoises on the lid; egg-shell china sets in quaint octagonal cane boxes; yellow ivory crucifixes.

But while "a thousand other oddments were cased, or piled, or merely thrown into the room," they were nothing, mere distractions to be ignored, compared to the real work. This, as we soon find out, is the work of understanding the entire perceptual system behind knowing what to notice. Correcting Kim's wandering glance, Lurgan Sahib declares, "My work is on the table—some of it."

> It blazed in the morning light—all red and blue and green flashes, picked out with the vicious blue-white spurt of a diamond here and there. Kim opened his eyes.[1]

This evocative passage captures in a nutshell an ancient worldview rooted in spell-binding magic, hermetic technology, and the sorcery of optical illusion. But the British author's gem-studded descriptions also allow us to see jewels as present-day examples of embodied cognition, tokens of mental rehearsal, and springboards for hypnagogic imagining. The ability to discern the difference between truth and deception is one of the leitmotifs of the novel. As part of his training within the dim confines of the curio shop, Lurgan Sahib shows Kim how to discriminate "sick" balas rubies and artificially "blued" turquoises from undoctored sapphires and glowing pearls. This exacting practice serves as prelude to the "Jewel Game. "

Not unlike contemporary virtual reality tools (electronic gloves, stereo-scopic goggles), scintillant gems summon alternative realities. The marvel-filled shop in Simla is both the inspiration and the initial venue of the Jewel Game. Novice players such as Kim needed to be trained in keen observational skills, to develop fine-grained recall. In this they resemble contemporary geo-scientists who must train their sight and pattern-recognition skills on the craquelure of dried river beds or the fissures in melting Arctic sea ice.

To gain this visual expertise, the casteless orphan is enticed into playing with a jealous opponent. Not only is this Hindu boy already adept at the game but he is the protégé of Lurgan Sahib. Kim and his fierce competitor must scrutinize a handful of stones, "trifling odds and ends," cast onto a copper tray and just as swiftly removed by the master of the game. Then the battle begins.

The game is simple: two players are challenged to remember and describe precisely the appearance of various stones—their mineral composition, their flaws, their colors, cracks, chips, size, shape, inscriptions, age, veining, and suggestive imagery. The winner is the one who demonstrates the most commanding technique, the most perfect recall. To put it scientifically, the Jewel Game is an attentional and detectional experiment requiring subjects to find and identify singular forms in a complex visual field (see fig. 11.3). This test of perceptual and recollection skills suggests that only a highly focused awareness is capable of attaining the true, the real.

In Kipling's novel, the two opponents engage in repeated rehearsals of noticing and concentrating. They practice the perceptual "work" of looking at a confusion of shiny objects and holding their complex surface details in consciousness. The exercise serves as the cornerstone of an unorthodox kind of secret-service training. The uncanny knack they develop for remembering the minute visual properties of very different sorts of jewels also acts as a springboard into imaginary realms. What becomes clear, however, is that this power of luminous spatial arrays to attract and transport us owes less to mysticism and more to a fundamental discriminatory task of the primate visual system: the basic human need to search a cluttered visual scene for objects of interest. This is a problem visual artists frequently and variously pose to themselves. To mention only a few: think of Clement Valla's laser-cut MDF tables mounted with 3-D reproductions from the Metropolitan Museum of Art (*Surface Survey*, 2014), of Lynn Aldrich's *Wunderkammer* in a bird cage (*The Universe in Captivity*, 2015—inspired by the richly dappled *Unicorn in Captivity* tapestry, also in the Met), or of Thai calligrapher Tang Chang's gesturally abstract "poetry drawings," dating from the late 1960s, which repeat words until they become alien shapes.

I have been using Kipling's game as a provocative way to think with and about the effects of gems and jewels. By asking what holds vision—what *fascinates*—amid the nonstop rush of conflicting information bombarding our senses in the course of everyday life—I want to shed light on integrative consciousness.[2] Noticing signifies cognitive receptivity, the careful absorption in mindful seeing.[3] And gems have served to engross us, to protract our atten-

tion spans, combatting boredom as well as distraction.[4] Observing or watching brings things to the center of our apprehension to the exclusion of all else.

The theory of fascination—founded on the power of suggestion and the supposed ability of natural or engraved gems to attract or repel cosmic influences—is thus newly relevant. The belief in the occult ability of individual colored stones to confer their virtues on the wearer and to transmit them at a distance through the force of concentrated vision raises key neuroscientific questions about consciousness and the functions of our attentional networks. Like the art lover who succumbs to his discoveries and becomes an ardent collector, the "gem watcher" can become a practicing gem wearer.[5]

Fascination, or the artificial compelling of "awareness, concentration, consciousness and noticing," has a venerable history inseparable from the rise of optical technologies.[6] It is fundamental to the global practices of crystal ball scrying and divination. These rituals involve staring into sacred wells, glass mirrors, globules of quick silver, polished steel, level water, or pools of ink in order to discover something unknown, fateful, that is otherwise invisible (see fig. 12.2).[7] Such bewitching glossy surfaces serve "to attract the attention of the gazer and to fix the eye until, gradually, the optic nerve becomes so fatigued that it ceases to transmit to the sensorium the impression made from without and begins to respond to the reflex action proceeding from the brain."[8] In short, as the gem historian George Frederick Kunz remarks, the vertiginous effect of prolonged gazing is that the internal impression appears to be externally projected, seeming to originate outside the beholder's body.

Sparkling stones were long believed to mirror a "biorealistic"—in Jaron Lanier's word—universe of wonders. That is, their watery depths and brilliant surfaces were much more than reflectors of their surroundings. Ancient legends tell of the unsettling effects wrought by ominous and luminous stones, patterned minerals, sacred charms, symbolic signats, astrological tokens, and prophylactic talismans, on highly sensitive nervous systems.[9] This is no doubt owing to the refractive power of cut gems in particular: glinting beryl, translucent jade, or polished turquoise, as well as faceted diamonds could be disorienting, distracting, misguiding our perceptual apparatus with dreamlike sense data (see fig. 11.2).

A dim and distant light reflected from the smooth or angled surface of the stones could appear to emanate from deep within them. This fact infuses some of the most intense light-pieces of Robert Irwin or James Turrell—where a monochromatic color projection exists simultaneously as radiant surface and subtly layered depth. More dramatically, Tim Otto Roth has projected spec-

Figure 12.2 Olafur Eliasson, *Open Ego*, 2015. Installation view, Mirrored Gardens, Hualong Agriculture Grand View Garden, Panyu, Guangzhou, 2015. Photograph: Luo Xianglin, Chen Shengming. Private collection. © 2015 Olafur Eliasson.

trographic data from NASA's Hubbell Space Telescope in green laser light, using this power of scintillant color to make present the remote origins of the universe. The oscillating lines, glinting at architectural scale, uncannily resemble not only brain waves but the astral gleam in the depths of prismatic stones.

Put in terms of physiology and cognition, something astonishing happens when conflicting images are presented to each of our two eyes. Rather than forming a stable composite, the images jockey for dominance, with perceptual awareness spontaneously alternating every few seconds between one and the other. Paradoxically, the observer's conscious state is continuously in flux—like Kim's struggle to attend to and integrate heterogeneous sensory data—while the visual stimuli remain invariant.[10] This intense whole-body struggle represents both a conceptual and a perceptual achievement: the winning of coherence from diverse impressions.

Gems and jewels thus exceed both their ancient role as magical artifacts and their contemporary incarnation as consumer products (expensive rocks bought or sold "because they are pretty"), that is, as fashionable ornaments directed at arousing our drives and desires. I propose, instead, that we view them primarily as controlling phenomenological experiences, material events that commandeer our visual attention.[11] They share this power of inducing rapt physical and psychological engagement with legions of spellbinding optical devices. Eric Dyer's filmic zoetrope-sculptures (strobe-lit constructions made with rapid-prototyping digital printers) makes this connection plain.[12] In his twenty-first-century retooling of a popular nineteenth-century kinetic toy, the spinning drum exhibits, as it whirls by, not only recurrent rectangular or lozenge shapes, but hypnotically flashing colors. Before our optic nerve can coalesce this sequence into a seamless scene, we experience it as a kaleidoscopic mosaic of irradiated color-forms that are mysteriously lit from within.

The animated abstract imagery of combinatoric optical devices, then, launches viewers into spatial exploration. Analogously, beautifully colored eye-tracking stones are part of a larger interactive system that reaches out to frontal, peripheral, and depth perception. These wonder-stimulating arts demonstrate what neuroscientists studying the more than three dozen visual areas of the brain are proving, namely, that "to see is to attend."[13]

There is a resonance between observation and imagination. Sometimes, when gazing is intense and continuous, the optic nerve can become temporarily paralyzed. At other times, when the activity is more intermittent or vol-

Figure 12.3 Tim Otto Roth, *From the Distant Past*, 2010 (detail). Installation view (first presentation), Hubble Space Telescope III conference, Venice, 2010. A green scanning laser projects spectra from distant galaxies onto the wall of the Palazzo Cavalli-Franchetti. Courtesy of Imachination Projects. Photograph: ESA/Hubble. CC BY 4.0 International, https://creativecommons.org.

Figure 12.4 Eric Dyer, *Mud Caves #2*, 2017. UV pigment cured on polycarbonate with synchronized strobe light. 47 × 47 × 4 inches. Courtesy of the artist. Here Dyer is preparing to spin the zoetrope, which "activates" it and produces the illusory blend.

untary, the optic nerve is merely deadened to external impressions while remaining active to stimuli coming from different brain regions. This recursive condition is conducive to the generation of visions in the seer. The hallucinatory Jewel Game thus also anticipates today's neuroscientific research into hypnosis and the effects of suggestion—that mental state showing changes in "baseline mental activity after an induction procedure and typically experienced at the subjective level as an increase in absorption, focused attention, disattention to extraneous stimuli, and a reduction in spontaneous thought."[14]

This hypnotic power of gems reveals the brain-mind's selection of physical features, like shape, from the flow of distracting sensory events. But it also helps to illuminate the enigma of the evolutionary purpose of color vision. Kipling's evocation of the riveting emotional as well as chromatic cues moving the eyes and grabbing the notice of the players ("all red and blue and green flashes" or "the vicious blue-white spurt of a diamond") makes the case for the essential role played by brightness and color in fixing the attention in a complex environment. Recall the high-arousal conditions operating in Lurgan Sahib's shadowy and dappled curio shop—an establishment, we are told, more cluttered than the Lahore Museum.[15] Like a shock threat, each precious object flashes in the gloom.

On one hand, the players' engagement with the jewels shows what happens cognitively and emotionally when our senses converge on the same place.[16] On the other hand, this kind of sensory imaging/imagining also reveals something of our neural and behavioral ability to focus attention on information in one sensory modality (for example, color vision, as in "yellow ivory"; tactility, as in "raw garnets"; or scent, as in smelly "oddments") while ignoring information in another.[17] Looked at from a psychophysical perspective and in terms of recent research on voluntary and involuntary attention, the effort of noticing diverse physical features is like trying to understand and remember scattered words audible in the hubbub of a cocktail party.[18] Kim's recollection or forgetting of the look of the stones is not absolute. During a complex visual search, some memories are more lucid, while others are faded or more tenuous. This spectrum, from clarity to unclarity, suggests a viewer paying less attention to some stimuli than to others that are more salient. Yet Kim's struggle to recall every sensory detail distinguishing the jewels shows that the sensory data remains available for later analysis.

Kim's attempt to combine and separate complex sensory signals coming from motley objects in the world is an externalization of the more general problem of visual sense. Vision's mechanisms are coded along a number

of separable dimensions: color, orientation, shape, brightness, direction of movement. These features must be synthesized to form a single object, bound together and fixated by attention. While debate continues to swirl around the question of whether we first behold an object or its characteristics, jewels and jewelry suggest the primacy of the qualities (size, hue, faceting, brilliance) over the recombined representation.

Gems and jewels, then, create an interactive environment composed of affecting things. Because their purpose is to be noticed, to command interest, they enable us to be in someone else's mind. By scrutinizing them, we make someone's activity the center, object, or topic of our attention. As portable devices for creating an intense kind of connectedness and communication, efficacious gems shed light on the neuroscientific problems of attention, memory, and reflection. They also tell us a lot about visual illusion. Seeing can block thinking, just as thinking can block seeing.

So I want to conclude with another passage concerned with selective attention from Kipling's illuminating novel. The Jewel Game forms a bookend with an earlier trial in which Lurgan Sahib pushes a heavy clay water jug across a fifteen-foot table toward his apprentice. Magically, it halts at his elbow without spilling a drop. A skeptical Kim is then asked to slide it back. He vainly protests, saying it will break, as it inevitably does.

Kipling vividly describes the scene. At first, the young hero envisions the glitter of crystalline water in the curved fragments of the jug lying on the floor. Then Lurgan Sahib lays his hand on the back of the boy's neck, holding his head as if in a vise, and he suddenly sees instead "one large piece of the jar where there had been three, and above them the shadowy outline of the entire vessel." In the end, to the astonishment of Lurgan Sahib, Kim is able to thwart the power of the induced optical illusion, refusing to behold the smashed jar as reforming itself into a single solid shape. The lesson for this essay is that this conscious, tremor-filled bodily effort — "like a swimmer before sharks" — to resist the dark deception and get at the truthful observation is based on his will to see the broken shards and notice the spilled water, that is, to attend, and "to think it *was* broken."[19]

The primal belief in performative substances that lure and allure — carved or engraved talismans, spell-averting or procuring amulets, shimmery hypnotic moonstones, animated eye-stones, binding love charms[20] — surprisingly intersects with contemporary questions about how we orient our conscious and unconscious mental processing toward sensory stimuli, activate ideas from memory, and maintain ourselves in an alert or contemplative state. This

essay has argued that gemstones have always been extensions of our senses, bodies, and minds. Today, however, we can also understand them as tools for focused thinking, for demonstrating the connection between attention and consciousness.

Historically, these magical, medicinal, and therapeutic notions about how material objects can be operative in themselves as well as mobilized by others were largely based on substances in the earth believed capable of influencing our physical and spiritual environment. Attention has often been compared to a spotlight that enhances the efficiency of discovering the events falling within its beam. As Kipling's novel makes plain, jewels engage our attentional system because their salient, showy physical characteristics make it seem they are deliberately drawing our vision to them. This control of visual orientation also entails detection, that is, the ability to make specific contact between our focused attention and a specific external signal.[21] Consequently, jewels as powerful attractors are actually keyed to our involuntary as well as our voluntary attentional processes.[22]

13

From Observant Eye to Non-Attentive "I"

The Camera as Cognitive Device

Recent research in the neurosciences has opened up century-old debates concerning the mechanics of human perception. Philosophers, social scientists, and cultural historians, in turn, are reevaluating longstanding theories about the ways in which we experience and interact with the world. One fruitful investigative avenue has been to pursue a new cognitive phenomenology grounded in the context of an individual dynamic consciousness. These exciting findings locating knowledge-formation in our sensorimotor system, I believe, open up a conversation with older discussions of the camera as simultaneously an artistic and a technical apparatus.

It is also a moment when, for millennials, nothing is hidden, little is sheltering. Offices are wide-open, lined with cubicles that have no wall or back. Building facades are Instagrammable abstractions remote from often boxy interiors and cold digital interfaces. In this paradoxical environment of radical exposure and creeping surveillance a "personal" image is, more often than not, a self-flaunting or wishfully disguising selfie. One could argue, I suppose, that given ubiquitous hacking and interminable breaches in social media, it's wise to use skimming devices that reveal only the top layer of someone's life.

The phenomenological approach to explaining how conscious-

Figure 13.1 teamLab, *Flowers and People Cannot Be Controlled but Live Together—A Whole Year per Hour*, 2015. Interactive digital installation. Sound: Hideaki Takahashi. Photograph © teamLab. Courtesy of teamLab and Pace Gallery.

ness arises in the brain extends inquiry to the entire body and its interaction with its surroundings. Thus recent neuroscientific research is trained, not only on the separateness, but on the adjacency of neural activity centers, their interconnectivity, as well as the role of peripheral mechanisms in cognition. Most importantly, this research underscores the myriad ways the visual and the motor cortices are connected by showing how sensory stimulation may not possess an intrinsic character, but definitely does vary according to our spatialized movements. Such a broadened investigative agenda goes well beyond the study of the modular brain and its individual neurons. While not denying the importance of brain modularity and single cell function, it seeks to understand the embedded, embodied, distributed body perceptively feeling its way through the shifts of a patterned and patterning environment.[1]

As a once-central visual medium, historical photography provides rich evidence for the explicit or implicit role the enactive body plays in making us aware that we are aware.[2] Like distributed cognition or dynamic consciousness, the camera, too, is a plastic instrument, capturing our cognitively shaped habits of seeing: those rule-bound dynamic relationships between perceiver and object. In aesthetic terms, we can think of them as the lasting "styles" by which we experientially explore the world.

The exhibition *See the Light* (Los Angeles County Museum, 2013–2014) reveals a paradox if not an irony. From its inception in the early nineteenth century, photography foregrounded the combined perceptual and technical effort exerted by the observing eye to forcibly still its unruly subject: the animated ambient and its lively contents. Think of Gambier Bolton's two-horned rhinoceros or Stuart Kipper's striated iceberg floating off Antarctica (exercises in natural history documentation), or Antonio Beato's travel record of a ship coasting along Luxor's shoreline. Figuring out how to translate sensations of motion into a mental map reconstructing the world as visual requires training or cognitive skill.[3]

Looking up from underneath the cultural surface leads to a new understanding of the "naturalness" of sensory stimulation as varying as a function of movement. That is, we gain insight both into our ordinary, easy mode of exploring the world visually as well as into those strained, awkward sensations arising when that impulse is thwarted. The neuroscientific view from below, then, allows us to appreciate more profoundly the artifice and contradiction inherent in all those static photographic objects recording architectural monuments, as well as the effects of modern industrialization and urbanization (as in Édouard-Denis Baldus's *Bridge and Workers, Paris*; George Barnard's *Trestle Bridge*; Evelyn Hofer's *Duomo, Florence*). What is significant is not that early cameras were incapable of accurately capturing motion as a believable transition from one thing or situation to another (instead of the inadvertent picture of an inscrutable smear). Rather, and more positively, they allow us to understand how central motion is to vision and to thought—the fact that we must intuit or infer some spatial absence or temporal gap should these effects not be realistically recorded.

The technological limitations of early photography—the inability to mimic the natural dynamic relationship between perceiver and object—led to interesting sensory substitutions, which are especially evident in portraiture, where tactile-visual translations reigned. This reconstruction of the visual style of exploring the world by invoking touch is evident, for example, in the tattered—even Beau Brummelesque—elegance of William Carrick's Victorian dandy–*Chimney Sweep* (not lost, later, on Irving Penn) and in the suave modernist smoothness of Edward Weston's nudes. We should think of the traditional camera, then, as a box capable of collecting visual information, certainly, but equally able to summon sensations of tactility and even to propose olfactory and auditory substitutions.

This leaves us with a final question. Does the research coming out of

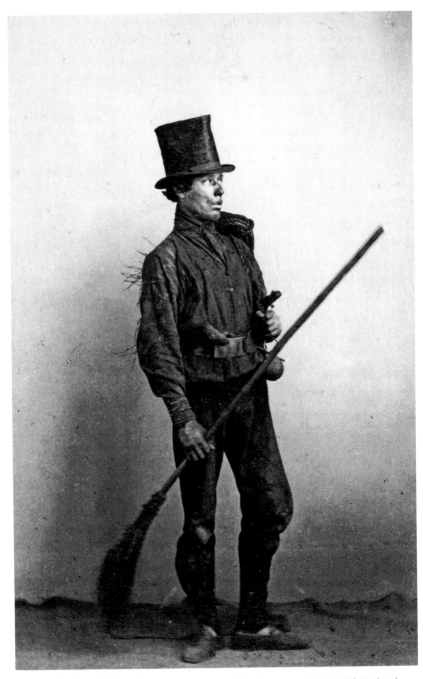

Figure 13.2 William Carrick, *Chimney Sweep*, ca. 1860. Albumen print. Scottish National Portrait Gallery.

the brain sciences suggest that there might be some value in rethinking the ways in which we design and employ the available means of representation in the twenty-first century? Today, with the advent of increasingly small digital devices and PDAs, the embedded lightweight camera produces a parade of seemingly self-generated images. Think of the familiar sight of a tablet or cell phone held high over the head of a tourist who is automatically clicking away. Paradoxically, given the amount of neuroscientific and cognitive scientific research devoted to issues of attention, photography in contemporary IT culture could be offered as evidence, not of our perceptual acuity, but of our perceptual pathologies of clicking, not looking.

What in the nineteenth and twentieth centuries had been the scientific framing and orienting device par excellence—creating compelling images by interestingly stopping, translating, and fixing the phenomenal flow—has become in our media-saturated environment one more device furthering our growing non-attentiveness to each other and to our surroundings. Like "friending" on Facebook, does taking selfies against every conceivable backdrop not turn the non-I into just another backdrop? Of course, this is not to deny that photography is also a critical contemporary art form keenly aware of its altered evidentiary function. Jeff Wall, for example, engages in actively constructed "emphatic picture making." He speaks of trying "to extend the sense of what permits something to be seen in a picture—that is, with an ambition to matter in terms of proposing what a picture is at its most significant level."[4]

My comment is directed, rather, to photography's current subsumption into contextless image practices such as internet clipping. If the world inherently asks us to spatially accommodate our bodies to it, what will advancing sensorimotor restrictions do to our perception of the world "at its most significant level"? If the plasticity of the brain is promoted through the co-creational dynamics of "the seeing act," what happens to it in the era of automated image generation, automated image retrieval, automated image processing, automated image exchange? What can photography be in such a closed-circuit image culture? As we become more and more enthralled by self-organizing, self-processing systems, photography might consider looking to neuroscience for new foundational insights. Since everything is reproducible, it seems true that originality is becoming more difficult than ever. Now, perhaps, the only way to be original is to go to one's library or photo archive or into an entirely new and different cognitive space.

14

Seizing Attention

Devices and Desires

> The message we listen for so carefully must be mediated
> through our own experience, our personality, our heredity,
> our inner needs. Can we ever break free of the devices and
> desires of our own hearts?
> —P. D. JAMES, *Devices and Desires*[1]

Whatever else early-modern apparatus did, it artfully vied for and temporarily engaged only specific features of our noticing mechanisms. In an era where information is flattened into ubiquitous data that is continually whittled by hidden algorithms and microchips, it's important to emphasize that, historically, mirrors, cameras obscuras, microscopes, telescopes, Claude glasses, kaleidoscopes, zoetropes, and clockwork automata, as well as the optical telegraph and the pinhole camera offered limited strategic platforms that addressed our selective attention in escapable ways.(see fig. 12.4).[2]

Today, conscious attention—that narrow band of brain function enabling people to be more than fleetingly aware of what they are holding in mind—is becoming scarce. Given our new economy of equivocal devices, it's not surprisingly, then, that this precious frontal-lobe real estate (estimated to be only 10 percent of our total cognitive horsepower) has become the kind worth selling.[3]

Neurons, synapses, and the brain's swiftly forming and dissipating electrical patterns of information now constitute the tantalizing mental territory eagerly competed for by a questing array of software and black magic hardware. Despite relentless and apparently unstoppable hacking, digital apps and other revolutionary tools continue to push us into the inscrutable dimension of intimate personal marketing. Significantly, this new, surveilling type of monitoring is paid for by "the attention we offer to providers who track our habits and preferences."[4] Not unlike the use of cognition-enhancing drugs, these often unregulated practices, relying on both external and embedded (prosthetics, robotics) sources of control, raise profound philosophical as well as everyday ethical issues concerning subjective agency and the undermining of free will.[5]

There seems no doubt we are witnessing the spiraling use of cognitively-informed marketing tactics grounded in the desire to bypass the prefrontal cortex entirely either by inciting impulsive behavior or, conversely, by inducing delayed response through embedding data in working memory should a prospective buyer (unfortunately) be focused on some other task at the opportune moment. This strategy is all the more insidious—as the nebulous term "the Cloud" indicates—since we don't know where our data and our software is really located. Recent additions to the goal of selling by appealing to our covert desires through brain science (turning us into what? addicts of specific products and processes?) include emotion-sensing technologies astutely directed at the thalamus, amygdala, hippocampus, and more generally the covetous limbic system. Not surprisingly, this affect-seizing apparatus is frequently tied to advertising and "the monetizing of the moment." As one of Samsung's researcher's declared, "If we know the emotion of each user, we can provide more personalized services."[6]

In the late nineteenth century, William James drew an important and still valid distinction between two types of attention. Certain kinds of objects, events, and situations effortlessly engage our involuntary attention: "strange things, moving things, wild animals, bright things" strike us without our consciously wanting to be struck. There are, however, phenomena that do not effortlessly slip into the mind: these require our voluntary, directed, or selective attention instead. This executive attention—at the heart of intense practice, expertise, and sustained thinking—is fueled by working memory and lies at the heart of effortful activity, process rather than ends, concentration.[7]

These opposing kinds of attention translate into two different modes of embodied thought. Consider first Jean-Jacques Rousseau's languorous rev-

eries as he drifted across the rippled mirror of Lac de Bienne. Sailing away from the clamoring duties of ordinary life, the philosophe's unfocused somatosensory system is impressionistically at one with the reflective ambient. Like a parade of magic lantern slides or unfurling kaleidoscopic images, his wandering daydreams proliferated, crossbred, evolved.

Now contrast Rousseau's plein air recovery from the hectic environment of Paris to the hard demands of sharp thinking.[8] Instead of solitary, soft immersion within the natural world, the harshly abutting political and social patchwork typical, say, of Cruikshank's pointed caricatures roughly focuses the viewer's attention, obliging her to buckle down and piece the incongruent parts together. As is true in the use of those aperture-ruled optical devices (from the telescope to the pinhole camera), executive neural areas are dramatically exerted when demanding and powerful things oblige us to pay close attention, to create sense out of confusing or overwhelming environmental noise.

Creating in the digital age is, to be sure, a central challenge for neuroscience, and a challenge and opportunity for the visual humanities as well. As artists, art historians, and visual humanists, I believe, we need to be more than archivists, more even than chroniclers of the contagiousness of imagery across cultures and societies. As I've argued here and elsewhere, given the fact that we live in a time of virtual and augmented realities we need to collaborate with the neurological community in the study of art's most enduring insights—from the underlying logic of forms, to the mirroring dynamic of ritualized gesture and performance, to the continuing force of symbols. Not collaborating is leading to marginalization. If anyone doubts this, then Google the growing art-related research produced by the scientific community—good, bad, or indifferent—yielding influential results with or without our help.[9]

One such collaborative project that usefully could be jointly addressed is the question of what these diverse devices teach us about the operations of human attention, whether hard-wired or culturally modified, in the past or in the present. What makes this ancient perceptual apparatus not obsolete but, in fact, cognitively informative and still eye-opening? Given the current reign of illusionistic VR and the design of digital- and biological-based games falling outside any box or screen, what could be more significant than understanding different ways of experience-framing? And what about the greatest conundrum of all: the as yet unresolved problem of how these two perceptual systems (the involuntary and the voluntary) interconnect? Why is it socially,

culturally, and ethically important that we hold these powerful brain operations in some kind of balance? How might art styles from minimalist to baroque, genres from emblematic to descriptive, and media from traditional to new help unlock this deeply relevant puzzle?

The digital revolution has made it harder not only to categorize cultural products but to categorize practitioners in the emerging creative sector. Where once we spoke easily about artists, illustrators, or designers, we now work with a more expansive boundary-crossing vocabulary. Where once we could speak about works of art, we now deal with the rise of "creative industries."[10] These networked crossings and interminglings of making with devices reflect the fact that, for more than two decades, the courses of media art and design have no longer been locked into single media crafts such as drawing, painting, sculpture, film, graphic design, or web design. And if skill mergers and intellectual hybridity are common in current art practice, isn't it time for a brandless art whose relational skills and methods are unshackled from the glut bloating international art fairs and the circus of the contemporary art market? Let's get rid of the popular notion that creativity—whether in the arts, sciences, or technology—should be an unexamined absolute: unmoored from responsibility and subject to no constraint. Might we configure, instead, a sharp-eyed and ethically responsible spatial/sensory studies reaching into whatever fields the questions or problems demand. Aware of, and knowledgeable about the past, yes, while forever alive to the present and thus newly relevant, even indispensable.

Acknowledgments

After 2008, I went on the road. I am deeply indebted to the people and institutions that have since invited me to join them for a time. These include the Humanities Institute at SUNY Buffalo (where I was invited by James Bono, Nancy Anderson, and Tim Dean, then director of the Institute); the Institute for Advanced Studies, Budapest (invited by rector Gábor Klaniczay); the University of Melbourne, where I held the Miegunyah Chair (invited by Barbara Creed and Jeannette van Hoorn); the Georgia Institute of Technology, where for two years I served as Distinguished University Visiting Professor (invited by Kenneth Knoespel and interim president Gary Schuster), followed by a year as Distinguished Critic in the College of Architecture (invited by George B. Johnston, chairman of the School of Architecture and Alan Balfour, then dean of the College of Architecture). My gratitude knows no bounds to these scholars and administrators.

At the University of Chicago Press, I thank my longtime editor, Susan Bielstein, for her steadfast encouragement, James Whitman Toftness for his unflagging help with images and permissions, and Joel Score for the editorial taming of my baroque tendencies. I am grateful as well to James Curtis for preparing the index.

While at Georgia Tech, I was fortunate to forge informal ties as

well with Emory University, as an affiliate of the Center for Mind, Brain, and Culture (invited by its founding director, Robert Mc-Cauley) and of the Neuroethics Seminar (by its director, Karen Rommel-fanger). After becoming a member of the Visiting Committee for the Savannah College of Art and Design (SCAD), and organizing two multi-institutional interdisciplinary symposia and exhibitions at Georgia Tech, I also had a foothold at SCAD Atlanta (through their associate dean of Communication, Design, and Liberal Arts, Denise Smith). My intellectual life continues to be enriched by these and other cultural institutions in the city where I now make my home.

I do much of my writing at my summer cottage in Wisconsin. Many of these essays would not have seen the light of day without director Anita O'Brien and the patient librarians at the Aram Public Library in Delavan. I am so grateful for their help. I must also acknowledge the insightful comments of my two anonymous reviewers. I've done my best to incorporate their useful suggestions.

My deepest thanks go to irreplaceable friends and tenacious, inspiring students, chief among them: Mary Argo, Anna Arnar, Sally Bould, Mary Dougherty, Jim Elkins, Suzanne Ghez, Roald Hoffmann, Wadad Kadi, Faraz Kamali, Elizabeth Liebman, John Peponis, Dawna Schuld, James Siffermann, and above all Ann Seeler—to whom this book is dedicated in fondest memory.

Notes

Preface

1. Kiki Smith, quoted in Thomas Gebremedhin, "The Magic of Fall Fashion at the Venice Biennale," *Wall Street Journal Magazine*, August 14, 2017.

2. John McPhee, *Draft No. 4* (New York: Farrar, Straus, Giroux, 2017).

Introduction

1. Iris Murdoch, *The Black Prince* (1973; Vintage, 1999), 205.

2. Gretchen Rubin, "Med Student Stitches Unique Study Aids," *Medicine on the Midway* (University of Chicago), January 29, 2018.

3. Joseph Conrad, *Heart of Darkness and The Secret Sharer* (Toronto: Bantam Classics, 1981), 136.

4. See MIT mathematician Max Tegmark's *Life 3.0: Being Human in the Age of Artificial Intelligence* (New York: Knopf, 2017), esp. chap. 2, "Matter Turns Intelligent."

5. See the recent exhibition and catalog *Jewelry of Ideas: The Susan Grant Lewin Collection* (New York: Cooper Hewitt Smithsonian Design Museum, 2018).

6. "A Beautiful Accident," *Meta-Morf 2018*, 5th Trondheim Biennale for Art and Technology, March 9–10.

7. *Louise Bourgeois: The Red Sky*, Los Angeles: Hauser & Wirth, Los Angeles, February 17–May 20, 2018.

8. Shaoling Ma, "Stone, Jade, Medium: A Neocybernetic *New Story of the Stone*," *Configurations*, no. 1 (Winter 2018), 26, 21.

9. *Simone Forti: Time Smears*, The Box, Los Angeles, January 27–March 24, 2018.

10. Joshua Rothman, "As Real as It Gets: Are We Already Living in Virtual Reality," *New Yorker*, April 2, 2018, 32. The article looks at the recent theories of philosopher of mind Thomas Metzinger and his collaborators, on virtual embodiment and the simulation of out-of-body experience.

1: "Black and Glittering"

1. Alan Hollinghurst, *The Line of Beauty* (New York: Bloomsbury, 2004), 15.

2. *The Nightwatches of Bonaventura*, trans. Gerald Gillespie (Chicago: University of Chicago Press, 1971), Nightwatch 13, p. 94.

3. For a sunny view of ubiquitous connectivity, see Parag Khanna, *Connectography* (New York: Random House, 2016).

4. See my essay "From Communicable Matter to Incommunicable 'Stuff': Extreme Combinatorics and the Return of Ineffability," in *Ineffability: An Exercise in Comparative Philosophy of Religion*, ed. Timothy D. Knepper and Leah E. Kalmanson, 9–27 (Cham: Springer, 2017), and reprinted in this volume.

5. See "Unintelligibility," *Roget's International Thesaurus*, 4th ed., rev. by Robert L. Chapman (New York: Harper & Row, 1984), esp. 549.1, 8, 10, 11, 13.

6. Suzanne Vrancia, "The Ad Revolution," *Wall Street Journal*, June 22, 2016, R1–R8.

7. Bonaventura, Nightwatch 11, p. 83.

8. William Gibson, *Zero History* (New York: Berkley Books, 2010), 84.

9. Cited in Alexandra Wolfe, "Prizewinner Plumbs Surveillance," *Wall Street Journal*, June 11–12, 2016), C12.

10. Gibson, *Zero History*, 155, 441–42.

11. Gibson, *Zero History*, 97, 268. Gibson's aversion to conspicuous design was, indeed, prescient. See Ruth Jamieson, "The New Wave of Anti-Design Magazines Will Question Your Sense of Taste—And That's a Good Thing," *AIGA Eye on Design*, May 11, 2016, eyeondesign.aiga.org. But whereas Gibson favored a timeless minimalist aesthetic, these exiles from the fashion industry favor the ugly, the untidy, the cheap.

12. For the marvelous vocabulary describing textile surfaces, see Elizabeth Dyer, *Textile Fabrics* (Cambridge, MA: Riverside Press, 1923), esp. 60–77, on how various "finishes" affect values.

13. See the exhibitions #*techstyle* (Boston Museum of Fine Arts, 2016) and Andrew Bolton, *Manus x Machina: Fashion in an Age of Technology* (Metropolitan Museum of Art, Costume Institute, New York, 2016).

14. For illustrations of plugged-in fashion, see Eric Wilson, "Future Shock," *InStyle*, June 2016, 39–41.

15. See my introductory essay, "Revealing Technologies/Magical Domains," in *Devices of Wonder: From the World in a Box to Images on a Screen*, ed. Barbara Maria Stafford and Frances Terpak, 1–142, exh. cat. (Los Angeles: Getty Museum, 2001).

16. Adam Gopnik, "Feel Me," *New Yorker*, May 16, 2016, 64–65,

17. Hannah Bethke, "Evidence of the Power of Judgment: An Encounter with Gertrude Luebbe-Wolff," *Koepfe und Ideen*, no. 11 (2016), www.wiko-berlin.

18. Voicing the pipes for *Aura Calculata*, the organ builders Jäger & Brommer made a remarkable discovery. It is commonly assumed that an organ pipe has a single optimal sound (with a clear fundamental tone) due to the pipe scaling (mensur). But to the surprise of the organ builders the pipes for *Aura* could be voiced in such a way, that, depending on the water level, they can play two optimal sounds. www.pixelsex.org/aura.

19. "Der Grossen Genentwurf," *Badische Zeitung*, "Lokales," April 6, 2016. The translations from the German are mine. Also see my essay "Art/Structure: Visualizing the Structure of Analogy," in *Logic Phantasies*, exh. cat. (Aschaffenberg, 2019).

20. http://www.agnesmocsy.com.

21. Sascha Lobo, "Digital Is Sometimes Radical—Risks and Opportunities for Marketing!" (lecture), ZKM Media Theater, Karlsruhe, June 2, 2016.

22. "Play It Again: How Ragnar Kjartansson Turns Repetition into Art," *New Yorker*, "Profiles," April 11, 2016.

23. See my *Artful Science: Enlightenment Entertainment and the Eclipse of Visual Education* (Cambridge, MA: MIT Press, 1994), esp. 42–45.

24. See Stafford and Terpak, *Devices of Wonder*.

25. Siegfried Zielinski, *After the Media: News from the Slow-Fading 20th Century* (Minneapolis: Univocal Press, 2013); see "Introduction [the Argument]: 'The Media Have Become Superfluous,'" in which the German media theorist outlines the beginnings of an "atlas of media thinking." Also see Sean Cubitt, *The Practice of Light: A Genealogy of Visual Technology from Prints to Pixels* (Cambridge, MA: MIT Press, 2014), 168–71, 217–20.

26. Terence Dickinson, *Hubble's Universe: Greatest Discoveries and Latest Images* (New York: Firefly Books, 2014), 41–42.

27. C. E. Morgan (using the nom de plume K. Aubere) in her novel *The Sport of Kings*, citing a fictitious Darwinian essay, "Limitless Variation and the Ascent of Life." See the book review by Kathryn Schultz, "Track Changes," *New Yorker*, May 9, 2016, 70.

28. Frank Wilczek, "A Vision of the Void," *Wall Street Journal*, August 27–28, 2016, C4.

29. Carl Sagan, *Pale Blue Dot: A Vision of the Human Future in Space* (New York: Random House, 1994), 155–60.

30. See *Public, Private, Secret*, a disturbing exhibition of post-2000 photos and videos curated by Charlotte Cotton ICP Museum, New York, through January 8, 2017.

2: Lying Side by Side

1. John Updike, *Museums and Women and Other Stories* (New York: Knopf, 1972), 4–5, 13–15.

2. Scott Brown, "Infinite Jest," *Wired*, August 2009, 54.

3. Updike, *Museums and Women*, 11–12.

4. For a broader discussion of compressive synthetic genres, see my *Echo Objects: The Cognitive Work of Images* (Chicago: University of Chicago Press, 2007), chap. 2.

5. Cited in Susan Rubin Suleiman, *Risking Who One Is: Encounters with Contemporary Art and Literature* (Cambridge, MA: Harvard University Press, 1994), 82.

6. Philip Thurthle and Robert Mitchell, "The Acme Novelty Library: Comic Books, Repetition, and the Return of the New," *Configurations* 15 (Fall 2007): 290.

7. Updike, "I Am Dying, Egypt, Dying," in *Museums and Women*, 112.

8. See F. Husserl on Berkeley on representation, in *Logical Investigations*, trans. J. N. Findlay (London: Routledge, 1970), 393–405.

9. Updike, "The Sea's Green Sameness," in *Museums and Women*, 160.

10. Christo and Jean-Claude/CVJ, *Exit Gate* (2005), HBO Documentary Films (Maysles Film Production, 2007).

11. Jeanette Hoorn, "Tom Roberts' Portrait of Charlie Turner and Darwin's *Expression of the Emotions and Man and Animals*," in *Reframing Darwin. Evolution and Art in Australia*, ed. Jeanette Hoorn (Melbourne: Mieegunyah Press, 2009), 132–35.

12. Vittorio Gallese and George Lakoff, "The Brain's Concepts: The Role of the Sensory-Motor System in Conceptual Knowledge," in *Cognitive Neuropsychology* 22, nos. 3–4 (2005): 455–79.

13. Camille Sweeney, "Banking on a Chemical Reaction," *New York Times*, July 30, 2009, E3.

14. Clive James, "Monja Blanca," *New Yorker*, July 27, 2009, 48–49.

15. Chad Williamson, "Kant and the Feelings of Reason," *Eighteenth-Century Studies* 42 (Summer 2009): 577–80.

16. Edmund Burke, *A Philosophical Enquiry into the Origin of our Ideas of the Sublime and Beautiful* (1757), ed. J. T. Boulton (London: Routledge and Kegan Paul; New York: Columbia University Press, 1958), 113.

17. Kirstin Valdez Quade, "The Five Wounds," *New Yorker*, July 27, 2009, 65.

18. See Bennett Gilbert, "Some Neglected Aspects of the Rococo: Berkeley, Vico, and Rococo Style" (2014), http://works.bepress.com/bennett-gilbert/1/.

19. *Take Your Time: Olafur Eliasson*, Museum of Contemporary Art, Chicago, May 1–September 13, 2009.

20. Vilayanur Ramachandran, *The Emerging Mind*, BBC Reith Lectures 2003 (London: Profile Books, 2003), 28–30.

21. On the differences between mechanistic and organic time, as analyzed by the Russian Formalists, see Ilya Kliger and Nasser Zakariya, "Organic and Mechanistic Time and the Limits of Narrative," *Configurations* 15 (Fall 2007): 331–53.

22. For a discussion of solidity, see Elaine Scarry, *Dreaming by the Book* (New York: Farrar, Straus, Giroux, 1999), 12–13.

3: The Ultimate Conjuncture

1. Daniel Dennett, cited in Joshua Rothman, "A Science of the Soul: A Philosopher's Quest to Understand the Making of the Mind," *New Yorker*, March 27, 2017, 46.

2. Joyce Carol Oates, "Shot," in *Where Is Here?* (Hopewell, NJ: Ecco, 1992), 91.

3. Francesco Casetti, "Notes on a Genealogy of the Excessive Screen," https://dev .screens.yale.edu/sites/default/files/files/Screens_Booklet.pdf.

4. Stephen T. Asma, *The Evolution of Imagination* (Chicago: University of Chicago Press, 2017).

5. Alva Noë, *Action in Perception* (Cambridge, MA: MIT Press, 2004).

6. Daniel Dennett, *Consciousness Explained* (1991), and many subsequent volumes.

7. Oates, "Shot," 91.

8. See Margaret Talbot's disturbing article on the spread of addiction in Martinsburg, Hedgesville, and Shepherdstown—wonderful towns I experienced many times on foot. "The Addicts Next Door," *New Yorker*, June 5/12, 2017, 78–83.

9. Note the timely conference "I Work, Therefore I Am," European Metamorphosis of Labour, Brussels, November 9–11, 2017.

10. Tyler Volk, *Quarks to Culture: How We Came to Be* (New York: Columbia University Press, 2017), 11–22.

11. John le Carré, *Our Game* (New York: Knopf, 1995), 218.

12. For the pros and cons, see Jerry Kaplan, "Don't Fear the Robots: Smart Machines Will Replace Some Jobs, but They Will Create Many More," *Wall Street Journal*, July 22–23, 2017, C3, and "Can the Tech Giants Be Stopped?" *Wall Street Journal*, July 15–16, 2017, C1–C2.

13. See Nina Maria Frahm, "International Governance of Neuroscience and Neuro-technology: Whom to Trust with the Assessment of Future Pathways?" Neuroethics Blog, November 7, 2017, http://www.theneuroethicsblog.com/2017/11/international-gover nance-of.html.

14. Kelly Weinersmith and Zach Weinersmith, "The Future of Programmable Stuff," *Wall Street Journal*, November 4–5, 2017, C4; italics mine.

15. For a defense of this drone mentality, see Jerem Rabkin and John Yoo, "'Killer Robots' Can Make War Less Awful," *Wall Street Journal*, September 2–3, 2017, C4.

16. Arun Sundarajan, *The Sharing Economy: The End of Employment and the Rise of Crowd-Based Capitalism* [Cambridge, MA: MIT Press, 2016]; Cathy O'Neil, *Weapons of Math Destruction: How Big Data Increases Inequality and Threatens Democracy* (New York: Crown, 2016).

17. Siddhartha Mukherjee, "The Algorithm Will See You Now," *New Yorker*, April 3, 2017, 46–53.

18. See my "Thought Gems: Inferencing from the Impersonal Crystalline," *Art Jewelry Forum*, Fall 2017, and reprinted in this volume.

19. See "Algorithmic Injustice," *New-Media Curating Digest*, March 7–14, 2017 (#2017-29), http://lab.cccb.org/en/algorithmic-injustice/.

20. "Movie Research Results: Multiasking Overloads the Brain," Academy of Finland, April 26, 2017.

21. Elissa Newport, "Development, Plasticity, and Language Reorganization after Pediatric Stroke" (lecture), Center for Mind, Brain, and Culture, Emory University, October 16, 2017.

22. Anne Carson, "Back the Way You Went," *New Yorker*, October 31, 2016.

23. On the host of invisible rays in the universe, from radio waves to gamma rays, see Bob Berman, *Zapped: From Infrared to X-Rays: The Curious History of Invisible Light* (New York: Little, Brown, 2017).

24. Stephen J. Morse, "Criminal Law and Neuroscience: Hope or Hype?" Neuroethics Blog, August 1, 2017, http://www.theneuroethicsblog.com/2017/08/criminal-law-and -neuroscience-hope-or.html.

25. See the Centerbeam Symposium, ZKM/Karlsruhe, September 2, 2017.

26. "Embodied AI" (discussion), Helix Center for Interdisciplinary Investigation, New York, October 22, 2016.

27. "What Is Happening to Our Brain," conference-art festival, guest curated by Melanie Buehler, Warren Neidich, and Andrew Lepecki, Gerrit Rietveld Academie and Stedelijk Museum, Amsterdam, March 22–24, 2017.

28. Arthur Conan Doyle, *The Lost World* (1912), ed. Ian Duncan (Oxford: Oxford University Press, 1995), 145.

29. From Ursula K. Le Guin, *The Left Hand of Darkness*, cited in Julie Phillips, "Out of Bounds," *New Yorker*, October 17, 2016, 44.

30. Visual Art Source, weekly newsletter, March 10, 2017, visualartsource.ccsend.com.

31. Conference announcement, "Epitome: From Fragmentation to Re-Composition (and Back Again)," Ghent University, Belgium, May 23–25, 2018.

32. Susan Greenfield, *Mind Change: How Digital Technologies Are Leaving Their Mark on Our Brains* (New York: Random House, 2015), 293n1.

33. Katja Jylkka, "'Witness the Pleiosaurus': Geological Traces and the Loch Ness Monster Narrative," *Configurations* 26, no. 2 (2018): 207–34; Oliver Laric, *Hundemensch* (exhibition), Metro Pictures, New York, March–April 2018.

34. Charles Dickens, *Bleak House*, ed. George Ford and Sylvere Monod (New York: Norton, 1972), 5.

35. Ian Duncan, introduction, in Doyle, *Lost World*, ix–xi.

36. Adina Roskies, "Mental Alchemy," Neuroethics Blog, August 29, 2016, http:// www.theneuroethicsblog.com/2016/08/mental-alchemy_23.html.

37. "Design in Nature" (discussion), Helix Center for Interdisciplinary Investigation, New York, April 22, 2017.

38. Robert M. Sapolsky, "Does Belief in Free Will Make Us More Ethical?" *Wall Street Journal*, "Mind and Matter," September 2–3, 2017, C2.

39. Dennis Larivee, "The International Roots of Future Neuroethics," Neuroethics Blog, January 30, 2018, http://www.theneuroethicsblog.com/2018/01/the-international -roots-of-future.html.

40. Interview with Milton Glaser, *Wall Street Journal*, "Weekend Confidential," March 17–18, 2018, C11.

4: Reconceiving the Warburg Library

1. Nicholas Carr, "Chaos Theory," *Wired*, June 18, 2010.

2. Hans Liebeschütz, "Aby Warburg (1866–1929) as Interpreter of Civilisation," *Leo Baeck Institute Yearbook* 16, no. 1 (1971): 225–36, 234.

3. Sandra D. Mitchell, *Unsimple Truths. Science, Complexity, and Policy* (Chicago: University of Chicago Press, 2009), 51.

4. See David Shields, *Reality Hunger: A Manifesto* (New York: Knopf, 2010), 20–32.

5. Rowland, quoted in Daniel Mendelsohn, "God's Librarians: The Vatican Library Enters the Twenty-First Century," *New Yorker*, January 3, 2011, 29.

6. For a fascinating discussion of spatial connections in a museum setting, see P. Zamani and John Peponis, "Co-Visibility and Pedagogy: Innovation and Challenge at the High Museum of Art," *Journal of Architecture* 15, no. 6 (2010): 858.

7. See Anna Somers Cocks, "The Warburg Institute Is Fighting for Its Life," *Art Newspaper*, July–August 2010 (published online July 20, 2010); Martin Gayford, "Warburg Institute, Saved from Nazis, Faces Bureaucratic Threat," *Bloomberg News*, July 20, 2010. Also see Ingrid R. D. Rowland, "Move the Warburg to L.A.?" *New York Review of Books*, October 14, 2010, a letter written in response to Anthony Grafton and Jeffrey Hamburger, "Save the Warburg Library," *New York Review of Books*, September 30, 2010.

8. Charles Hope, cited in "Warburg Goes to War," Art History Today (blog), July 21, 2010, artintheblood.typepad.com/art_history_today/2010/07/warburg-goes-to-war.html.

9. Julienne Hanson, Bill Hillier, and Hilaire Graham, "Ideas Are in Things," *Environment and Planning B: Planning and Design* 14, no. 4 (1987): 363–85.

10. David Owen, "The Efficiency Dilemma," *New Yorker*, December 20–27, 2010, 78–85.

5: From Communicable Matter to Incommunicable "Stuff"

1. Jeb Bush's widely publicized response to the Umpqual Community College shootings in Roseberg, Oregon, on October 1, 2015.

2. Liam Jefferies, "Greetings," Curatorial Resources for Upstart Media Bliss, www.crumbweb.org, accessed March 10, 2015.

3. Note the nostalgic interest in "vintage" materials fostered by historic suppliers such as Winsor & Newton, Liquitex, Conté à Paris, and Lefranc & Bourgeois, all of which still purvey sketching tools, paints, chalks, pastels, gels, fluids, all manner of deeply textured colored powders, creams, and fixatives.

4. See the conference "Material Culture in Action: Practices of Making, Collecting and Re-Enacting Art and Design," Glasgow School of Art, September 7–8, 2015.

5. See "Naturally Hypernatural," ed. Suzanne Anker and Sabine Flach, special issue of *Antennae: The Journal of Nature in Visual Culture* 33 (2015).

6. Johnjoe McFadden and Jim Al-Khalili, *Life on the Edge: The Coming of Age of Quantum Biology* (New York: Crown, 2015).

7. See Shirley S. Wang, "Surgery's Far Frontier: Head Transplants," *Wall Street Jour-*

nal, June 5, 2015, A1, A8, http://www.wsj.com/articles/surgerys-far-frontier-head
-transplants-1433525830.

8. Lewis Carroll, *Alice in Wonderland and Through the Looking Glass* (New York: Grosset & Dunlap, 1946), 192–93. Also see the commentary in Robert Douglas-Fairhurst, *The Story of Alice* (New York: Belknap, 2015).

9. Carroll, *Alice in Wonderland,* 164–65.

10. Barbara Marie Stafford, "Compressive Compositions: Emblem, Symbol, Symbiogenesis," chap. 2 in *Echo Objects: The Cognitive Work of Images* (Chicago: University of Chicago Press, 2007). Making the competing story lines of television shows like *Game of Thrones* or *Orange Is the New Black* cohere is a screen analogy to the surgical physico-cognitive problem of making the compelling compounded mouse apprehendable. John Jurgensen, "How Many TV Shows Can Your Brain Handle?" *Wall Street Journal,* June 12, 2015, D1–D2.

11. Samuel Taylor Coleridge, *Biographia Literaria; or, Biographical Sketches of My Literary Life and Opinions,* ed. James Engall and W. J. Bate (Princeton, NJ: Princeton University Press, 1983), 1:304.

12. Although a disappointing antireligious tirade, biologist Jerry A. Coyne's stark dichotomies between religion and science usefully distinguish science from scientism—i.e., excessive trust or faith in all things scientific. Coyne, *Faith vs. Fact: Why Science and Religion Are Incompatible* (New York: Viking, 2015).

13. Dominique Berthet, *Une esthétique du trouble* (Paris: L'Harmattan, 2015).

14. James J. O'Donnell, "Ways of Knowing," chap. 6 in *Pagans: The End of Traditional Religion and the Rise of Christianity* (New York: HarperCollins, 2015); Barbara Maria Stafford, "The Magic of Amorous Attractions," chap. 3 in *Visual Analogy: Consciousness as the Art of Connecting* (Cambridge, MA: MIT Press, 2001).

15. Iris Murdoch, *The Book and the Brotherhood* (New York: Viking, 1988), 122–23.

16. Murdoch, *Book and the Brotherhood,* 133.

17. Murdoch, *Book and the Brotherhood,* 132, 132, 136.

18. Murdoch, *Book and the Brotherhood,* 6.

19. Barbara Maria Stafford, *Body Criticism* (Cambridge, MA: MIT Press, 1991) and "Seizing Attention: Devices and Desires," *Art History* 39, no. 2 (2016): 422–27.

20. Monica Youn, "Goldacre," *New Yorker,* June 1, 2015, 36–47.

21. Julius Genachowski and Robert M. McDowell, "How to Feed a Data-Hungry Public," *Wall Street Journal,* July 28, 2015.

22. Nathan Heller, "High Score," *New Yorker,* September 14, 2015, 90.

23. Oculus VR founder Palmer Luckey, quoted in Alexandra Wolfe, "Palmer Luckey," *Wall Street Journal,* "Weekend Confidential," August 8–9, 2015, C11.

24. Suzanne Anker and Sabine Flach, *The Glass Veil: Seven Adventures in Wonderland* (New York: Peter Lang AG, 2015).

25. Erich Schwarzel, "Why 3-D Printers Scare Hollywood," *Wall Street Journal,* July 21, 2015, B1.

26. Reinhold Niebuhr, *The Children of Light and the Children of Darkness: A Vindica-*

tion of Democracy and a Critique of Its Traditional Defense (Chicago: University of Chicago Press, 1944), 16–17.

27. On self-causation, see the exhibition *Causa Sui*, featuring artworks by Ann Stewart, Whitespace Gallery, Atlanta, Georgia, June 2015.

28. Shirley S. Wang, "Scientists See Ways to Target Alzheimer's in Proteins," *Wall Street Journal*, July 21, 2015, D2.

29. Richard Bright, ed., "BioMedArt," special issue of *Interalia* 13 (June 2015).

30. See, for example, the following exhibitions by Oron Catts and Ionat Zurr: *NoArk: The Tissue Culture & Art Project* (2007); *NoArk II: The Tissue Culture & Art Project* (2008–2010); *Odd Neolifism* (2010); and *NoArk Revisited: Odd Neolifism* (2011).

31. Anthony Burgess, *A Clockwork Orange* (New York: Norton, 1986), 25.

32. Primo Levi, "Quaestio de Centauris," *New Yorker*, June 8–15, 2015, 59.

33. Christopher Salter, *Alien Agency: Experimental Encounters with Art in the Making* (Cambridge, MA: MIT Press, 2015).

34. The term *semi-living* was coined in 1996 by Catts and Zurr and first appears in print in their exhibition catalog *Tissue Culture & Art Project: Stage 1* (Perth Institute of Contemporary Arts, 1998). See also Catts and Zurr, "Tissue Culture and Art(ificial) Wombs," in *Next Sex: Sex in the Age of Its Procreative Superfluousness* (Sex im Zeitalter seiner reproduktionstechnischen Überflüssigkeit), ed. Ars Electronica, Gerfried Stocker, and Christine Schöpf, 252–53 (Vienna: Springer, 2000). See figure 5.6 for photographs of the final TEMA project, *Futile Labor*, which was first displayed in October 2015.

35. Warren Neidich and Barry Schwabsky, "Enstranging Objects" (announcement), Saas Fee Summer Institute of Art, 2015.

36. Burgess, *Clockwork Orange*, xiii.

37. Eudora Welty, "One Writer's Beginnings" (1984), in *Stories, Essays, and Memoir*, ed. Richard Ford and Michael Kreyling (New York: Library of America, 1998).

38. John Colapinto, "Lighting the Brain," *New Yorker*, May 18, 2015, 77.

39. Alexander Mordvintsev, Christopher Olah, and Mike Tyka, "Inceptionism: Going Deeper into Neural Networks," Google Research Blog, accessed June 17, 2015, http://googleresearch.blogspot.com/2015/06/inceptionism-going-deeper-into-neural.html; italics added.

40. Pedro Domingos, *The Master Algorithm* (New York: Basic Books, 2015).

41. See the exhibition and conference "Festival of the Unconscious: The Unconscious Revisited at the Freud Museum," London, June 24–October 4, 2015.

42. John Peponis, Sonit Bafna, Saleem Mokbel Dahabreh, and Fehmi Dogan, "Configurational Meaning and Conceptual Shifts in Design," *Journal of Architecture* 20, no. 2 (2015): 215.

43. Peponis et al., "Configurational Meaning," 216.

44. Murdoch, *Book and the Brotherhood*, 258.

6: Impossible to Name

1. Monica Youn, "Brownacre," *New Yorker*, May 23, 2016, 40.

2. Ovid, in Jon R. Stone, *The Routledge Dictionary of Latin Quotations* (New York: Routledge, 2005), 83.

3. Thomas Bulfinch, "Pythagoras," in *Bulfinch's Mythology* (New York: Thomas Y. Crowell Company, 1963), 288–91.

4. Plotinus, *Ennead* 2.9.15.

5. Amina Wright, *Stubbs and the Wild*, Holburne Museum, Bath, June 25–October 2, 2016.

6. Plotinus, "On Beauty," *Ennead* 1.8 4–5.

7. See the exhibition *Invisible Man: Gordon Parks and Ralph Ellison in Harlem*, Art Institute of Chicago, May 21–August 28, 2016.

8. *Jeff Wall* (exhibition), Marian Goodman Gallery, New York, October 30–December 19, 2015.

9. See Frank Wilczek, *A Beautiful Question* (London: Penguin, 2015).

10. James Turrell, interview with Brainard Carey, Yale University radio station WYBCX, November 3, 2015.

11. *Radiant Space*, McClain Gallery, Houston, May 7–August 13, 2016.

12. Robert Irwin, *Excursus: Homage to the Square³*, Dia:Beacon, Beacon, NY, installed 2016. Location matters for any installation. This work was conceived for and debuted at Dia:Chelsea, in New York City (1999), in a somewhat different configuration and a very different atmospheric space.

13. Jen Bervin and Marta L. Werner, *The Gorgeous Nothings: Emily Dickinson's Envelope Poems* (New York: New Directions, 2013), includes transcriptions.

14. See http://jenbervin.com.

15. See http://intermediaprojects.org/pages/IntermediaProjectsPresentsUr.html. Also see Nancy Perloff, "Schwitters Redesigned: A Post-War Ursonate from the Getty Archives," *Journal of Design History* 23, no. 2 (June 2010): 195–203.

16. David Lodge, *Thinks . . .* (New York: Viking, 2001), 50.

17. John Banville, "De Rerum Natura," in *Forgiveness*, 146.

18. "Lisier D'Encre. Dany Danino," Art-of-the-day.info, July 25, 2016, http://www.art-of-the-day.info/a07076-lisier-d-encre-dany-danino.html.

19. Carl Safina, *Beyond Words: What Animals Think and Feel* (New York: Henry Holt, 2015), 383–91.

20. Joyce Poole, "Elephant Memories," in *Animal Wise. The Thoughts and Emotions of Our Fellow Creatures*, ed. Virginia Morell (New York: Crown, 2013), 132–57.

21. Joshua Rothman, "The Metamorphosis. What Is It Like to Be an Animal?" *New Yorker*, May 30. 2016, 70–71; Thomas Thwaites, *GoatMan: How I Took a Holiday from Being Human* (Princeton, NJ: Princeton Architectural Press, 2016).

22. Charles Foster, *Being a Beast: Adventures across the Species Divide* (London: Metropolitan Books, 2016); Werner Shedd, *Owls Aren't Wise and Bats Aren't Blind*.

A Naturalist Debunks Our Favorite Fallacies about Wildlife (New York: Harmony Books, 2001), 21–25, 170.

23. Neil Shubin, *Your Inner Fish. A Journey into the 3.5 Billion Year History of the Human Body* (New York: Pantheon, 2008), 144.

24. "From the Laboratory to the Studio: Interdisciplinary Practices in Bio Art," May 17–June 17, 2016, School of Visual Arts, New York City (announcement for summer residency, with Suzanne Anker, Joseph DeGiorgis, and visiting speakers), http://www .suzanneanker.com/?wysija-page=1&controller=email&action=view&email_id=73.

25. Tyler M. John, "New Frontiers in Animal Research: Neuroethics at the Center for Neuroscience and Society," Neuroethics Blog, July 19, 2016, http://www.theneuroethics blog.com/2016/07/new-frontiers-in-animal-research_19.html.

26. Milan Kundera, *Immortality* (New York: HarperCollins, 1999), 304.

27. Kundera, *Immortality*, 305.

28. Manuela Lenzen, "How Does the World Enter a Person's Head? And Just How Does It Then Reemerge?" in *Koepfe und Ideen: Ursprung der Sprache* (Minds and Ideas: The Origin of Language), (Berlin: Wissenschaftskolleg zu Berlin, 2016).

29. Lenzen, "How Does the World Enter?"

30. Lenzen, "How Does the World Enter?"

31. Lenzen, "How Does the World Enter?"

7: "Totally Visual"?

A version of this essay was published in Nannette Maciejunes and M. Melissa Wolfe, *Reflections: The American Collection at the Columbus Museum of Art* (Columbus: Columbus Museum of Art; Ohio University Press, 2018).

1. Edna Andrade, quoted in Jim Quinn, "Driven to Abstraction," *Philadelphia Inquirer Magazine*, April 2, 1989, 42.

2. Ronald W. Langacker, *Cognitive Grammar. A Basic Introduction* (Oxford: Oxford University Press, 2008), 215.

3. Amy S. Rosenberg, "An Op Art Original," *Philadelphia Inquirer Magazine*, January 11, 2007, E7.

4. Eleanor Heartney and Kenneth Snelson, *Kenneth Snelson: Forces Made Visible* (Lennox, MA.: Hard Press Editions; Hudson Hills Press, 2009), 22–25.

5. Karsten Schubert, *The Curator's Egg: The Evolution of the Museum Concept from the French Revolution to the Present Day*, 3rd ed. (London: Ridinghouse, 2009), 83–85.

6. Quoted in Joe Houston, *Optic Nerve: Perceptual Art of the 1960s*, exh. cat. (London: Merrell; Columbus Museum of Art, 2007), 62.

7. Paul Hertz, "Art, Code, and the Engine of Change," *Art Journal*, Spring 2009, 61–62.

8. Imagination Engines Inc., www.imagination-engines.com.

9. Robert Plotkin, "Stephen Thaler's Imagination Machines," *Futurist*, July–August 2009, 28–29.

10. See A. E. Eiben and J. E. Smith, *Introduction to Evolutionary Computing*, Natural

Computing Series (Vienna: Springer, 2008); John R. Koza, *Genetic Programming: On the Programming of Compuers by Means of Natural Selection* (Cambridge, MA: MIT Press, 1992).

11. Leo Corry, "Calculating the Limits of Poetic License: Fictional Narrative and the History of Mathematics," *Configurations* 15 (Fall 2007): 205.

12. See W. Douglass Paschall, *Sensational: Edna Andrade's Drawings*, exh. cat. (Philadelphia: Woodmere Art Museum, 2007).

13. Julie L. Belcove, "Tomaselli," *W*, July 2009, 70–79.

14. Debra Bricker Balken, *Edna Andrade: Paintings 1960-1990s*, exh. cat. (Philadelphia: Locks Gallery, 1997), 5.

15. Belcove, "Tomaselli," 72.

8: Dark Wonder

1. P. D. James, *Devices and Desires* (London: Faber & Faber, 1989), 62.

9: Still Deeper

1. Jim Davis, "The Sublime of Tragedy in Low Life," *European Romantic Review* 18 (April 2007): 162–63.

2. Longinus, *On the Sublime*, trans. W. H. Fyfe, Loeb Classical Library XXIII (Cambridge, MA: Harvard University Press, 1995), 163–65.

3. Alfred Gell, *Art and Agency: An Anthropological Theory* (Oxford: Oxford University Press, 1998), 22.

4. Georg Simmel, "Die Ruine," in *Philosophische Kultur: Über das Abenteuer, die Geschlechter und die Krise der Moderne*, ed. Jurgen Habermas (Berlin: Verlag Klaus Wagalach, 1998), 118–24.

5. On myth, see George S. Williamson, *The Longing for Myth in Germany: Religion and Aesthetic Culture from Romanticism to Nietzsche* (Chicago: University of Chicago Press, 2004).

6. Alfred N. Whitehead, *Modes of Thought* (New York: Free Press, 1968), 36.

7. Alfred N. Whitehead, *Adventures of Ideas* (New York: Free Press, 1967). Also see Michael Halewood, "On Whitehead and Deleuze: The Process of Materiality," *Configurations* 13 (2005): 62–63.

8. On the wide range of emotional cognition, see Paul Thagard, *Hot Thought: Mechanisms and the Applications of Emotional Cognition* (Cambridge, MA: MIT Press, 2006), 8.

9. Isabelle Stengers, "Whitehead's Account of the Sixth Day," *Configurations* 13 (2005): 38.

10. Douglas Hofstadter, *I Am a Strange Loop* (New York: Basic Books, 2007), 234.

11. Hofstadter, *I Am a Strange Loop*, 207, 213.

12. See Melynda Nuss, "Prometheus in a Bind: Law, Narrative, and Movement in *Prometheus Unbound*," *European Romantic Review* 18 (July 2007): 419.

13. For the scientific, psychological, and spiritual dimensions of Shelley's "lyrical

drama" (1818–1820), see Michael O'Neill, "Percy Bysshe Shelley, *Prometheus Unbound*," in *A Companion to Romanticism*, ed. Duncan Wu (Oxford: Blackwell, 1999), 259–68.

14. For an extended critique of what I term an "extreme" type of phenomenology, see "Impossible Will?," chap. 6 in my *Echo Objects. The Cognitive Work of Images* (Chicago: University of Chicago Press, 2007).

15. John Markoff and Andrew E. Kramer, "U.S. and Russia Split on Cyber Peril," *International Herald Tribune*, June 27–28, 2009, 1, 14.

16. See, e.g., Benedict Carey, "Who's Minding the Mind?" *New York Times*, Science Times, July 31, 2007, D1, D6; Rebecca Cathcart, "Winding through 'Big Dreams' Are the Threads of Our Lives," *New York Times*, Science Times, July 3, 2007, D1, D4.

17. Thagard, *Hot Thought*, 90–91.

18. Alfred North Whitehead, *Process and Reality: An Essay in Cosmology*, ed. David Ray Griffin and Donald W. Sherburne (New York: Free Press, 1978), 4.

19. Victor Erlich, *Russian Formalism: History–Doctrine*, 4th ed. (The Hague: Mouton, 1980), 171.

10: Strange Shadows/Marred Screens

An early version of this essay was first given as a lecture in the Mellon Symposium on *Extreme Screens*, Yale University, New Haven, CT, April 21, 2017.

1. Elizabeth Bishop, "The Map" (1946), cited in Claudia Roth Pierpont, "The Island Within: Chaos, Control, and Elizabeth Bishop," *New Yorker*, March 6, 2017, 75.

2. On the construction of emotions from bits and pieces of the body's reactions to the world, see Lisa Feldman Barrett, *How Emotions Are Made* (New York: Houghton Mifflin Harcourt, 2017).

3. Bishop, "The Sandpiper," quoted in David Mason, "Dark, Deep and Absolutely Clear" (review of Megan Marshall, *Elizabeth Bishop*), *Wall Street Journal*, February 11–12, 2017, C5.

4. "Hawthorne's Preface" to *The House of the Seven Gables*, in *The Portable Hawthorne*, ed. Malcolm Cowley (New York: Viking Penguin, 1976), 562.

5. Primo Levi, *The Periodic Table*, trans. Raymond Rosenthal (New York: Schocken, 1984), 34.

6. Nathaniel Hawthorne, "Rappaccini's Daughter" (1844), in *The Celestial Railroad and Other Stories* (New York: New American Library, 1963), 231–32, 237–41.

7. Nathaniel Hawthorne, "The Snow-Image," in *Celestial Railroad*, 266.

8. Anne Farrell, "The Neuroethics of Brainprinting," Neuroethics Blog, September 19, 2017, http://www.theneuroethicsblog.com/2017/09/the-neuroethics-of-brainprinting.html.

9. Nathaniel Hawthorne, "The Birthmark" (1843), in *Celestial Railroad*, 204.

10. Hawthorne, "Birthmark," 205. The reference is to the dazzling white sculpture *Eve Tempted*, modeled in 1842 by Hiram Powers.

11. See my *Artful Science: Enlightenment Entertainment and the Eclipse of Visual Education* (Cambridge, MA: MIT Press, 1994), 138, 184–90.

12. Stafford, *Artful Science*, 207, 209–10.

13. William Blake, "The Sick Rose," in *Songs of Experience: Selected Prose and Poetry of William Blake*, ed. Northrop Frye (New York: Modern Library, 1953), 42.

14. Claire Messud, *The Hunters: Two Novellas* (San Diego: Harcourt, 2001), 103.

15. See Goldstein's website, http://www.danielgoldsteinstudio.com/icarian/.

16. Email from Jason Lahman-Goldstein, April 17, 2017, after an impromptu encounter April 12 at the Nelson Atkins Museum.

17. Saul Bellow, "The Writer as Moralist," in *There's Too Much to Think About. Collected Non-Fiction*, ed. Benjamin Taylor (New York; Penguin, 2015), 133–65; quoted in Dwight Garner, "Striking Oil, Then Paying an Awful Toll" (review of David Grann, *Killers of the Flower Moon*), *New York Times*, April 13, 2017, C1.

18. See, e.g., Dalton Conley and Jason Fletcher, *The Genome Factor* (Princeton, NJ: Princeton University Press, 2017), on tracking the role of genes in governing social behavior.

19. For a discussion of scary gene drives and gene editing, especially the gene-editing tool CRISPR, see Michael Specter, "Rewriting the Code of Life," *New Yorker*, January 2, 2017, 34–43.

20. See Jennifer A. Doudna and Samuel H. Sternberg, *A Crack in Creation: Gene Editing and the Unthinkable Power to Control Evolution* (New York: Houghton Mifflin Harcourt, 2017). Also see the review article by Amy Dockser Marcus, "The Ethics of Gene Editing," *Wall Street Journal*, June 14, 2017, A17.

21. Peter Reiner, "What Can Neuroethicists Learn from Public Attitudes about Moral Bioenhancement?" Neuroethics Blog, August 30, 2017, http://www.theneuroethicsblog.com/2017/08/what-can-neuroethicists-learn-from.html.

22. Anil Ananthaswamy, *The Edge of Physics: A Journey to the Earth's Extremes to Unlock the Secrets of the Universe* (Boston: Houghton Mifflin Harcourt, 2010), 181.

23. David Worrall, "William Blake and the Neuroscience of Visual Hallucinations" (lecture), Humanities Research Centre, ANU, September 5, 2016.

24. Frank Wilczek, "A Vision of the Void," *Wall Street Journal*, August 27–28, 2016, C4.

25. Raymond Malewitz, "Primo Levi's *The Periodic Table*: Chemistry as Posthumanist Science," *Configurations* 24, no. 4 (2016): 421.

26. Per the manufacturer's website, https://www.surreynanosystems.com/vantablack.

27. John Gardner, *Grendel* (New York: Vintage, 1989), 63. Also see E. M. Forster, *A Passage to India* (New York: Harcourt Brace & Co., 1924), 137–38, 162–66.

28. James Putnam, curator, *Wittgenstein's Dream*, Freud Museum, London, 2016.

29. See Andy Clark, *Surfing Uncertainty: Prediction, Action, and the Embodied Mind* (Oxford: Oxford University Press, 2016) and "Neuroethics, the Predictive Brain, and Hallucinating Neural Networks," Neuroethics Blog, December 5, 2017, http://www.theneuroethicsblog.com/2017/12/neuroethics-predictive-brain-and.html.

30. Garner, quoted in James Wood, "Scrutiny," *New Yorker*, December 12, 2016, 76.

11: Thought Gems

1. Steven Pinker, *The Blank Slate: The Modern Denial of Human Nature* (New York: Viking, 2002), 40–41.

2. A. S. Byatt, "The Stone Woman," in *The Little Black Book of Stories* (New York: Vintage International, 2003), 132.

3. Susan Greenfield, *Mind Change: How Digital Technologies Are Leaving Their Mark on Our Brain* (New York: Random House, 2015), 72.

4. Adolfo Bioy Casares, *Invention of Morel*, trans. Ruth L. C. Simms (1940; New York: New York Review Classics, 2003), 46.

5. Carl G. Jung, *Man and His Symbols* (London: Aldus, 1964), 209.

6. Joyce Cary, *The Horse's Mouth* (New York: Harper and Brothers, 1958), 186.

7. Helen Czerski, "Light at Diamond Speed," *Wall Street Journal*, June 10–11, 2017, C4.

8. See my essay "The Jewel Game: Gems, Fascination and the Neuroscience of Visual Attention," in *Contemporary Jewelry in Perspective*, ed. Damian Skinner (San Francisco: Art Jewelry Forum, 2015), 189–94.

9. Helen Czerski, "The Ring of a Ripe Watermelon," *Wall Street Journal*, July 1–2, 2017, C4.

10. For a compendium of accessible science lessons ranging from electromagnetics to supercapacitors, see James Kakalios, *The Physics of Everyday Things* (New York: Crown, 2017).

11. Victoria Finlay, *Color: A Natural History of the Palette* (New York: Ballantine, 2002), 6–7.

12. Giulio Tononi, *Phi: A Journey from Brain to Soul* (New York: Pantheon, 2003).

13. Adam Gopnik, "A New Man: Ernest Hemingway, Revised and Revisited," *New Yorker*, July 3, 2017, 64.

14. Peter Brannen, *The Ends of the World* (London: Ecco, 2017).

15. On our era's lack of intimacy, see Courtney Maum's novel *Touch* (New York: Putnam, 2017).

16. Christoph Ransmayr, *The Last World: A Novel with an Ovidian Repertory*, trans. John E. Woods (New York: Grove Weidenfeld, 1990), 139.

17. David Owen, "The End of Sand," *New Yorker*, May 29, 2017, 28–33.

18. Richard O. Prum, *The Evolution of Beauty* (New York: Doubleday, 2017).

19. See announcement for Pétursson's exhibition, August 17–September 30, 2017, at i8 Gallery, Reykjavik, https://i8.is/exhibitions/158/.

20. Byatt, "Stone Woman," 120–25, 136.

21. Ransmayr, *Last World*, 140–41, 116–17.

22. Ransmayr, *Last World*, 126–27.

23. See, e.g., Ara Norenzayan, "Social Cognition, Theory of Mind, and Belief in Gods," presented at Summer Workshop on Social Cognition, Autism, and Religiosity, Center for Mind, Brain and Culture, Emory University, May 18, 2017, http://cmbc.emory

.edu. Also see Norenzayan's book *Big Gods: How Religion Transformed Cooperation and Conflict* (Princeton, NJ: Princeton University Press, 2013).

24. See my *Echo Objects: The Cognitive Work of Images* (Chicago: University of Chicago Press, 2007).

12: The Jewel Game

1. Rudyard Kipling, *Kim* (New York: Modern Library, 2004), 153.

2. See my introduction, "Crystal and Smoke: Putting Image Back in Mind," in *A Field Guide to a New Meta-Field: Bridging the Humanities-Neuroscience Divide*, ed. Stafford (Chicago: University of Chicago Press, 2011).

3. See my *Echo Objects: The Cognitive Work of Images* (Chicago: University of Chicago Press, 2007), chap. 6.

4. For a summary of recent research on mobile technologies ushering in an age of distraction, see Cathy N. Davidson, *Now You See It: How the Brain Science of Attention Will Transform the Way We Live, Work, and Learn* (New York: Viking, 2011).

5. Robert Wyndham, *Enjoying Gems: The Lure and Lore of Gemstones* (Brattleboro, VT: Stephen Greene Press, 1971), 13.

6. M. R. Bennett and P. M. S. Hacker, "Attention, Awareness and Cortical Function: Helmholtz to Raichle," in *History of Cognitive Neuroscience* (Oxford: Wiley-Blackwell, 2008), 44.

7. See my *Visual Analogy: Consciousness as the Art of Connecting* (Cambridge, MA: MIT Press, 1999), esp. chap. 3, "The Magic of Amorous Attraction."

8. George Frederick Kunz, *The Curious Lore of Precious Stones* (Philadelphia: J. B. Lippincott, 1913), 176.

9. Isidore Kozminsky, *The Magic and Science of Jewels and Stones* (New York: G. P. Putnam's Sons, 1922), 18–71.

10. Frank Tong, Ming Meng, and Randolph Blake, "Neural Bases of Binocular Rivalry," *Trends in Cognitive Sciences* 10, no. 11 (2006), 502–11.

11. Colin McGinn, *Mindsight: Image, Dream, Meaning* (Cambridge, MA: Harvard University Press, 2004), 68.

12. See Eric Dyer, "Material Motion," *Art Journal* 77 (Spring 2018): 71–86.

13. Steven Yantis, "To See Is to Attend. Perspectives: Neuroscience," *Science*, 299 (January 3, 2003): 54–55.

14. David A. Oakley and Peter W. Halligan, "Hypnotic Suggestion and Cognitive Neuroscience," *Trends in Cognitive Science*, 13, no. 6 (2009): 264–70.

15. Robert J. Snowden, "Visual Attention to Color: Parvocellular Guidance of Attentional Resources?" *American Psychological Society* 13 (March 2002): 180–84.

16. Emiliano Macaluso, "Orienting of Spatial Attention and the Interplay between the Senses," *Cortex* 46 (2010): 282–97.

17. On this relatively poorly understood phenomenon, see Jennifer A. Johnson and Robert J. Zatorre, "Attention to Simultaneous Unrelated Auditory and Visual Events: Behavioral and Neural Correlates," *Cerebral Cortex* 15 (October 2005): 1609–20.

18. Bennett and Hacker, "Attention, Awareness and Cortical Function," 48–51.

19. Kipling., *Kim*, 154–55.

20. Paul E. Desautels, *The Gem Kingdom* (New York: Ridge Press/Random House, 1976), 12–30.

21. Michael I. Posner, Chareles R. Snyder, and Brian J. Davidson, "Attention and the Detection of Signals," *Journal of Experimental Psychology* 109, no. 2 (1980): 160–74.

22. See the review article by Michael I. Posner, "Attention: The Mechanisms of Consciousness," *Proceedings of the National Academy of Sciences* 91 (August 1994): 7398–7403.

13: From Observant Eye to Non-Attentive "I"

1. See my introduction, "Crystal and Smoke: Putting Image Back in Mind," in *Field Guide to a New Meta-Field: Bridging the Humanities-Neurosciences Divide*, ed. Stafford (Chicago: University of Chicago Press, 2011).

2. Alva Noë, *Out of Our Heads: Why You Are Not Your Brain, and Other Lessons from the Biology of Consciousness* (New York: Hill and Wang, 2009).

3. Donald D. Hoffmann, *Visual Intelligence: How We Create What We See* (New York: Norton, 2004), argues that everything we see is our construction of the world we see.

4. Jeff Wall, "On Pictures: Conversation with Lucas Blalock," *Aperture* 210 (Spring 2013): 43.

14: Seizing Attention

1. P. D. James, *Devices and Desires* (London: Faber & Faber, 1989), 376.

2. See my introduction, "Revealing Technologies/Magical Domains," in *Devices of Wonder: From the World in a Box to Images on a Screen*, ed. Barbara Maria Stafford and Frances Terpak, 1–142, exh. cat. (Los Angeles: Getty Museum, 2001).

3. Barbara Maria Stafford, *Echo Objects: The Cognitive Work of Images* (Chicago: University of Chicago Press, 2007), 201–5.

4. Raffi Khatchadourian, "We Know How You Feel," *New Yorker*, January 19, 2015, 58.

5. A. Chatterjee, "Cosmetic Neurology: The Controversy over Enhancing Movement, Mentation, and Mood," *Neurology* 63 (2004): 968–74.

6. Khatchadourian, "We Know How You Feel," 59. Perhaps this explosion of corporate interest in emotion is also tied to the explosion of affect studies launched by Antonio Damasio's book *The Feeling of What Happens* (New York: Harcourt Brace and Company, 1999).

7. On the uses and drawbacks of working memory (i.e., procedural memory), see Sian Beilock, *Choke: What the Secrets of the Brain Reveal about Getting It Right When You Have To* (New York: Atria, 2013), 66–67.

8. See Sian Beilock, "Greening the Brain: How the Physical Environment Shapes Thinking," in *How the Body Knows Its Mind* (New York: Atria, 2015), esp. 210–11; M. G. Berman et al., "Interacting with Nature Improves Cognition and Affect in Depressed Individuals," *Journal of Affective Disorders* 140, no. 3 (2012): 300–305.

9. On the fundamental problem of transforming 2-D retinal images into 3-D spatial

representations, see, e.g., Ari Rosenberg and Dora E. Angelaki, "Reliability-Dependent Contributions of Visual Orientation Cues in Parietal Cortex," *Proceedings of the National Academy of Sciences* 111, no. 50 (2014): 18043–48. Rosenberg demonstrates that when you look at a picture with perspective cues, you have a stronger sense of depth if you view it monocularly rather than binocularly (Leonardo, of course, was fascinated by this). His findings, however, locate the first neural correlate of this phenomenon, in a subpopulation of neurons in the parietal cortex that combine binocular disparity and texture cues for visual orientation.

10. See David Garcia, "Notes towards a Reframing of the Creative Question," http://new-tactical-research.co.uk/blog/notes-towards-reframing-creative-que.

Index